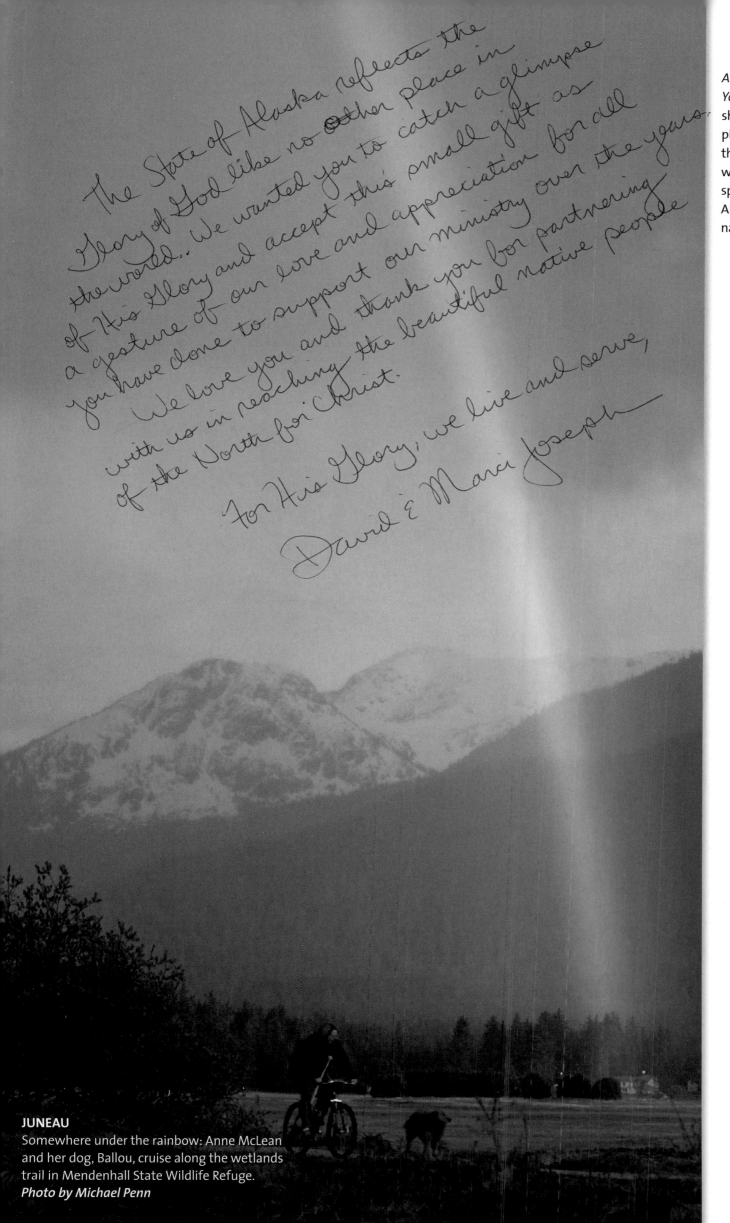

The State of Alaska reflects the Glory of God like no other place in the world... We wanted you to catch a glimpse of His Glory and accept this small gift as a gesture of our love and appreciation for all you have done to support our ministry over the years.

We love you and thank you for partnering with us in reaching the beautiful native people of the North for Christ.

For His Glory, we live and serve,

David & Marci Joseph

JUNEAU
Somewhere under the rainbow: Anne McLean and her dog, Ballou, cruise along the wetlands trail in Mendenhall State Wildlife Refuge.
Photo by Michael Penn

Alaska 24/7 is the sequel to *The New York Times* bestseller *America 24/7* shot by tens of thousands of digital photographers across America over the course of a single week. We would like to thank the following sponsors, the wonderful people of Alaska, and the talented photojournalists who made this book possible.

Adobe

OLYMPUS

LEXAR
Media

snapfish

jetBlue
AIRWAYS

WEBWARE

Google

DIGITAL
POND

ebaY

LONDON, NEW YORK, MUNICH, MELBOURNE, and DELHI

Created by Rick Smolan and David Elliot Cohen

24/7 Media, LLC
PO Box 1189
Sausalito, CA 94966-1189
www.america24-7.com

First Edition, 2004
04 05 06 07 08 10 9 8 7 6 5 4 3 2 1

Published in the United States by
DK Publishing, Inc.
375 Hudson Street
New York, NY 10014

DK Publishing, Inc. offers special discounts for bulk purchases for sales
promotions or premiums. Specific, large-quantity needs can be met with
special editions, personalized covers, excerpts of existing guides, and corporate
imprints. For more information, contact:
Special Markets Department
DK Publishing, Inc.
375 Hudson Street
New York, NY 10014
Fax: 212-689-5254

Cataloging-in-Publication data is available from the Library of Congress
ISBN 0-7566-0041-3

Printed in the UK by Butler & Tanner Limited

First printing, October 2004

CANTWELL
A nearly full moon pulls away from a crag
along the Alaska Range in South Central
Alaska. On a night following a fresh snowfall,
the sky is clear and the air chills to around 25
degrees. Humidity is 48 percent, and winds
are southerly at 5 miles per hour.
Photo by Robert Hallinen,
Anchorage Daily News

ALASKA 24/7

24 Hours. 7 Days. Extraordinary Images of One Week in Alaska.

Created by Rick Smolan and **David** Elliot Cohen

DK Publishing

About the America 24/7 Project

A hundred years hence, historians may pose questions such as: What was America like at the beginning of the third millennium? How did life change after 9/11 and the ensuing war on terrorism? How was America affected by its corporate scandals and the high-tech boom and bust? Could Americans still express themselves freely?

To address these questions, we created *America 24/7*, the largest collaborative photography event in history. We invited Americans to tell their stories with digital pictures. We asked them to shoot a visual memoir of their lives, families, and communities.

During one week in May 2003, more than 25,000 professionals and amateurs shot more than a million pictures. These images, sent to us via the Internet, compose a panoramic yet highly intimate view of Americans—in celebration and sadness; in action and contemplation; at work, home, and school. The best of these photographs, more than 6,000, are collected in 51 volumes that make up the *America 24/7* series: the landmark national volume *America 24/7*, published to critical acclaim in 2003, and the 50 state books published in 2004.

Our decision to make *America 24/7* an all-digital project was prompted by the fact that in 2003 digital camera sales overtook film camera sales. This technological evolution allowed us to extend the project to a huge pool of photographers. We were thrilled by the response to our challenge and moved by the insight offered into American life. Sometimes, the amateurs outshot the pros—even the Pulitzer Prize winners.

The exuberant democracy of images visible throughout these books is a revelation. The message that emerges is that now, more than ever, America is a super-sized idea. A dreamspace, where individuals and families from around the world are free to govern themselves, worship, read, and speak as they wish. Within its wide margins, the polyglot American nation manages to encompass an inexplicably complex yet workable whole. The pictures in this book are dedicated to that idea.

—*Rick Smolan and David Elliot Cohen*

American nightlight: More than a quarter of a billion people trace a nation with incandescence in this composite satellite photograph.
Photo by Craig Mayhew & Robert Simmon, NASA Goddard Flight Center/Visions of Tomorrow

But Then, That's Alaska

by Mike Doogan

Like most Alaskans, I live in a city and work in an office. My relationship to logging or commercial fishing is like yours: I see pictures.

But many mornings, I look to the north and there is Mt. McKinley, a brawny collection of rock, snow, and ice, big enough to create its own weather. There are many photographs of McKinley, but, believe me, there's nothing like seeing it firsthand.

The Alaska I was born into in 1948 didn't support much in the way of cities or offices. We were still a territory. About 120,000 of us lived here, and most people earned their bread by working with their hands. My father was a coal miner turned gold miner turned teamster and heavy equipment mechanic.

A lot has changed. Alaska became a state. Oil was discovered. The population quintupled. Cities and towns grew and grew.

The trip from there to here has been bumpy. Alaska has always been a land of new beginnings and last chances, drawing the dreamy, the desperate, and the dodgy. It got so bad during the pipeline boom of the late 70s that a lawyer I know said, only half in jest, that he was going to make his fortune by offering an Alaska Special to new arrivals: a divorce, a bankruptcy, and a name change, all for one low price.

But we survived. And Alaska today is a much different place. How? In many ways, some sublime, some ridiculous. You are holding in your hands a week's worth of Alaska faces and Alaska places that begins to stake out how

PRUDHOE BAY
One of 24 such mobile structures on Alaska's North Slope, Rig 7ES drills a well into the Kuparuk oil field. The North Slope supplies 17 percent of the nation's oil.
Photo by Judy Patrick

different. In the Alaska of today, finding the morning's latte is more important to most people than finding the winter's moose. The Alaska Native Claims Settlement Act brought new respect for Native ways—and new Native economic clout. In today's Alaska, we don't pay any state taxes; instead, we get an annual check from the Alaska Permanent Fund.

In many ways, though, Alaska remains unchanged by the hubbub.

We're still spread out pretty thin across the land—just more than 600,000 of us in 591,000 square miles.

We're still the captives of the romantic notions of people who live thousands of miles away. With oil revenues fading, our best economic prospect, drilling in the Arctic National Wildlife Refuge, is blocked by the nation's environmental yearnings.

We're still a ward of the federal government, which spends far more in Alaska than it takes out in taxes.

Lastly, we're still a tough, argumentative people, but we're generous with our knowledge and our help. If you don't believe me, just break down beside the road. Or lose your belongings in a fire. Help will arrive unbidden.

I know there are a lot of contradictions here. What can I tell you? For every statement you can make about Alaska, there's a "Yeah, but...."

Yeah, but there is one constant: We're tougher and stronger than the poor souls forced to live elsewhere because, even in the city, we live nose to nose with nature. But then, that's Alaska.

A third-generation Alaskan, MIKE DOOGAN *has been a journalist and writer for 30 years, and a columnist for the* Anchorage Daily News *since 1990.*

JUNEAU
The bow of photographer Michael Penn's
mahogany kayak noses into an iceberg
spawned by the Mendenhall Glacier on
Mendenhall Lake. Icebergs get their cool,
blue glow from dense crystal structures that
absorb low energy red, orange, and yellow
wavelengths and scatter high–energy blue
and green light.
Photo by Michael Penn

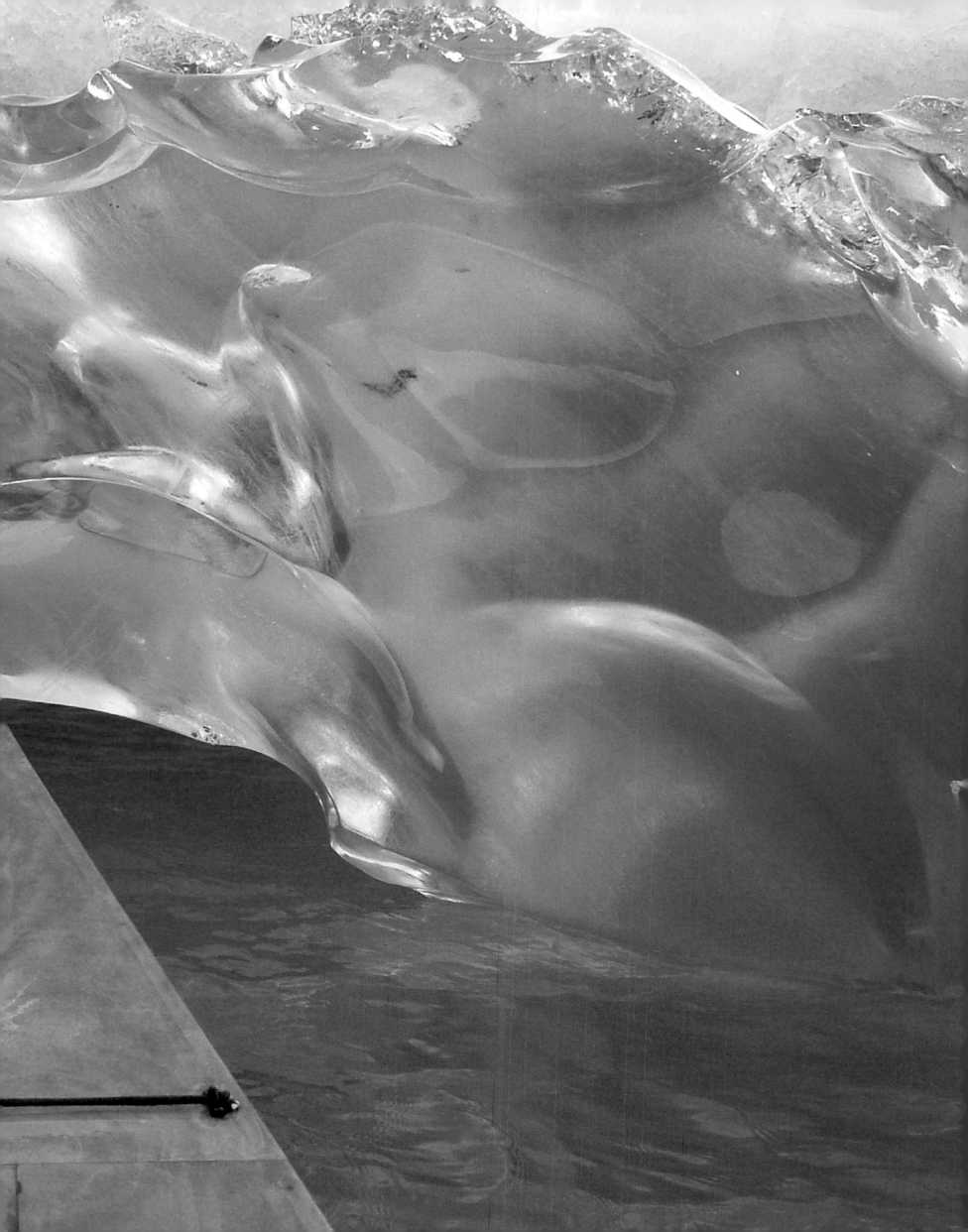

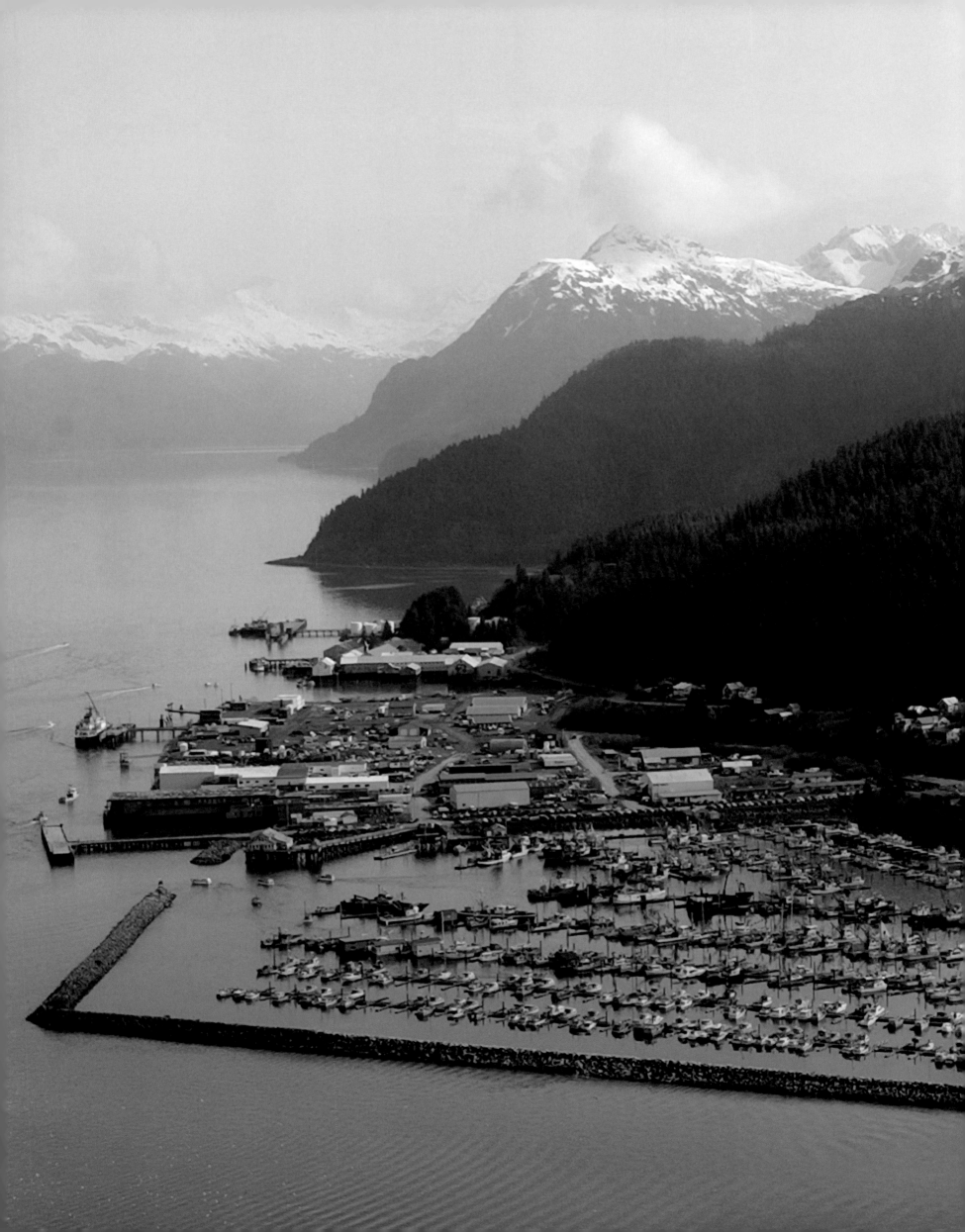

CORDOVA

The Exxon *Valdez* oil spill of 1989 in Prince William Sound devastated commercial fishing (salmon, lingcod, halibut) in the region. No fishing fleet was more affected than that of Cordova, on the sound's eastern reach. An old railroad depot, Cordova (pop. 2,454) and its waters are steadily recovering.
Photo by Marc Lester, Anchorage Daily News

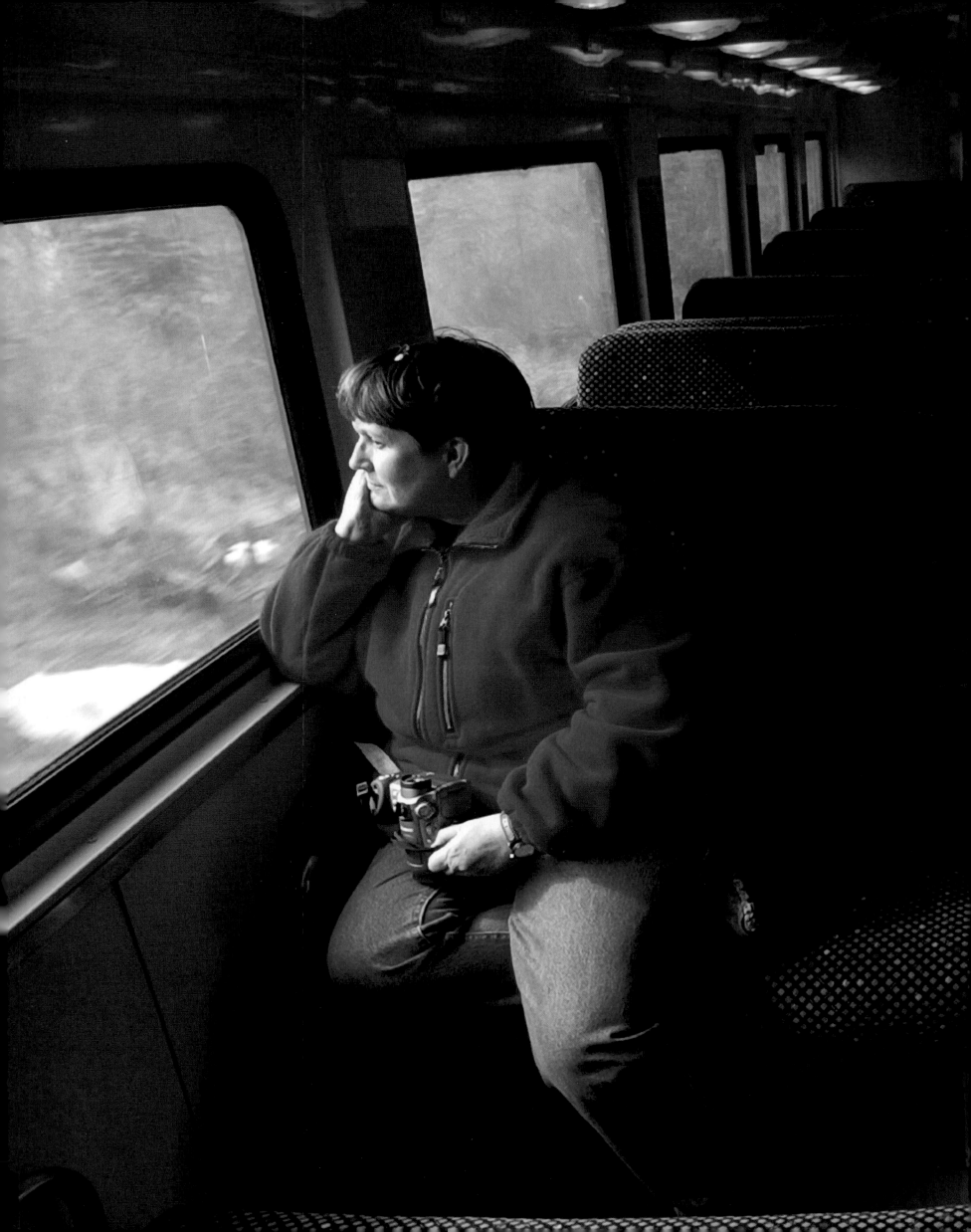

TALKEETNA

"Visually, Alaska is the most majestic place
I've ever seen," says South Carolina tourist
Nancy Chastain, en route to Hurricane Gulch
during this, her ninth visit to Alaska. "But it's
the culture that gets into your soul."
Photo by Stephen Nowers,
Anchorage Daily News

KWETHLUK

Then and now: As a Yup'ik girl growing up in a small village, Olinka Nicolai, 80, lived in a mud house, trapped rabbits, and traveled by dogsled. Today, she lives in the river town of Kwethluk, close to her great-granddaughter Josephine, 17, who surfs the Internet and listens to gospel CDs on her Walkman. But Olinka made sure Josephine learned essential survival skills like dressing fish, birds, and caribou.

Photo by Clark James Mishler

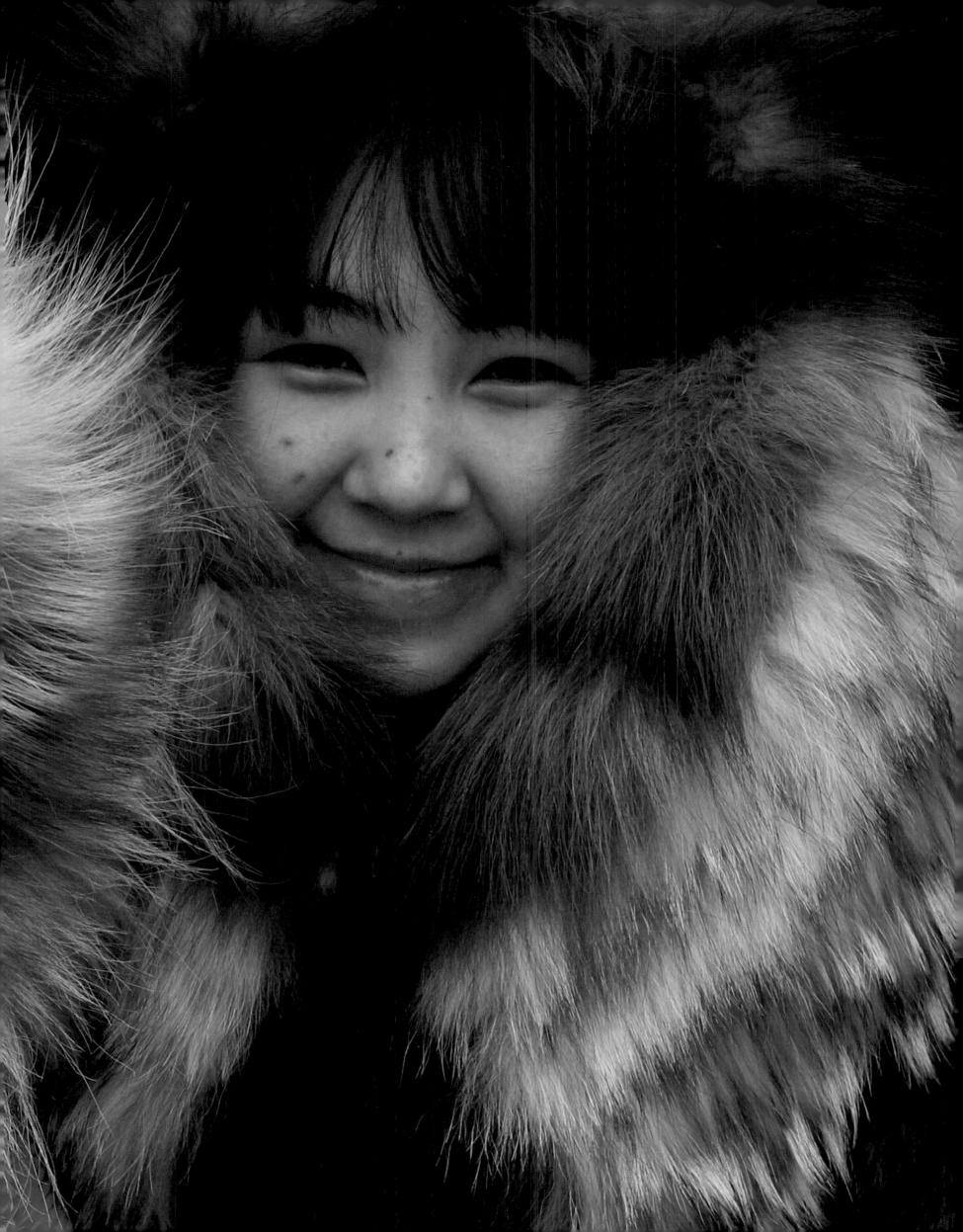

DENALI NATIONAL PARK
Despite traffic, wolves, hunters, and other
threats, caribou have maintained a steady
population of around one million in Alaska.
Photo by Robert Hallinen,
Anchorage Daily News

Hearth & Home

ANCHORAGE
Hoping to stay on the honor role, Central
Middle School of Science seventh grader Mara
Hill hunkers down to study in the basement.
Photo by Erik Hill

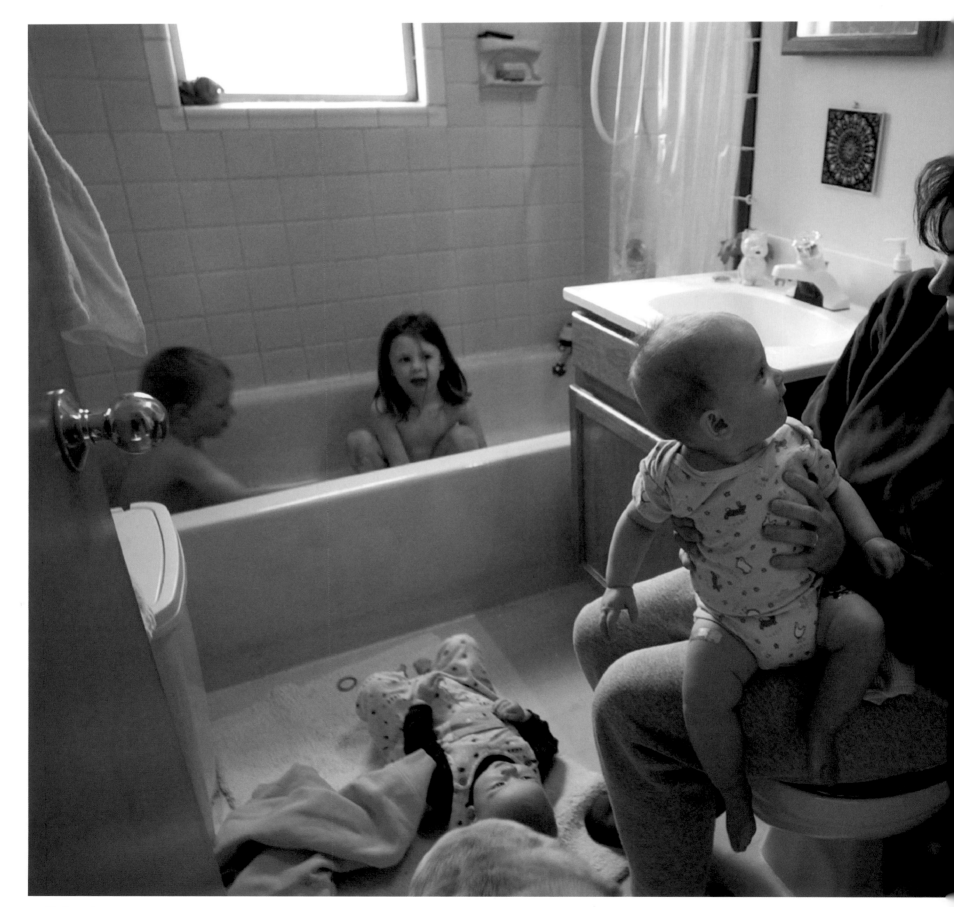

ANCHORAGE
With 20 hours of sunlight each day in May, getting her children (Joey, 4; Alisa, 6; and 7-month-old twins Ian and Rebecca) indoors and into the tub can be a challenge for Jennifer Aist. "It's so dark during the winter months that once spring comes around, none of us wants to come indoors, even if it's 11 o'clock at night."
Photos by Evan R. Steinhauser,
Anchorage Daily News

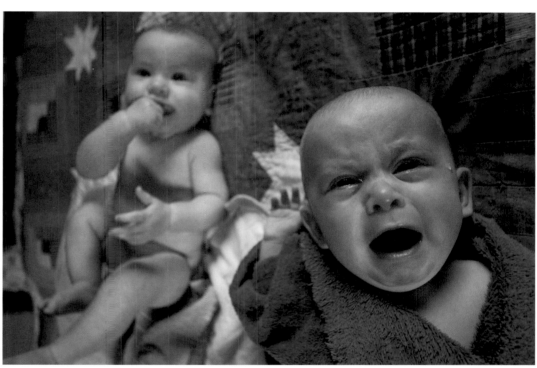

ANCHORAGE
Fraternal twins, Ian and Rebecca (crying), are as different as siblings born apart. "Rebecca's the intense one," says their mother Jennifer Aist.

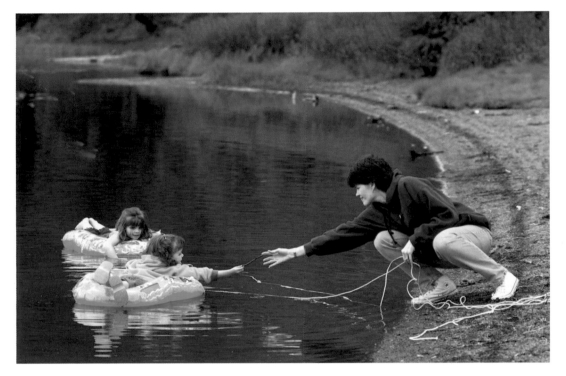

KETCHIKAN
Too cold to swim, too wet to ice skate,
McKenna Kimball and Catherine Hudson,
both 4, opt to float on Ware Lake. Hanging on
to the landward end of their tether is Catherine's
mother Lori Hudson, a social worker for the
Office of Children's Services.
Photo by Hall Anderson

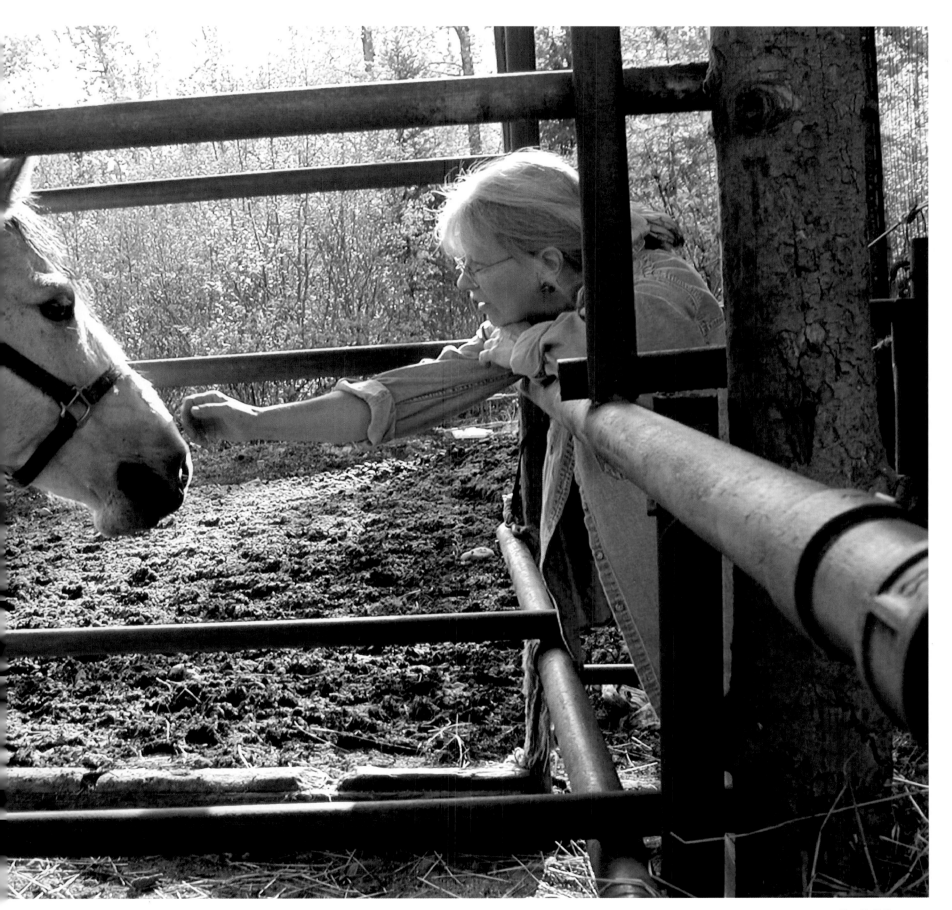

BUTTE

Zeke the packhorse noses in on a snack from
Mary Tribbey, visiting from Anchorage. Zeke lives
on a farm just outside of Butte with the Hansens,
who load him up with gear for moose-hunting
trips. The Hansens also raise hogs but consider
themselves "weekend farmers."
Photo by Charles Tribbey Photography

KWETHLUK

In the Yup'ik town of Kwethluk, Vera Spein—like most of her neighbors—uses a wood-burning stove to heat the family house. For cooking, she prefers her two-year-old propane stove. Her day includes plucking, cleaning, cutting, and freezing the fowl her family shoots—and caring for her youngest boy, born with Down's syndrome.
Photos by Clark James Mishler

KWETHLUK

In a town the size of Kwethluk (pop. 730), almost every community event is worth a visit. Sisters Jamie and Jonna Michael have just come home from watching the high school graduation. Now they're after dad to buy them a computer.

KWETHLUK

Gloria Olick and her six brothers grew up in Dillingham on Nushagak Bay and then moved into the wilderness, where her father trapped beaver. She married and divorced, and then married again to a commercial fisherman who brought her to Kwethluk and with whom she had four children. She has been a widow, she says, since June 11, 1979.

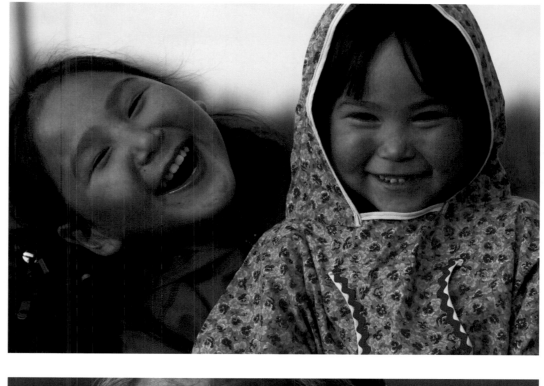

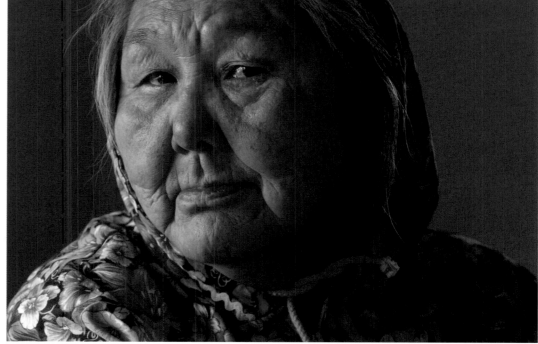

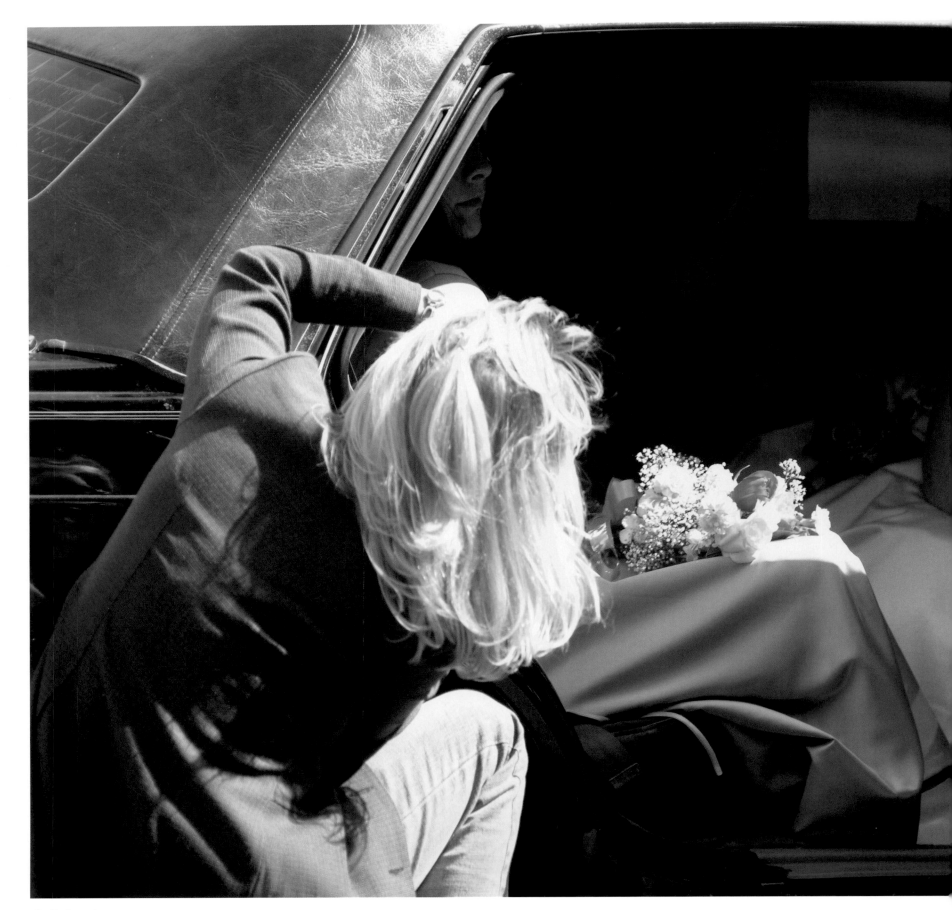

KETCHIKAN
Nineteen-year-old bride Eryn Sooter is about to be driven to her wedding in something old: a rare 1984 Honda Acccrd limousine lent by a family friend for the occasion. She wears her something new: matching earrings and necklace that set her mom back $9.99.
Photo by Hall Anderson

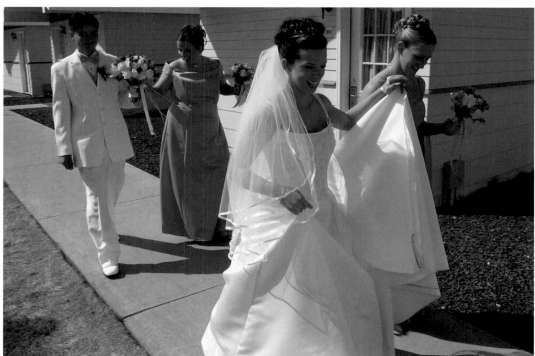

FAIRBANKS

The big day: Heading off to their wedding ceremony, bride Sarah LeClerc, 19, and groom Timothy Hams, 20, are a picture of relaxation. A college student and caterer, LeClerc created all the floral arrangements, set the reception tables, and baked her own four-tiered, fondant-frosted wedding cake.

Photo by Charles Shepherd

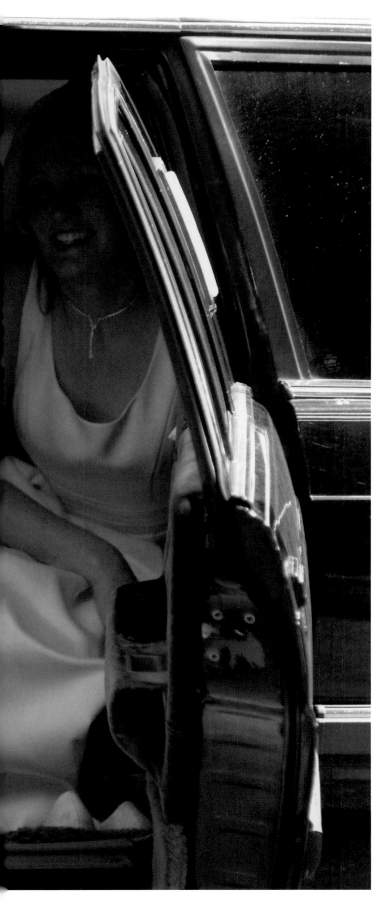

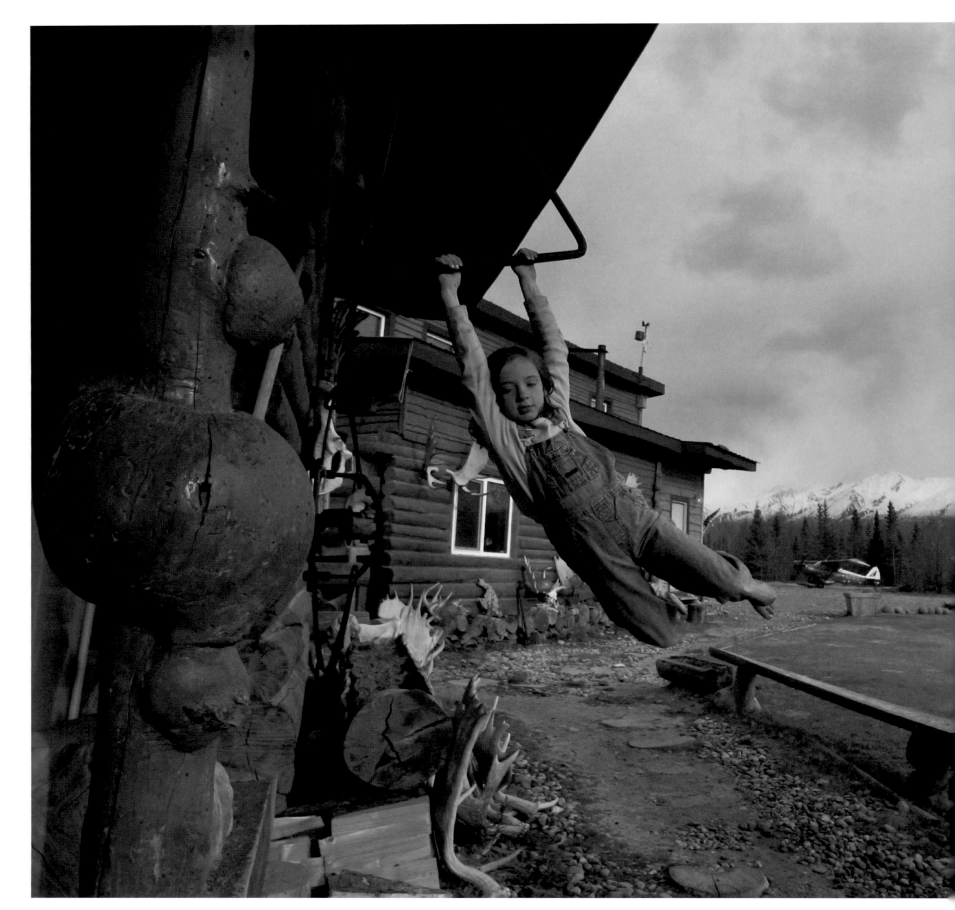

WRANGELL–ST. ELIAS
The wild life: Logan Claus, 8, swings from the dinner bell at Ultima Thule, her family's home and extreme-adventure lodge situated in the wilds of the 14-million-acre Wrangell–St. Elias National Park. Logan's nearest neighbors are a plane ride away, but she keeps busy with chores and guest tours of her 110-acre playground.
Photos by Jeff Schultz

WRANGELL–ST. ELIAS
Ellie, Paul, and Logan Claus, and family friend
Maegan Mackey while away the midday hour in
the cookhouse at Ultima Thule Lodge.

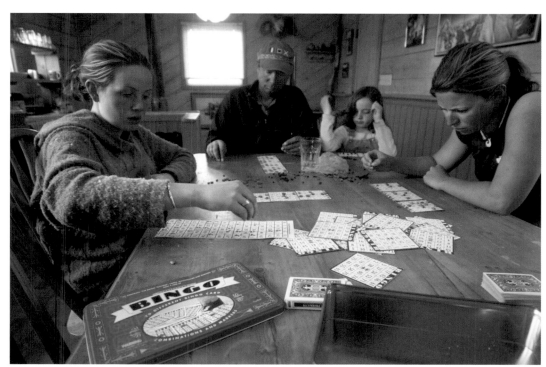

WRANGELL–ST. ELIAS
Champion musher Ellie Claus, 17, has won the 120-mile Junior Yukon Quest twice. The grueling competition involves a night sleeping outside in temperatures of 30 below. She cares for her 60 dogs at the kennel she named Paws and Claus.
Photos by Jeff Schultz

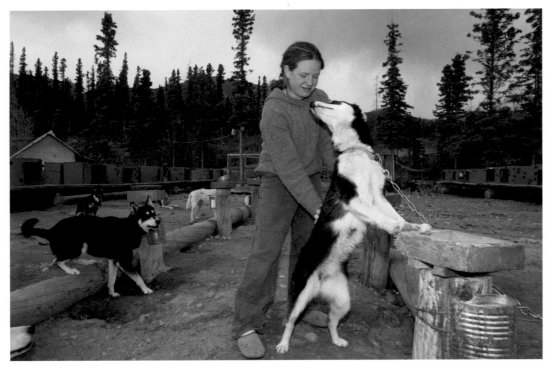

Eight-year-old Logan Claus (named after nearby Mt. Logan) measures 4'4" on the height wall—a notch above older sister Ellie at the same age.

ANAKTUVUK PASS
Born to a family of nomadic Nunamiut caribou hunters, Rhoda Ahgook renders *puiniq*, grease from crushed and boiled caribou bones valued for its portability and nourishment. She passes on the age-old recipe to the younger women in the village.
Photo by James H. Barker

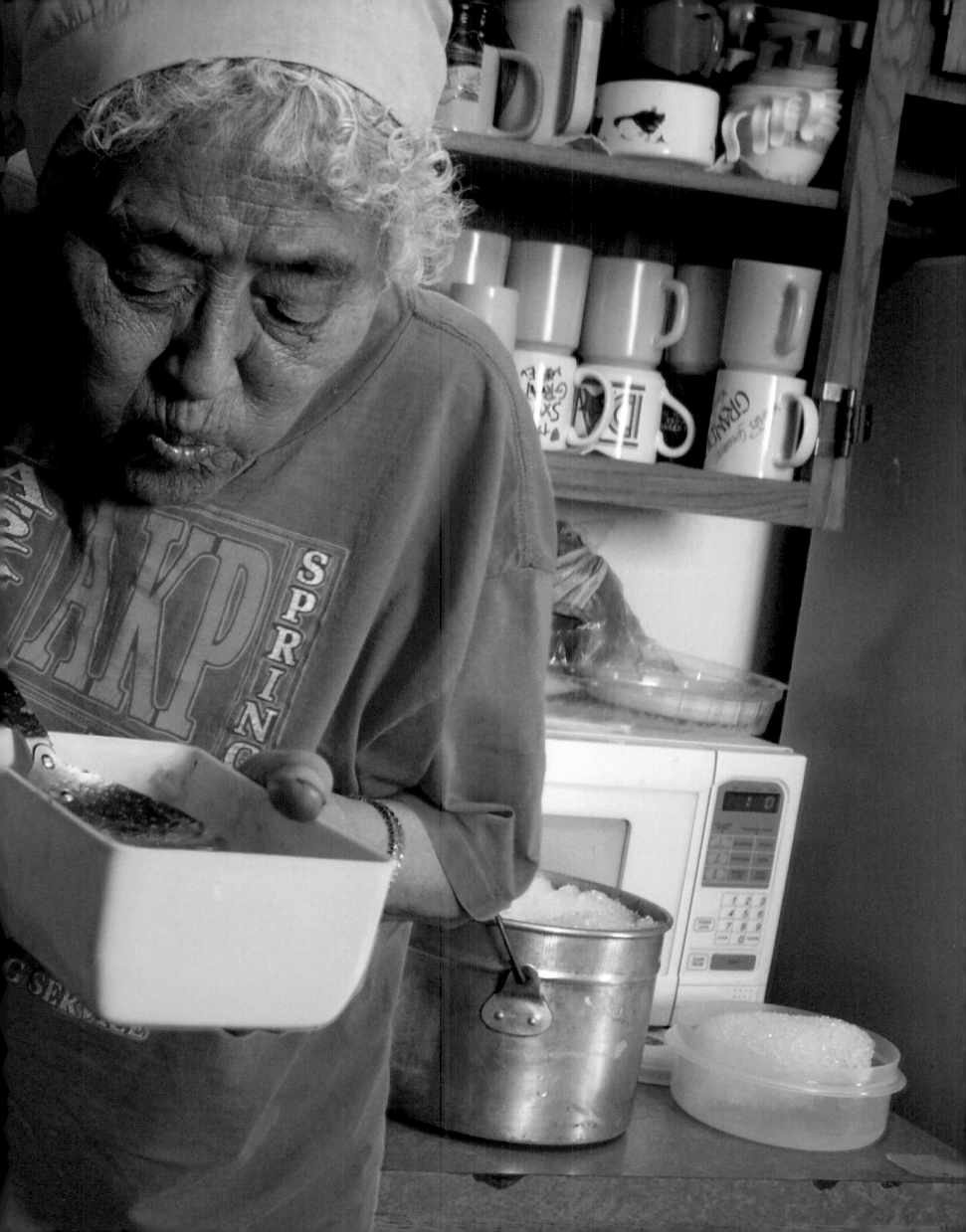

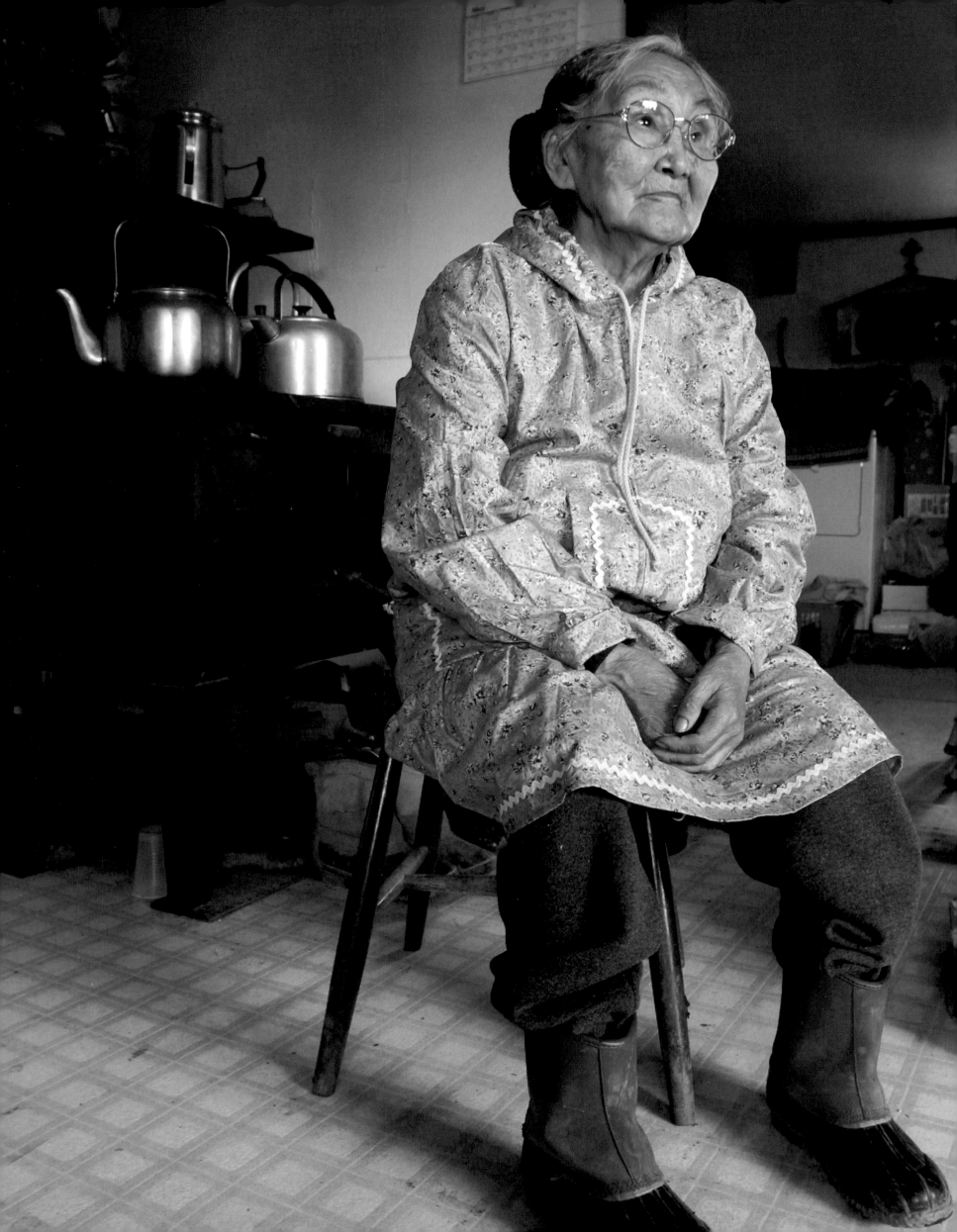

KWETHLUK

Olinka Nicolai, 80, fell and injured herself several years ago. Once active, the Yup'ik elder sits more than she used to—or wants to. She hurt her wrist when she fell, so if someone calls to ask her to sew a beaver hat, she must decline.

Photo by Clark James Mishler

KOTZEBUE

Sarah Evak, an 11-year-old Inupiaq, caught this sheefish while "jigging," or ice fishing, with her grandmother in Kotzebue Sound. Sheefish, which generally weigh up to 60 pounds, are a major subsistence food. The season starts in November and ends in June, when the ice melts and the fish head back up the Kobuk River.

Photo by James Mason

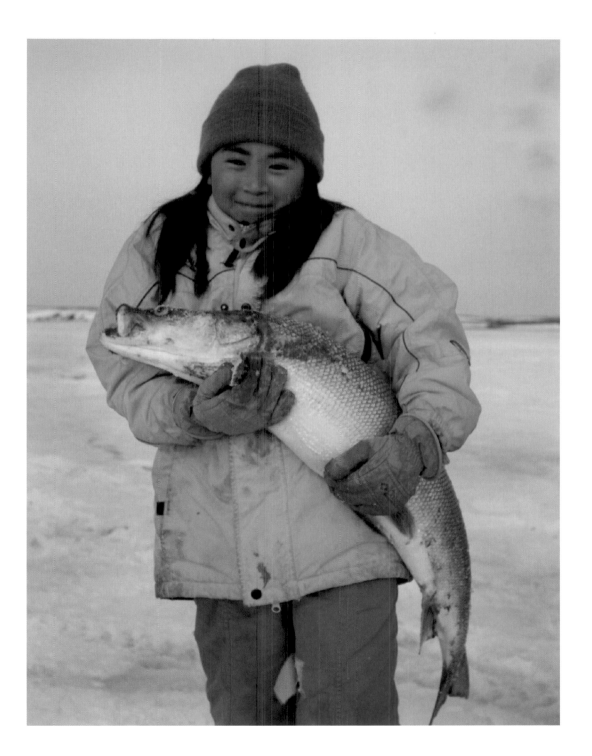

KWETHLUK

Surrounded by a mane of wolverine and a pair of grandchildren, 88-year-old former hunter David I. Jackson is also great-great-great-grandfather to children in another branch of the family. For ease and respect he is simp y called *aataq*—Yup'ik for father. His daughter, Wally John, adopted Ana M. John and David Paul John, both 6, from other family members.

Photo by Clark James Mishler

KWETHLUK

Kwethluk kith is kin. Teenagers Ruby Kerr and Mary Epchook are best friends and first cousins. Another commonality: They both like *kuspuks*, the colorful cloth parka favored by many native Alaskans. By tradition, *kuspuks* are sewn by female relatives, not store bought. Ruby's and Mary's pass that test.

Photo by Clark James Mishler

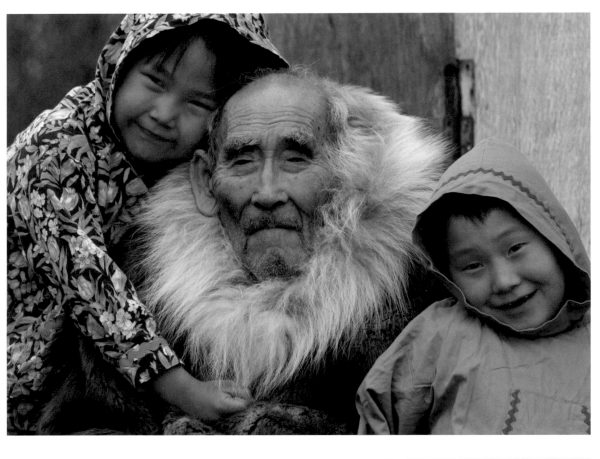

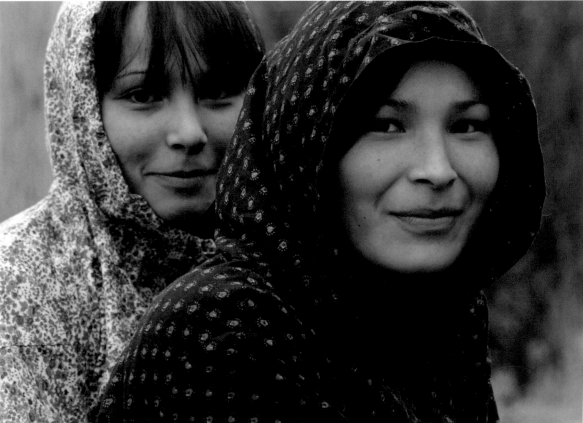

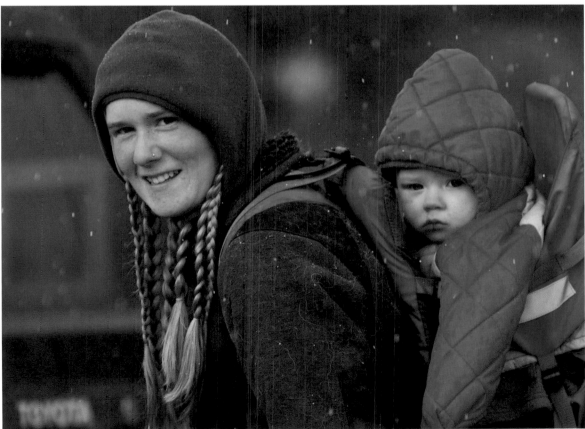

BUTTE

During summer months, Maddy Fleming, 3, visits her grandparents or their reindeer farm. Maddy, who lives in suburban Palmer, likes to tool around on her pink, battery-powered four-wheeler, and ride horses. Quiet moments in her grandmother Gene Williams's lap are nice, too.

Photo by Marc Lester, Anchorage Daily News

DENALI NATIONAL PARK

"Everyone comes to Alaska for a reason," says recent transplant and Minnesota native Anna Blackwell, 22. An avid hiker, Blackwell (with baby Shamus) came for the outdoor adventures and the mix of people.

Photo by Robert Hallinen, Anchorage Daily News

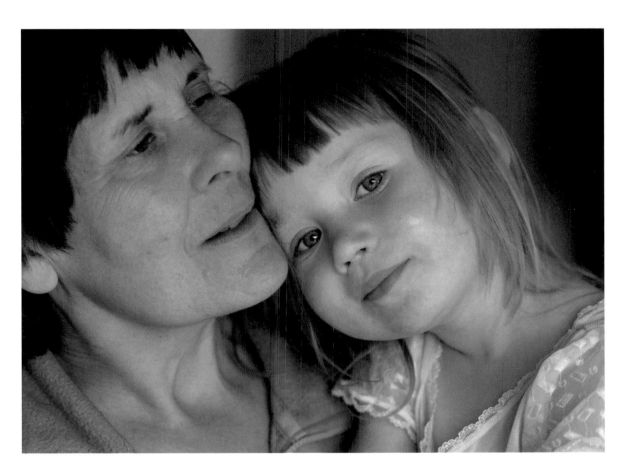

The year 2003 marked a turning point in the history of photography: it was the first year that digital cameras outsold film cameras. To celebrate this unprecedented sea change, the *America 24/7* project invited amateur photographers—along with students and professionals—to shoot and, via the Internet, submit digital images. Think of it as audience participation. Their visions of community are interspersed with the professional frames throughout this book. On the following four pages, however, we present a gallery produced exclusively by amateur photographers.

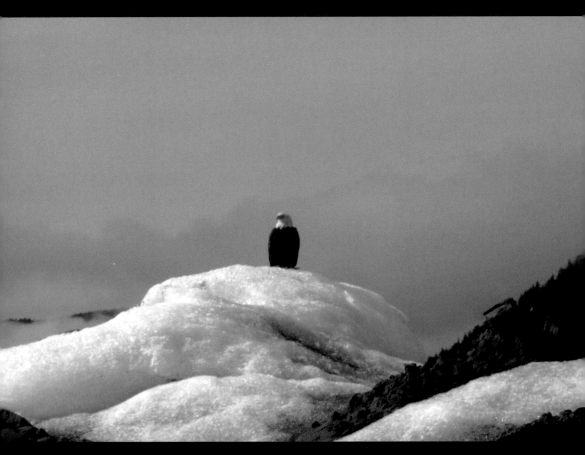

JUNEAU Once considered a salmon-stealing nuisance by fishermen, bald eagles had a $1 bounty on their heads until 1953. Alaska is now home to 30,000 of the birds, half the world's population.
Photo by Erika Green-Phillips

JUNEAU The blue ice of Mendenhall Glacier beckons to drivers on Egan Highway. It's an easy four-mile trek over wildflowers and tundra cotton grass. *Photo by Steven Christianson*

Reflections photo by Karen Cummins May 2003

UNEAU Just 10 miles from downtown Juneau, next to a University of Alaska campus, Auke Lake mirrors Mt. McGinnis and Mendenhall Glacier. *Photo by Karen Cummins*

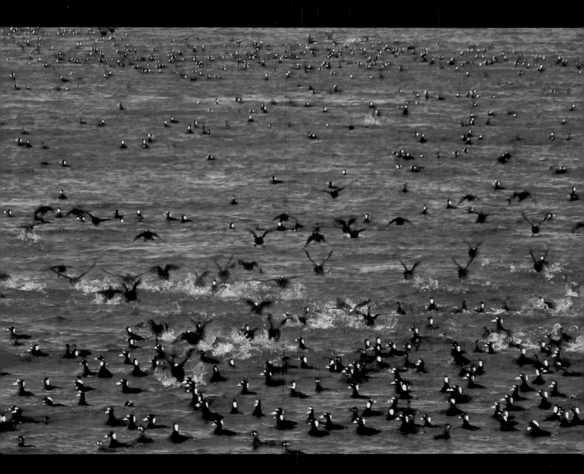

JUNEAU Thousands of surf scoters touch down in Berners Bay, a regular pit stop on their northern migration route. Like a discordant symphony, the scoters entertain Juneau-area residents with their high-pitched warbling and the crack of mussel shells. *Photo by Erika Green-Phillips*

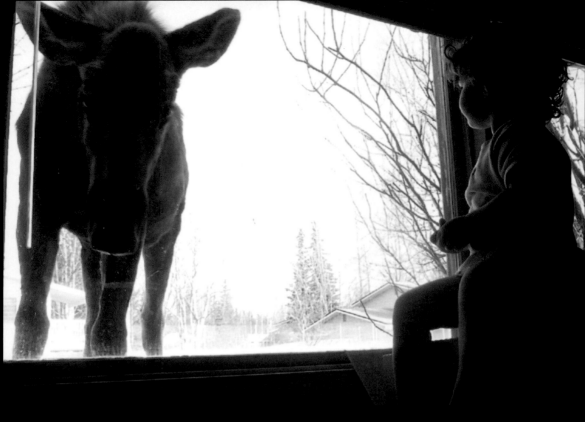

ANCHORAGE A quarrelsome, full-grown moose once chased a neighbor onto 2-year-old Charley Pico's porch, but this calf visited just to gaze through the window. *Photo by Cheri Griggs*

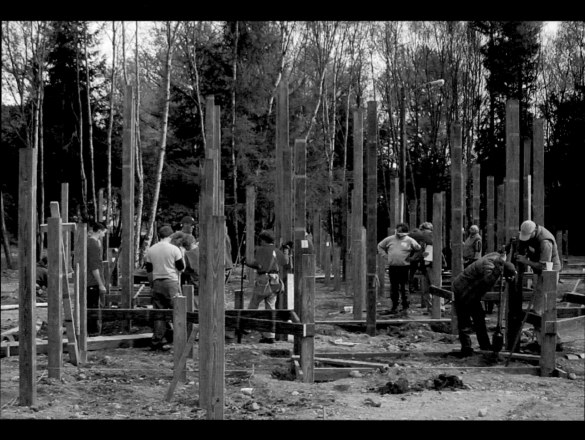

HAINES More than half of Haines's 2,400 residents collaborate to raise a new community playground in just five days. *Photo by Patricia Peters*

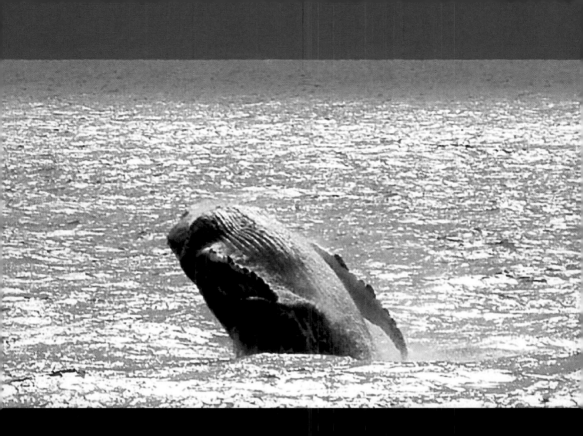

UNEAU A humpback whale breaches into a passing sheet of afternoon sunlight in Stephens Passage. *Photo by Kenneth Gill*

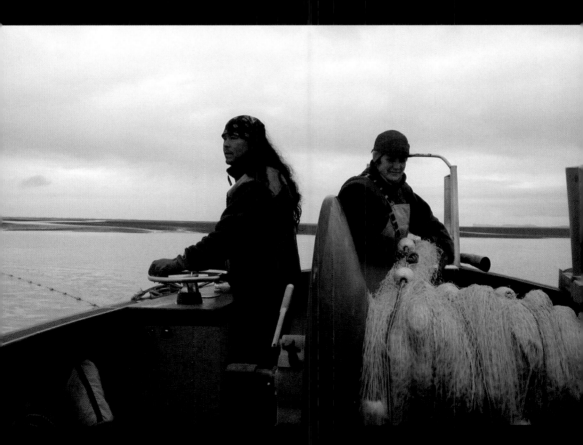

CORDOVA Dune Lankard and Lauren Joy Padawer pull up salmon nets on the bowpicker *On Course*. ankard, an Eyak Athabascan, works to foster Eyak tribal culture. *Photo by David Titcomb*

CORDOVA

On Prince Edward Sound, May 13 marks the opening day of the Copper River red and king salmon season. Aboard the bowpicker *Whatever*, Seattle chef Dan Thiessen waits for the fishing to start. Within 24 hours, he'll fly back to Seattle with coolers full of the season's first salmon to jazz up the menu at Chandler's Crabhouse.
Photo by Marc Lester, Anchorage Daily News

Hard At Work

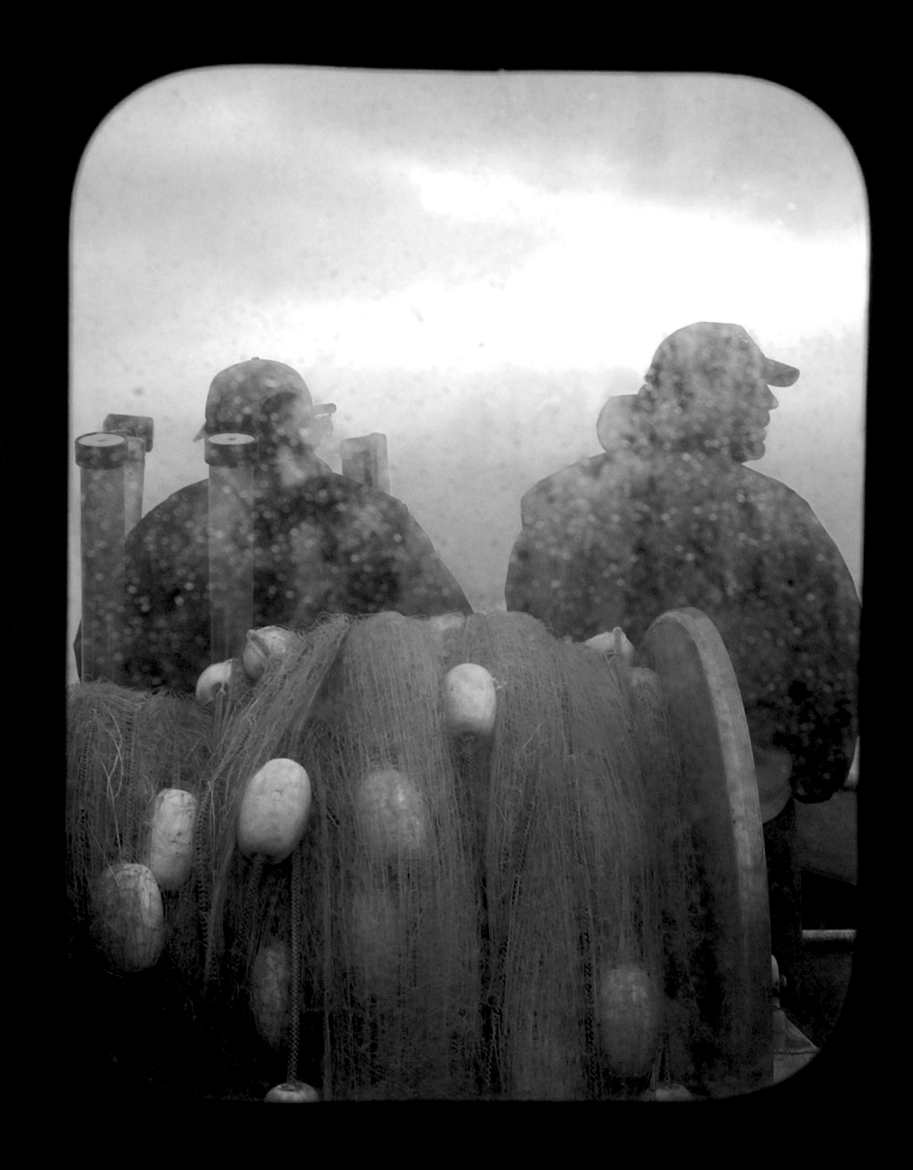

CORDOVA

More than 400 fishermen compete to snag as many salmon as they can on opening day of the commercial fishing season—when salmon prices reach their peak in high-end grocery stores and restaurants up and down the West Coast.
Photos by Marc Lester, Anchorage Daily News

CORDOVA

"It just needs a little pepper, a little lemon salt, and some sliced onion," says Albert Zelenak of Anchor Point. From his catch, he saves a few red salmon for a season-opener barbecue with his fellow fishermen. Each year, Zelenak prepares a home pack of about nine salmon. That stash will last all winter.

CORDOVA

Chilling in a cooler, freshly caught salmon await transport to seafood packers in Cordova, who then prepare the fish for air shipment to Seattle. Famous for their high oil content, Copper River salmon store large quantities of fat for the 300-mile, foodless journey from sea to spawning grounds.

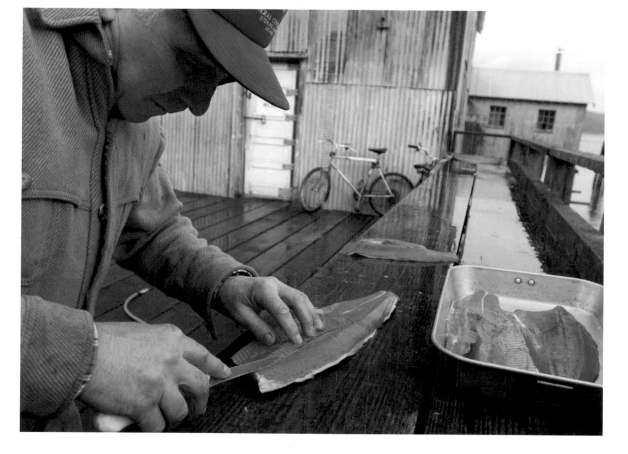

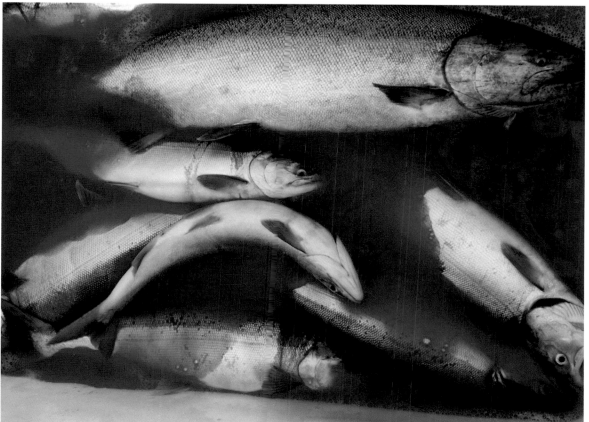

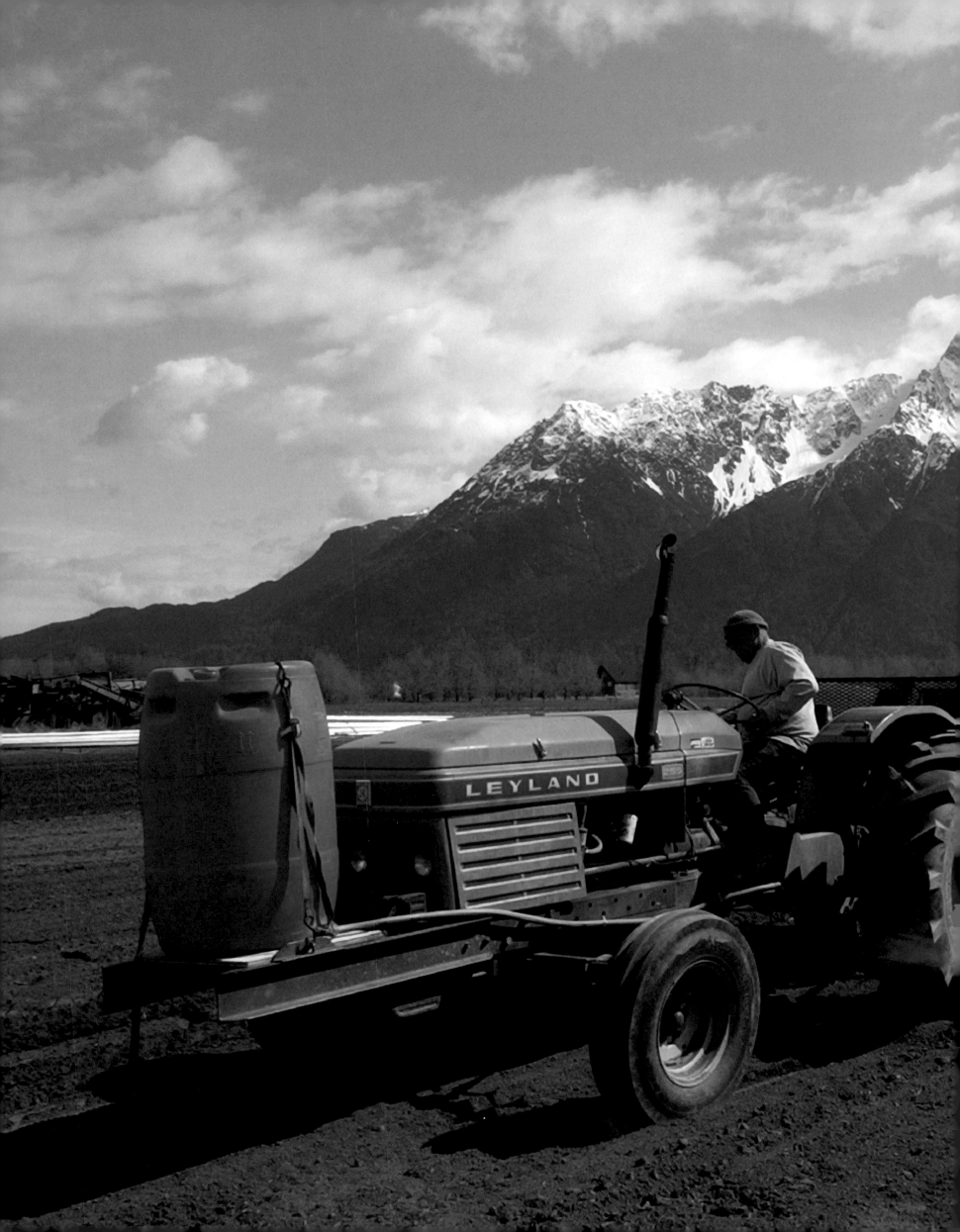

BUTTE

With the growing season telescoped into four short months, farming is a frenzied sprint for Ted Pyrah. "Plants grow quickly when it's light outside 24 hours," he says. "Their DNA goes out of whack, and we get 100-pound cabbages." Pyrah, 69, grows potatoes, cabbages, and beets on his 250-acre Pyrah's Pioneer Peak Farm, which he leases from the Mormon Church.
Photo by Stephen Nowers,
Anchorage Daily News

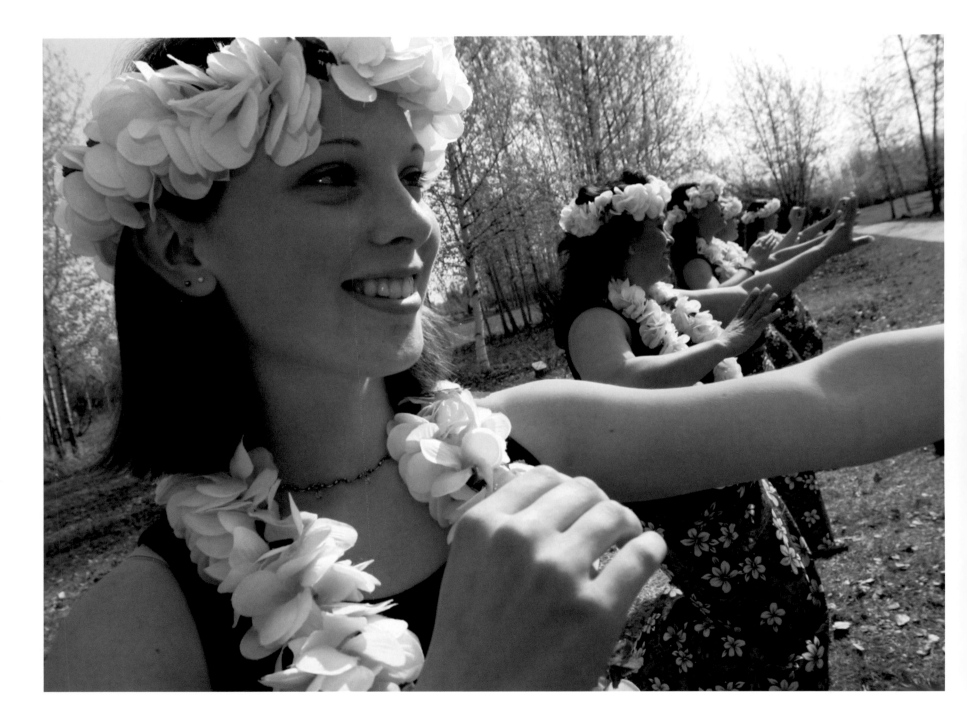

FAIRBANKS

Megan Kelly learned to dance the hula from her friend's Hawaiian mom, Joanne Olsen (dancing next to Megan). The South Sea Island Polynesian Dancers perform the traditional Hawaiian song "Wahine 'Ilikea" at the annual Heart Walk and Run fundraiser in Fairbanks. About 7,500 islanders live in Alaska, and cross-cultural currents between the 49th and 50th states run deep.
Photo by Charles Mason Photo, Corbis

ANCHORAGE

Before their annual showcase, Kristen DuBois, 18, limbers up with the Alaska Dance Theatre company. DuBois first pliéd when she was 7 and plans to attend the University of Oklahoma's School of Dance in the fall.

Photo by Marc Lester, Anchorage Daily News

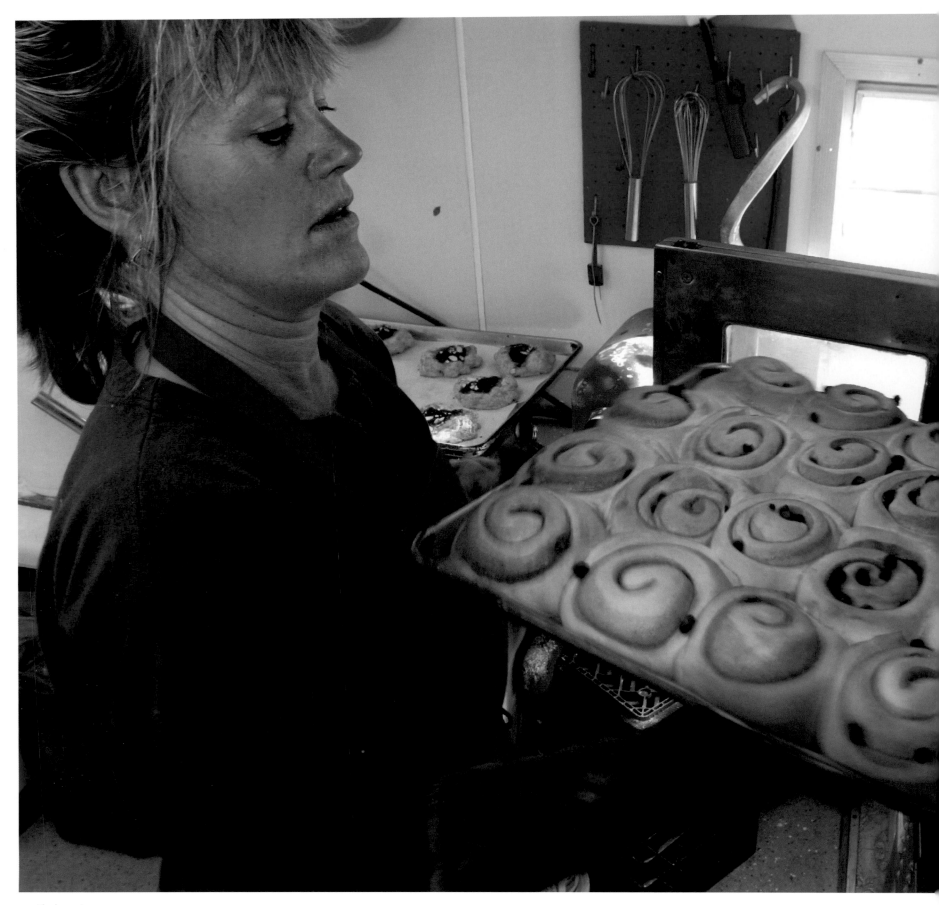

FAIRBANKS
Gretchen Petersen cooked in a mining camp before she and her sister Ingrid Herreid started Bun on the Run. Their mobile bakery is an old trailer in the Beaver Sports parking lot near the University of Alaska campus. Up at 4 a.m. to start baking, the sisters work nonstop until 6 p.m.
Photos by Charles Mason Photo, Corbis

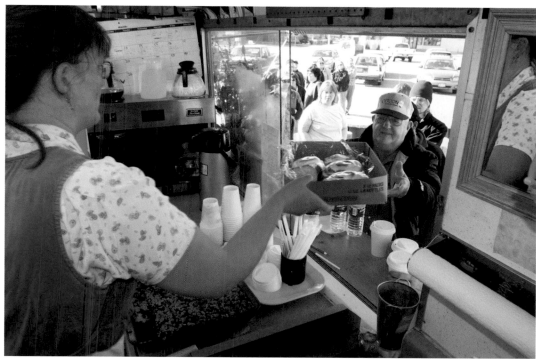

FAIRBANKS

Ingrid Herreid believes the secret ingredient of the bun business is the one-on-one with customers. After 17 years of selling their confections from May to September, the sisters know the customers well. "We see them through marriages, deaths, and births," says Ingrid.

Dallas Knighten, one of Alaska's 5,000 oil workers, swings 12-hour days, seven days a week, two weeks on, two weeks off. Stationed on the North Slope, 800 miles from the nearest population center, Knighten lives on site in a mobile camp. In steel-toed shoes and fire-retardant jumpsuit, he wrestles with a drill pipe on Rig 7ES.
Photos by Judy Patrick

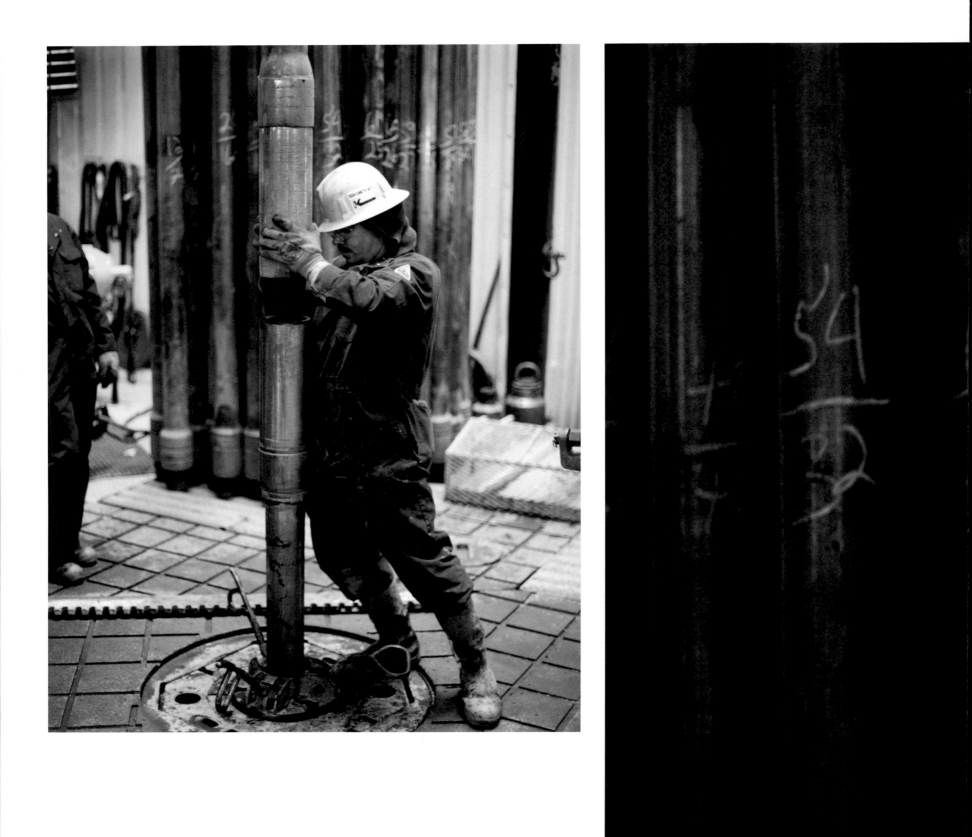

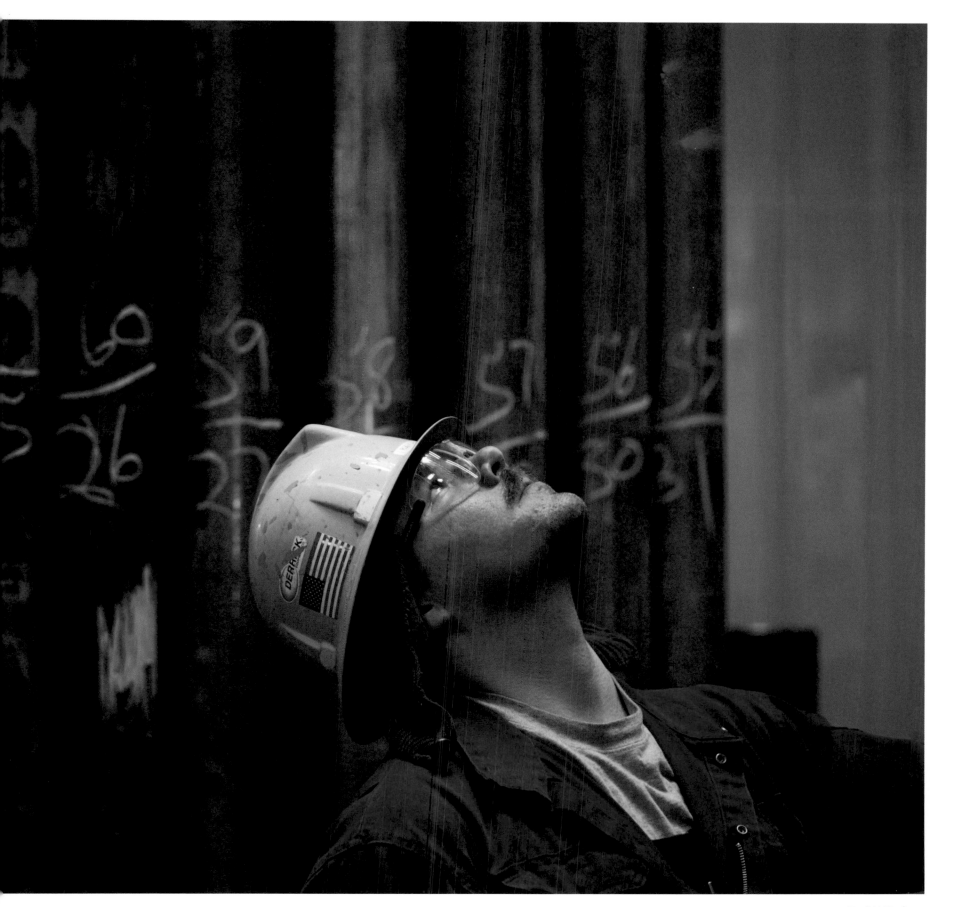

PRUDHOE BAY

Dallas Knighten stares up at a descending derrick as it prepares to latch onto and lift one of the 10-foot well pipes. When stacked, the pipes can tap the virgin oil up to 1,500 feet down. The numbers indicate each pipe's place in the stack. Oil rig workers like Knighten, referred to as roughnecks, earn an average annual salary of $70,000

WASILLA

Ever since Switzerland native Sven Haltmann, 26, saw his first sled dog 13 years ago, he's dreamed of running the Iditarod. He moved to Alaska in 2001. To save money for a husky pack, he works 60-hour weeks peeling white spruce logs with a draw knife. "I can't wait to have my puppies," he says.
Photo by Robert Hallinen,
Anchorage Daily News

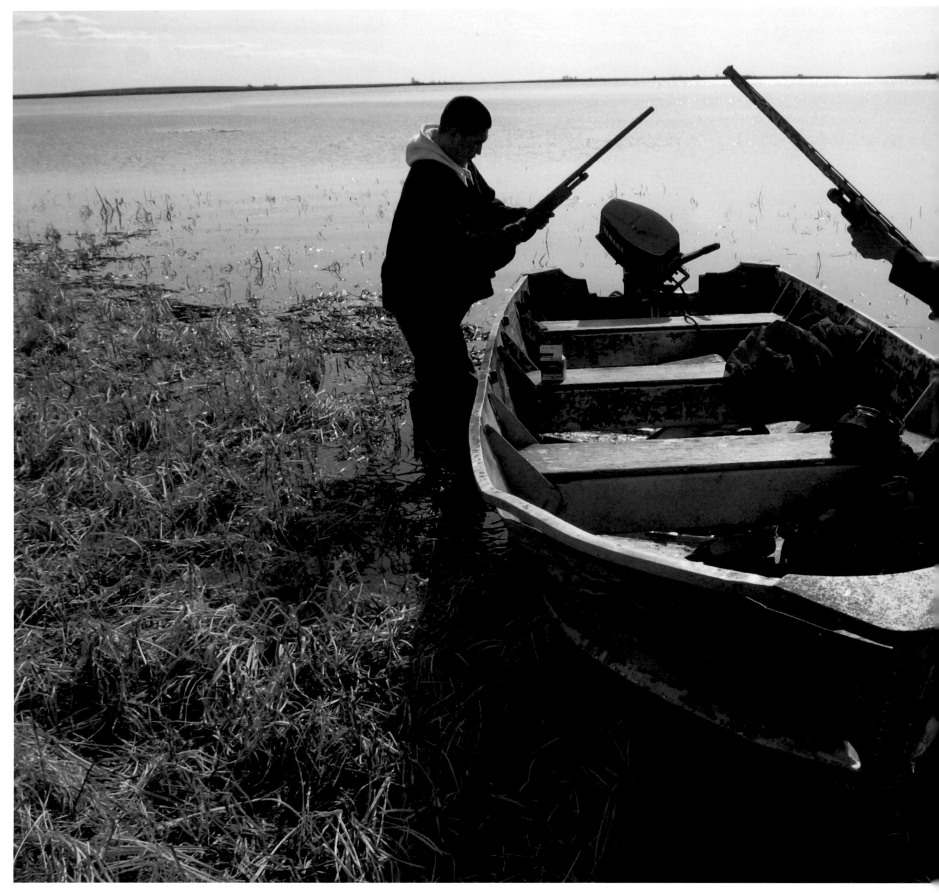

SWAN LAKE
Most families in Kwethluk, a small river town surrounded by tundra and tributaries of the Kuskokwim River, rely on subsistence hunting, fishing, and gathering for much of their food. Hunters often give some of their catch to older members of the village. Brian Spein and Ilarian Nicolai are after what they call black birds—fatty ducks also known as surf scoters.
Photos by Clark James Mishler

SWAN LAKE

Ilarian Nicolai, known as one of the best hunters in the area, says there are lots of good hunters. He hunts daily in good weather but might take Sundays off, in part to watch ball games on television. Try not to call him when the Chicago Cubs are playing.

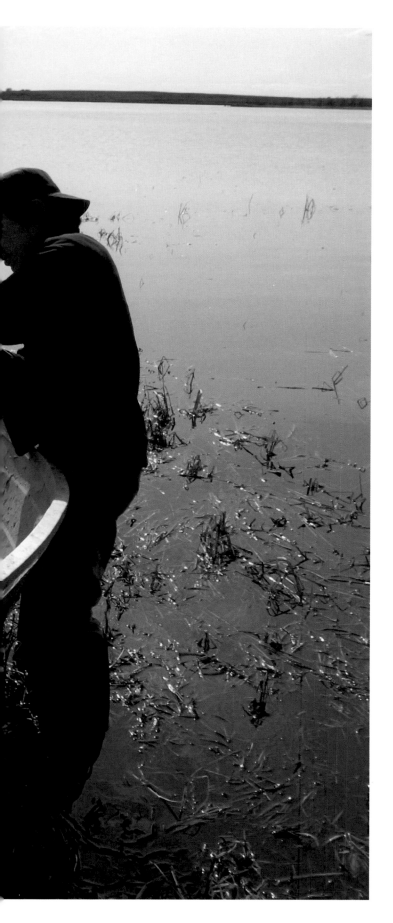

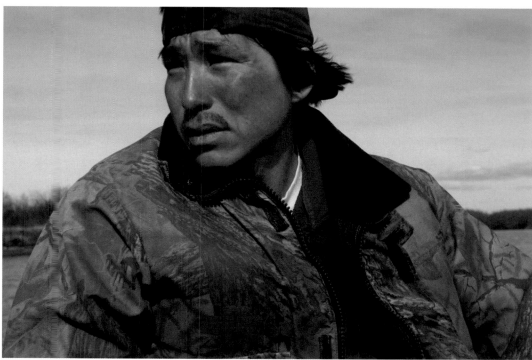

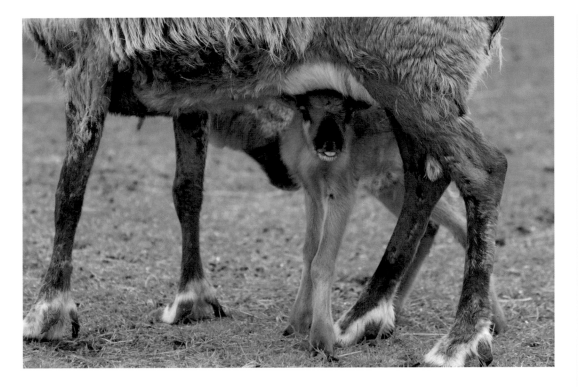

BUTTE

A century after the first guns were introduced to Alaskan tribes, the caribou population was close to collapse. To supplement the meat supply, Russians imported domesticated reindeer from Siberia in 1891. For years, herders have tried boosting consumer interest in reindeer meat, without much success—luckily for this newborn at the visitor-oriented Reindeer Farm.

Photos by Marc Lester, Anchorage Daily News

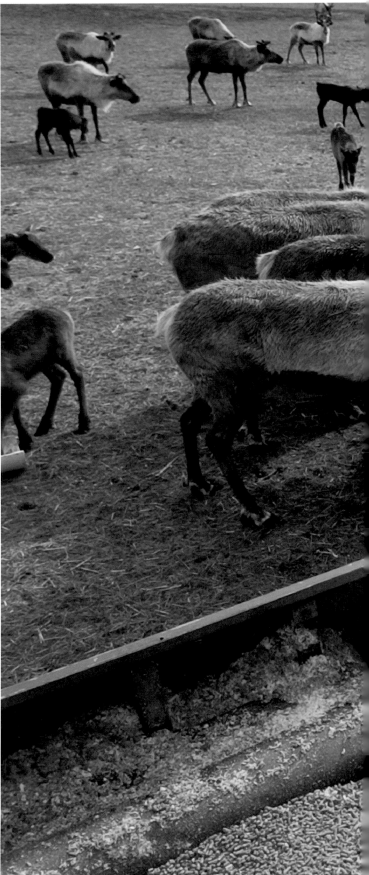

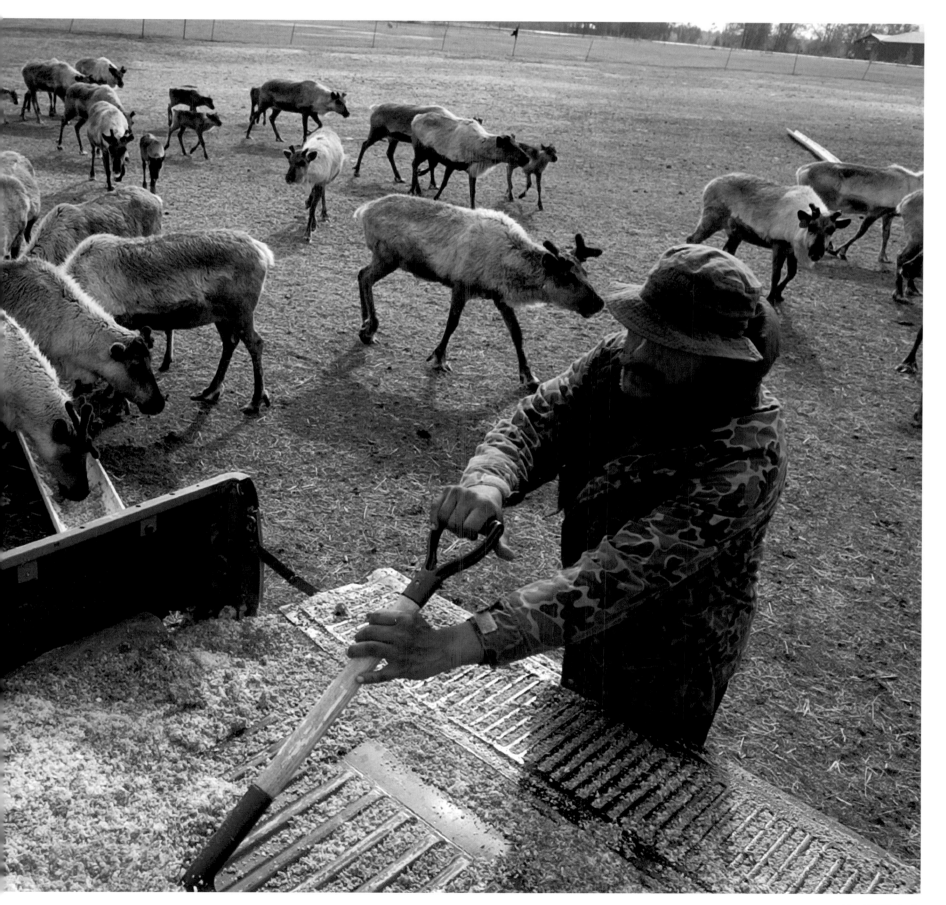

BUTTE

Farmhand Jim Gastelum's thrumming truck engine signals suppertime to the reindeer herd. They eat a mix of protein pellets, bread crumbs from a bakery in Anchorage, and beer mash from local breweries including Moose's Tooth, Snow Goose, Glacier, and Midnight Sun.

The alchemist: Jack Mahoney minds the 2,250-degree furnace at the Fort Knox mine's mill. Each day thousands of tons of ore are extracted from Alaska's largest gold mine. After being blasted, crushed, leached, and doused with cyanide, the ore is transformed into 99 percent pure molten gold.
Photos by Charles Mason Photo, Corbis

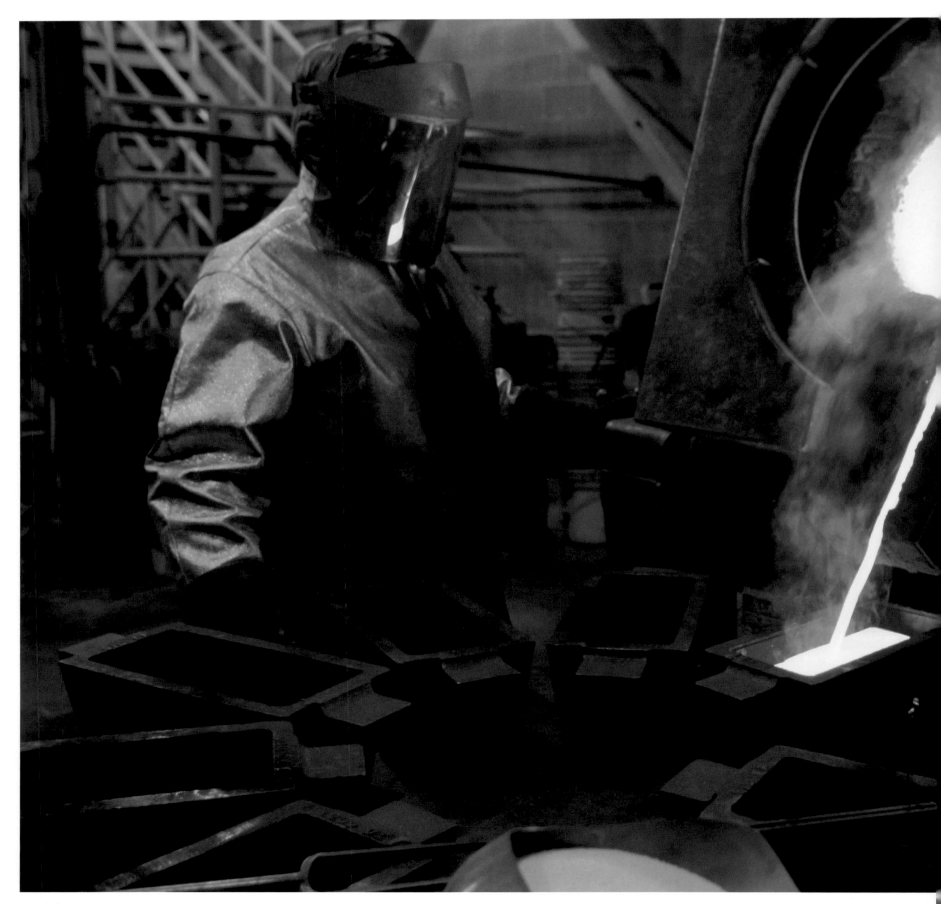

FAIRBANKS

The company has strict security procedures: Jack and his co-worker are locked in the building for their 10-hour shift. The company emails them a weather report before their drive home. The day's output? Five bars worth a cool million.

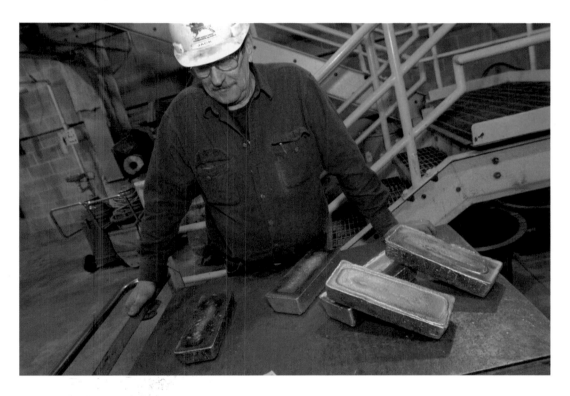

ANCHORAGE
Though this tie-down is sufficient most of the year, pilot John Norris says high winds destroyed 38 sea planes at Lake Hood the previous winter. Every March, Norris and his Cessna 180 join the 23-plane Iditarod Air Force, the team that keeps all the people, animals, and supplies moving for the 1,100-mile dogsled race.
Photo by Bill Roth, Anchorage Daily News

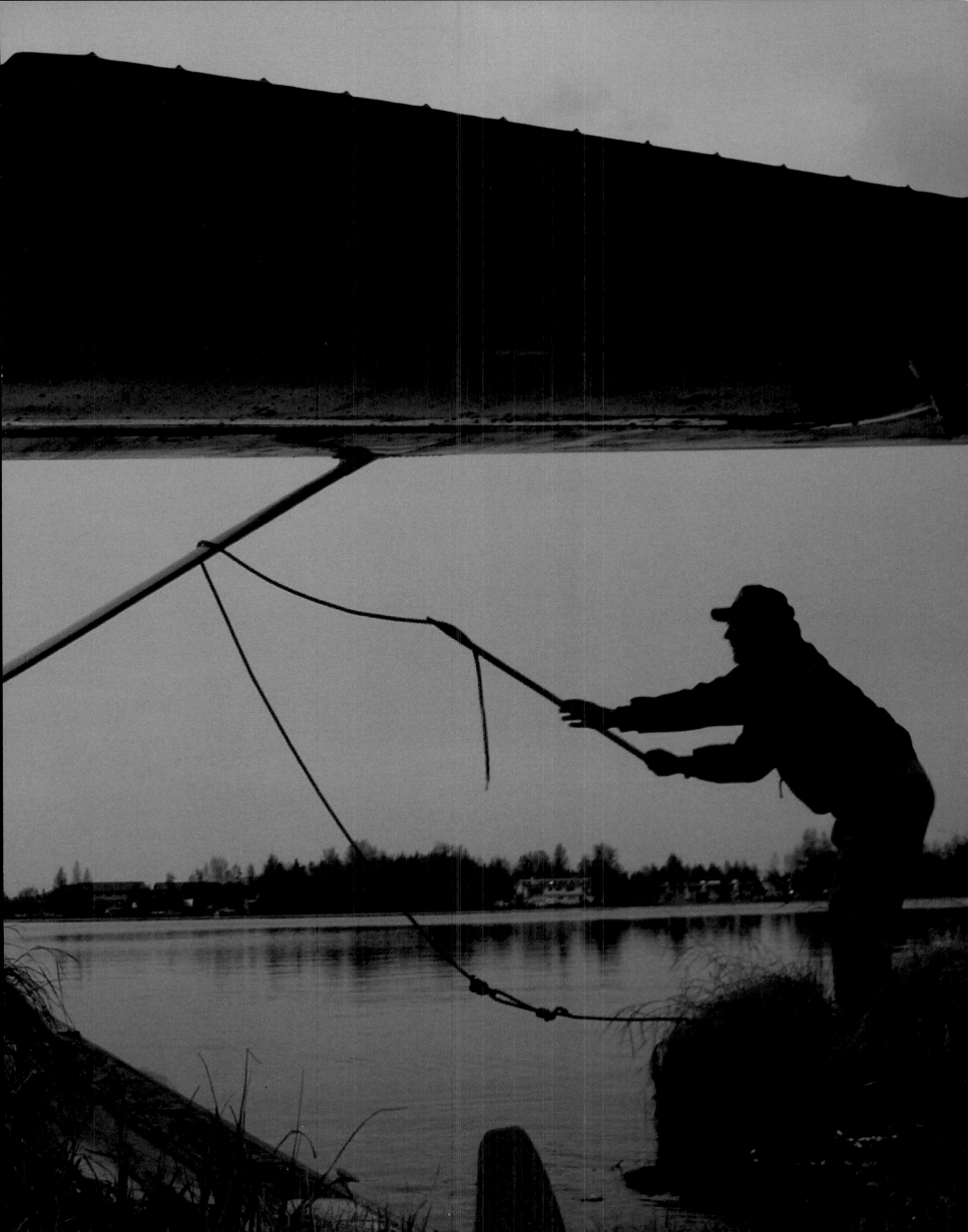

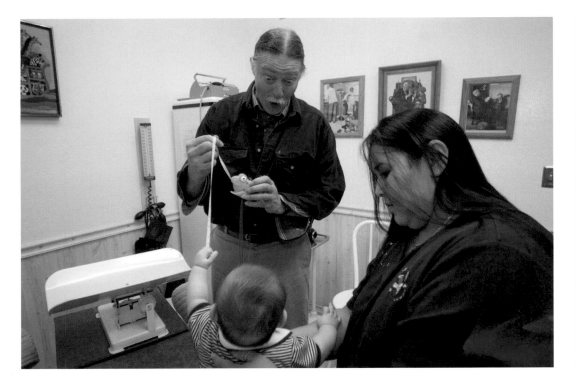

SELDOVIA

Priscilla Botero holds 5-month-old son Benjamin as he gets a checkup from Dr. Larry Reynolds, the only doctor in rural Seldovia (pop. 284). The maladies haven't changed much during his 30-year career. He sews up knife cuts, treats colds, and conducts physicals. For more serious problems, patients are flown to Homer, 25 miles across Kachemak Bay.

Photos by Jim Lavrakas, Anchorage Daily News

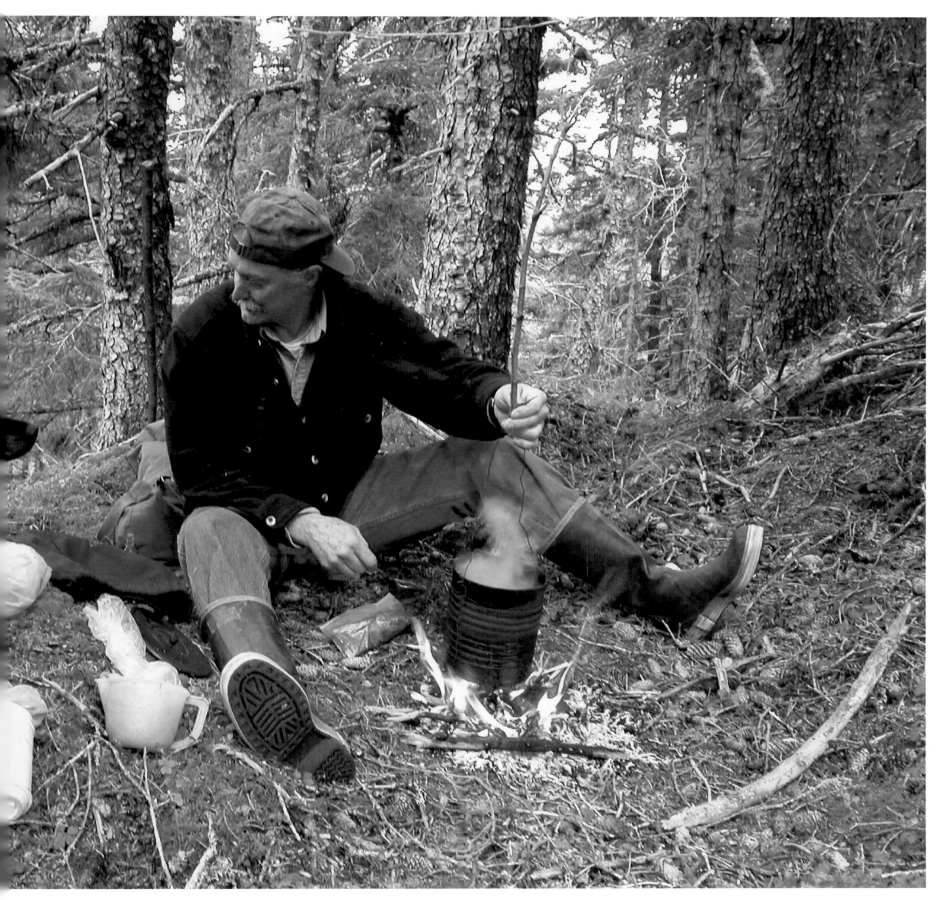

SELDOVIA

Dr. Reynolds, a dedicated backcountry adventurer, hikes or skis every chance he gets. After ascending 1,000 feet on the Rocky Ridge Trail with his dog Frodo, he stops to make coffee in a white spruce forest. Days off are sacred. "You don't come to Seldovia to make money," he says. "Some may call it difficult, but I call it wonderful."

SAXMAN

Tlingit master carver Nathan Jackson hews a
30-foot red cedar log into a totem pole he has
named *Opening the Box of Wisdom*. A year in the
making, the totem will be painted by Jackson's
wife, Dorica, before it's shipped 800 miles
north to the Alaska Native Heritage Center
in Anchorage.
Photos by Hall Anderson

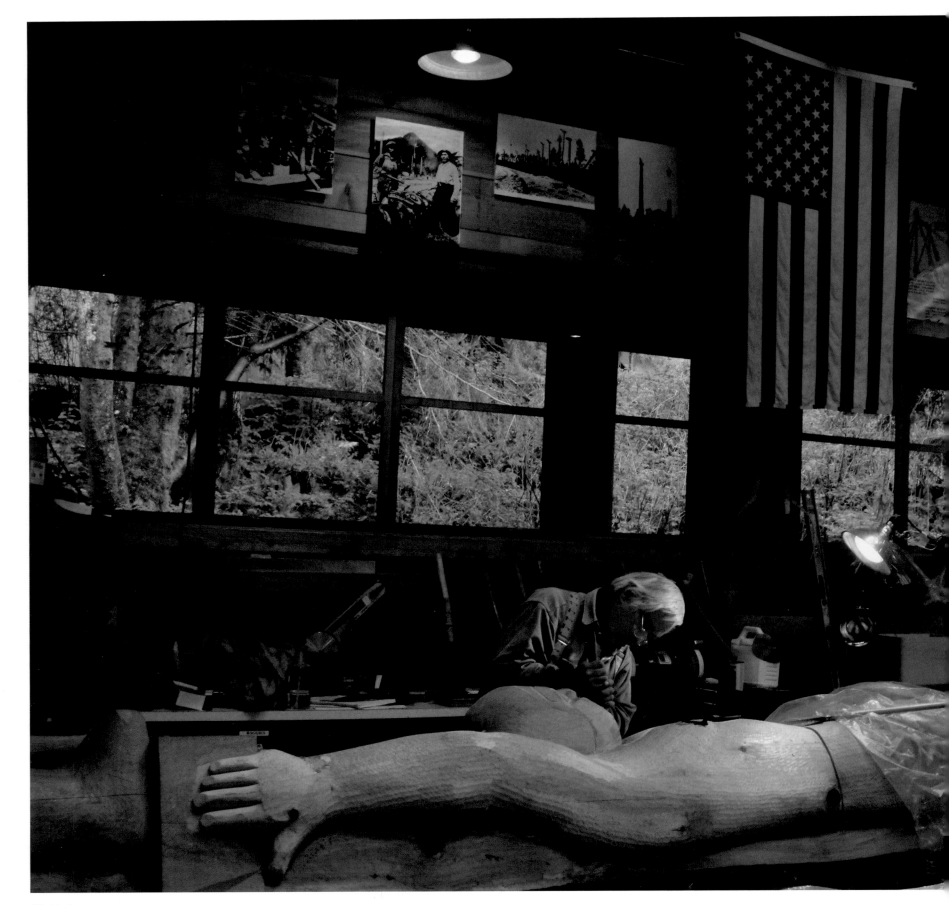

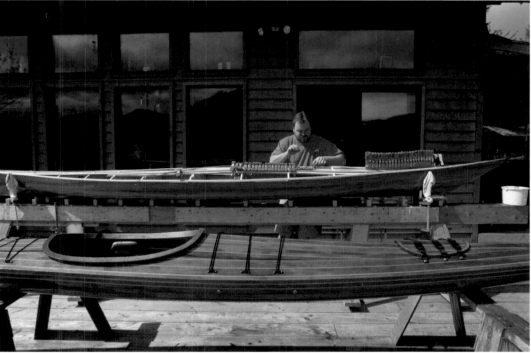

GRAVINA ISLAND

When school is out, special ed teacher Mike Rath works at home, fashioning quarter-inch-thick lengths of red and yellow cedar, spruce, and redwood into strip-style kayaks up to 18 feet long. His background music: Neil Young. It's a great rainy day project, Rath says—for a place with 160 days of rain a year.

ANCHORAGE

This painted basswood mask represents the loon *inua*, or helping spirit. In the animist Yup'ik tradition, a person learns from his spirit animal. Yup'ik artist Ayap'run Jack Abraham, who made this mask, relates the story of a lonely boy who hears his lost mother in the aching cry of the loon; it is, he says, an allegory for his own experience.
Photos by Robert Stapleton, Jr.

ANCHORAGE

Thumbless pierced hands attached to this loon figure indicate that a benevolent spirit will allow the bird to pass into the real world as game for a respectful hunter. Artist Abraham's design comes from Nunivak Island in the Bering Sea, close to Nelson Island and the village of Umkumiut where the artist was born.

ANCHORAGE

In his studio above a transmission shop, Abraham carves a spirit mask. He says he draws from traditional native designs for his sculptures but innovates, too. "I used some artificial sinew from that fake seal that I caught," he jokes.

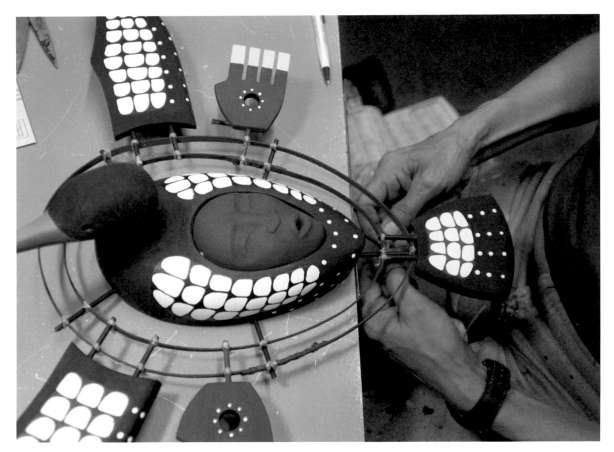

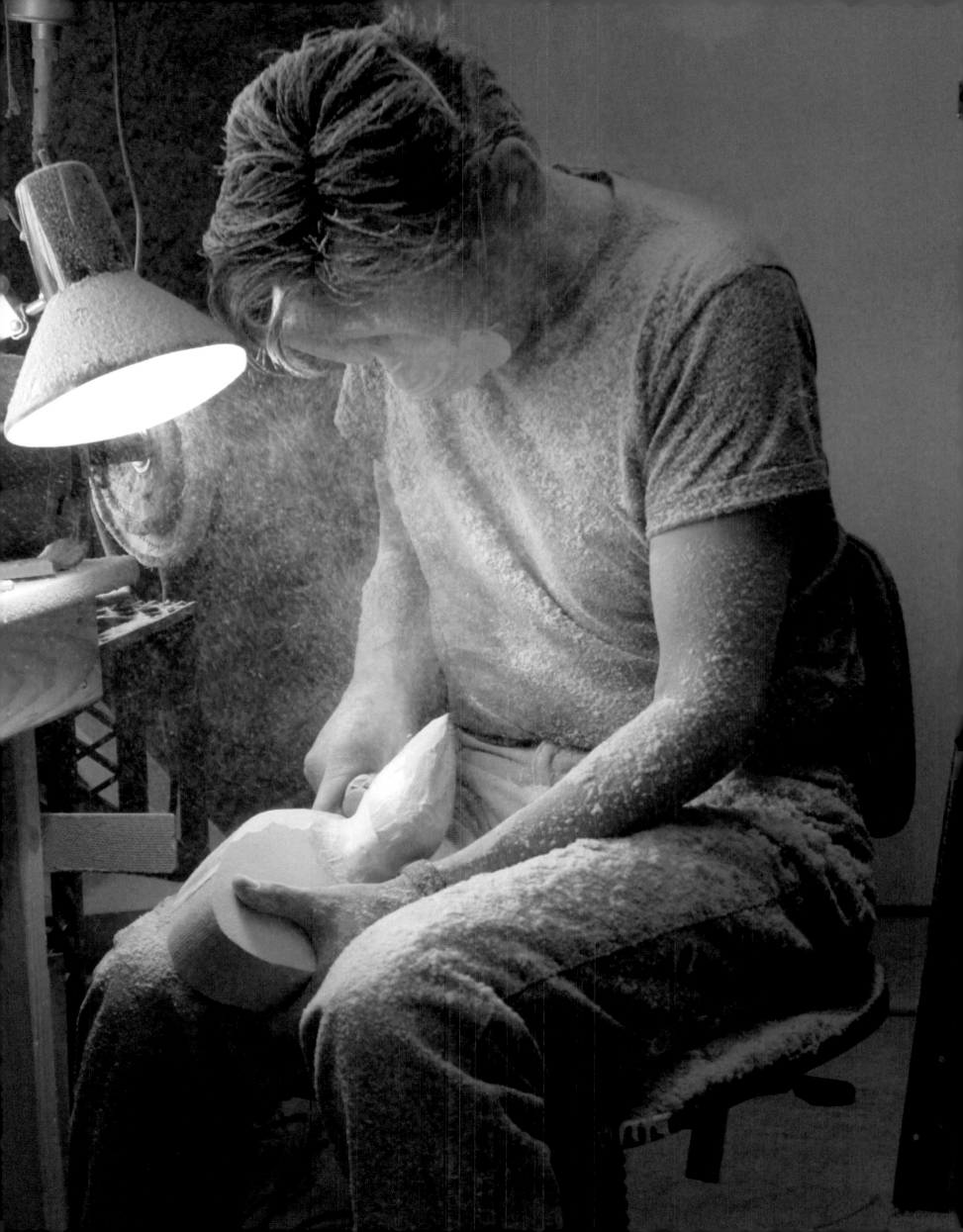

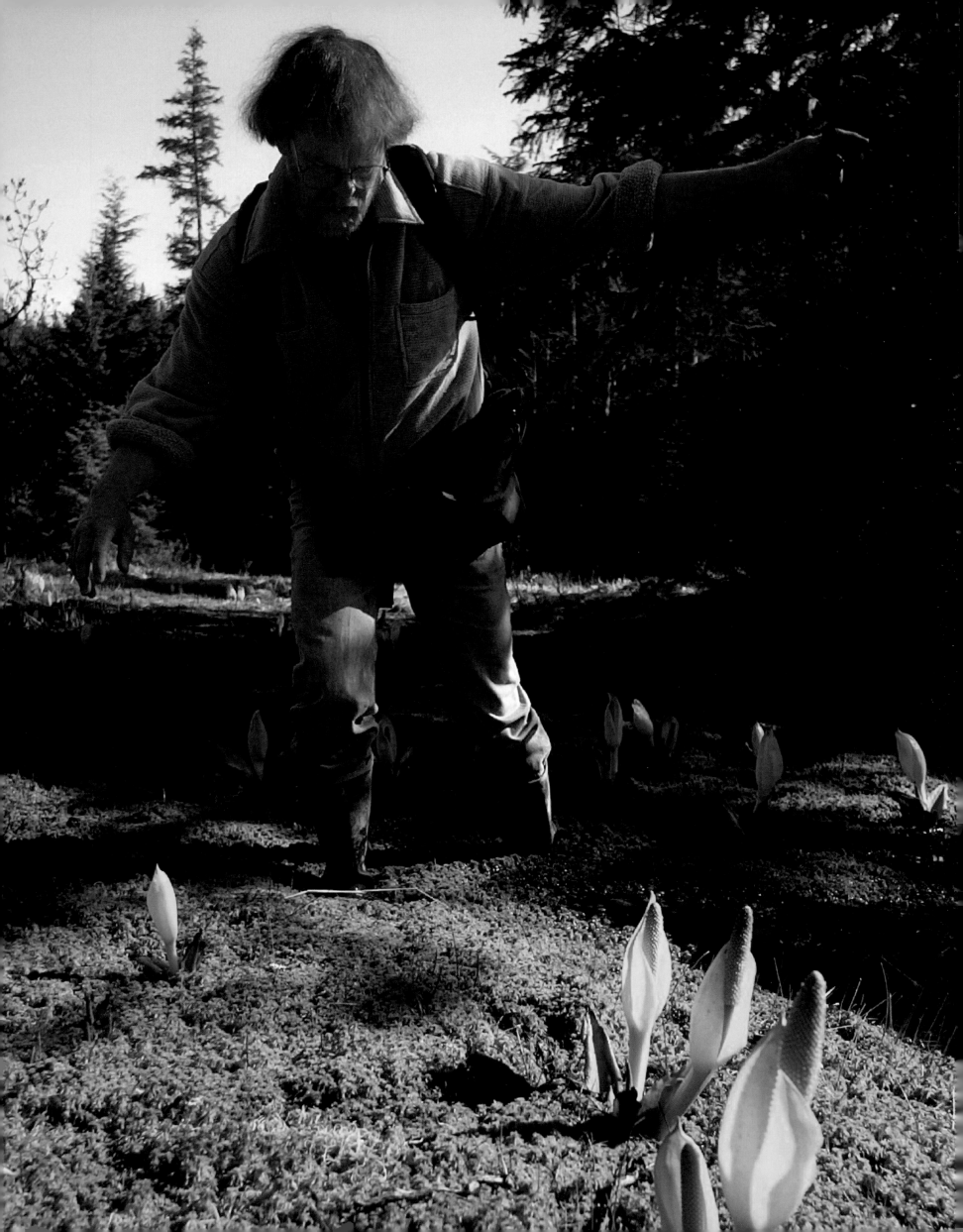

JUNEAU

A western toad eludes naturalist Richard Carstensen in the moss-covered ponds near Peterson Creek. His census of toadlets is part of an international effort to determine why the once-ubiquitous reptile is disappearing everywhere, from Mexico to Alaska. The self-taught ecologist from upstate New York hopes his data will yield a few clues.

Photo by Michael Penn

JUNEA J

The lowest tides of the year expose the teeming wilderness of the intertidal zone: masses of purple sea anemones, sea cucumbers, hermit crabs, starfish, and snails. A 12-legged sun starfish intertwines digits with biology professor Sherry Tamone.

Photo by Michael Penn

ANCHORAGE

Plant pests flourish in the warm, moist Anchorage Municipal Greenhouses. Among the several natural pest-control agents used in the public areas, ladybugs are by far the most attractive.

Photo by Fran Durner, Anchorage Daily News

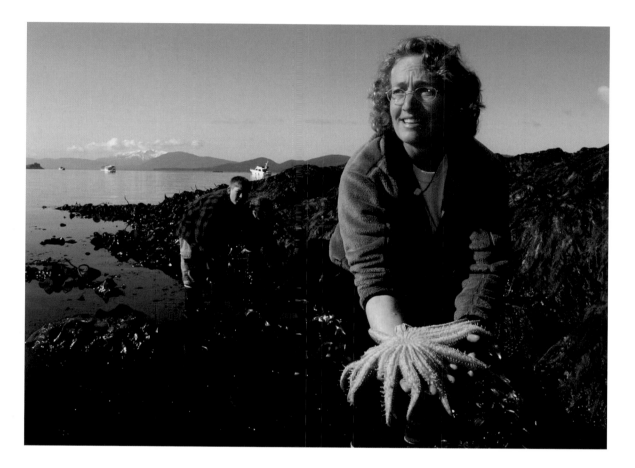

ELMENDORF AFB

Staff Sergeant Bobbi Baker is one of 150 Air National Guard controllers at Elmendorf Air Force Base. This nerve center monitors all of the air space over Alaska and northwest Canada, which sees more than 30,000 commercial, private, and military flights a month.

Photos by Mark Farmer, topcover.com

ELMENDORF AFB

Each plaque on the "wall of stars" in the Regional Air Operations Center represents an "intercept." When Elmendorf's radar picks up an unidentified aircraft, planes are dispatched to take photographs, discern the country of origin, and insure that the plane follows its assigned flight path. All of these intercepts—177 since 1983—represent Soviet Union/Russian aircraft.

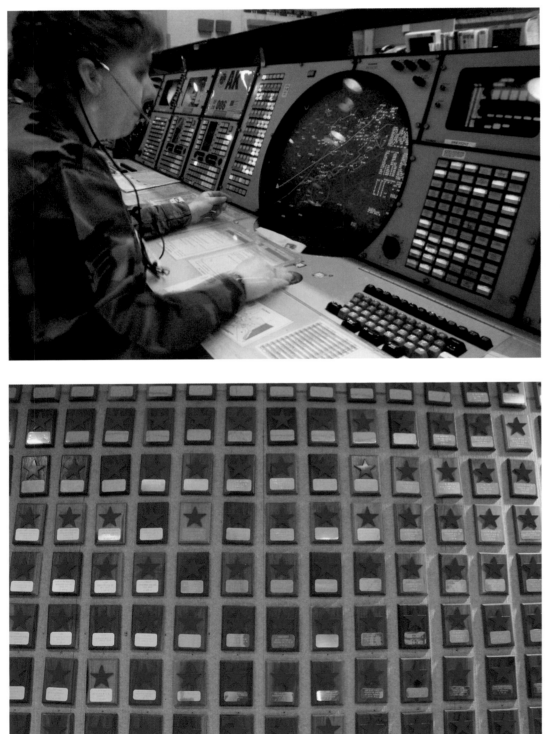

ELMENDORF AFB

The 13,000-acre base, established in 1940, is home to more than 7,000 active-duty personnel and three squadrons of F-15s. This F-15 enters the "combat alert cell," where the plane and pilot will remain on 24-hour alert.

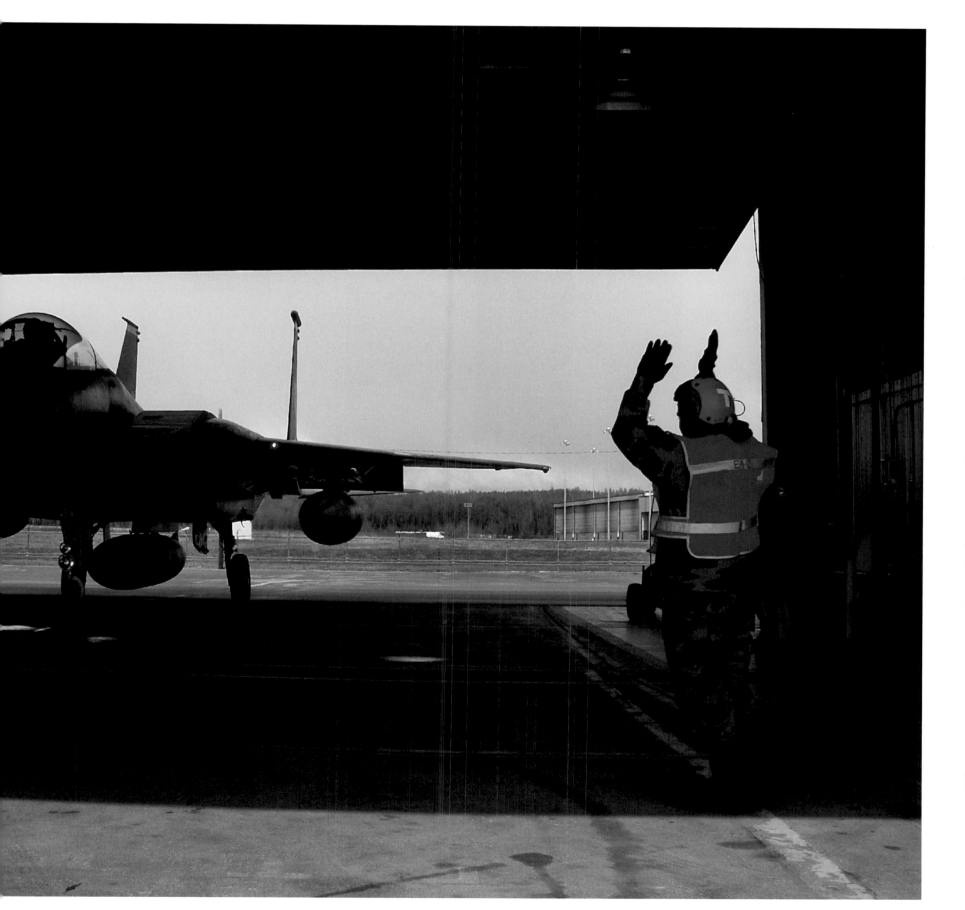

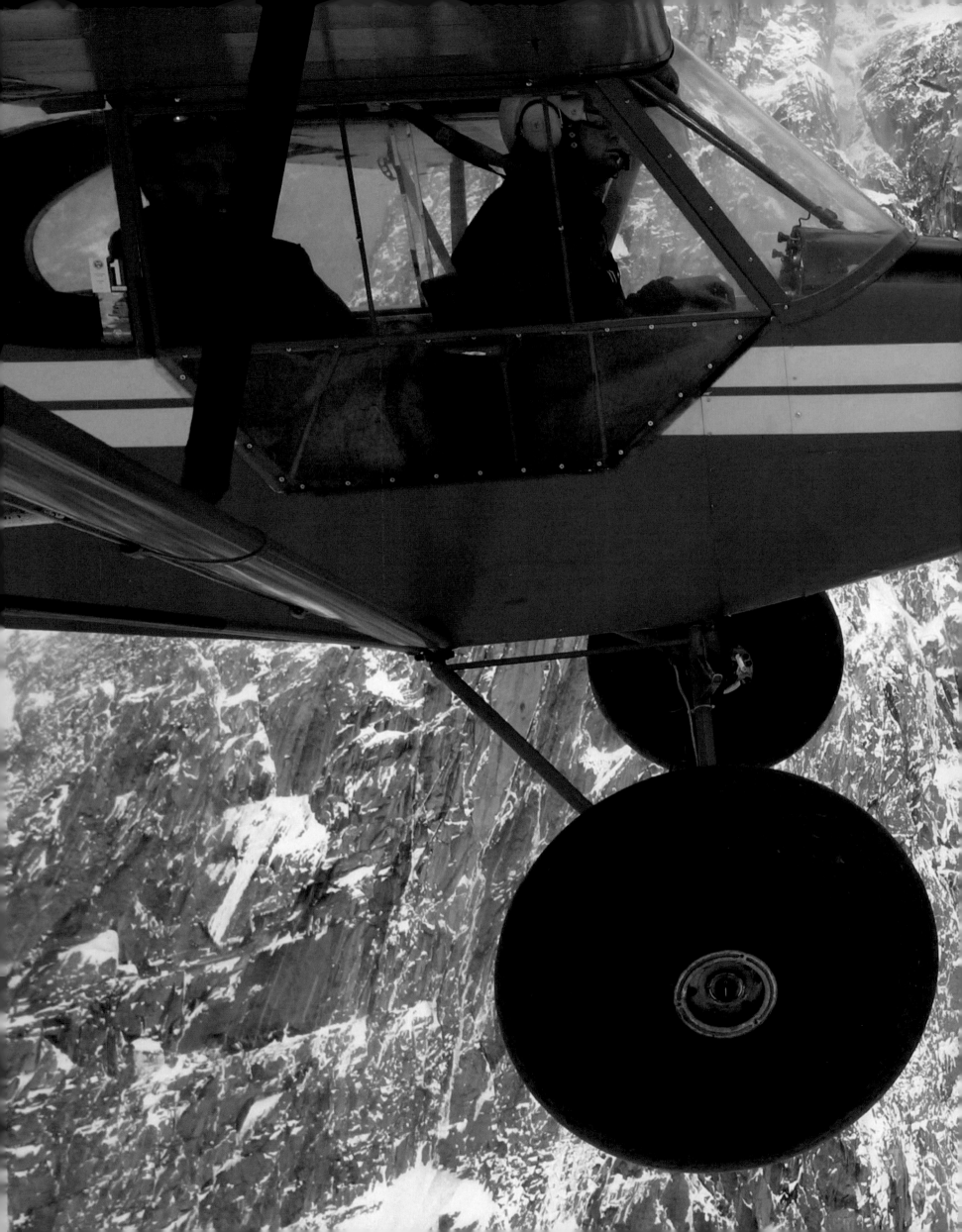

WRANGELL–ST. ELIAS NATIONAL PARK
At 5,000 feet up in the Twaharpies mountains, pilot Paul Claus and photographer Jeff Schultz use a radio remote to operate the Super Cub's wing-mounted camera. Claus, whose base lodge is in the heart of the vast Wrangell–St. Elias National Park, supports himself by flying well-heeled customers deep into the wilderness.
Photo by Jeff Schultz

BUTTE

Seasonal workers Jacob Peterson and Stacy Roberts sort seed potatoes at Pyrah's Pioneer Peak farm. Many of Pyrah's crop fields evoke memories of the old country for nearby immigrant communities. Russian families flock to the field to harvest turnips, cabbage, and potatoes, while Koreans drive up from Anchorage for October's daikon radishes.
Photo by Stephen Nowers, Anchorage Daily News

KETCHIKAN

She wants to own her own construction firm someday. Meanwhile, Danielle Miller, an apprentice heavy equipment operator with Operating Engineers Local 302, works on a major job: building a mile-long mountainside bypass road to relieve summer tourist traffic in downtown Ketchikan. Miller, 21, says she feels "privileged to be part of this awesome project."
Photo by Hall Anderson

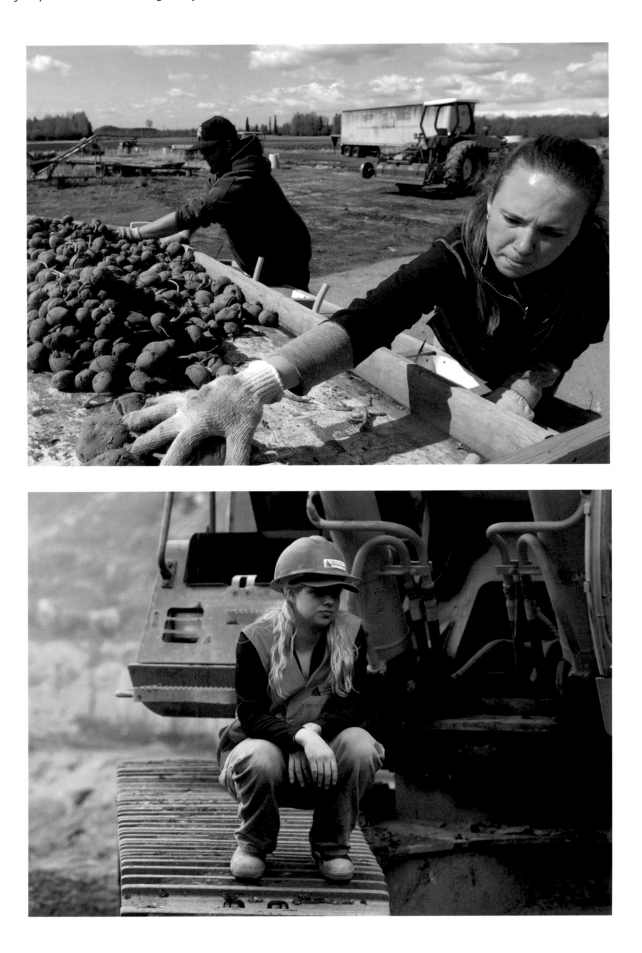

DENALI NATIONAL PARK

During the winter, Denali's 30 sled dogs aid rangers in patrolling the park for poachers. In the summer, they show off their sled-pulling skills around a track for an average of 4,000 tourists each week.

Photo by Robert Hallinen, Anchorage Daily News

CORDOVA

Skipper Tom McGuire operates the booms on the commercial fishing tender *Jac-Ol-Be* in Prince William Sound. Despite the depressed wild salmon market, he makes $350 a day. In winter, McGuire, 57, sometimes works construction on the North Slope oil fields. Otherwise, he's at his Haines home, which is just outside the reach of electric and power lines.

Photo by Marc Lester, Anchorage Daily News

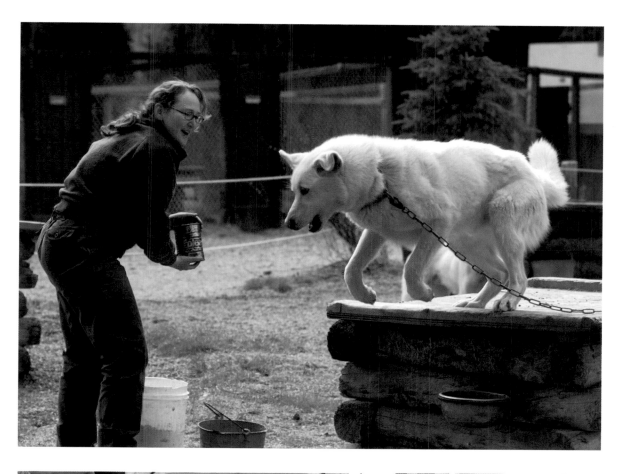

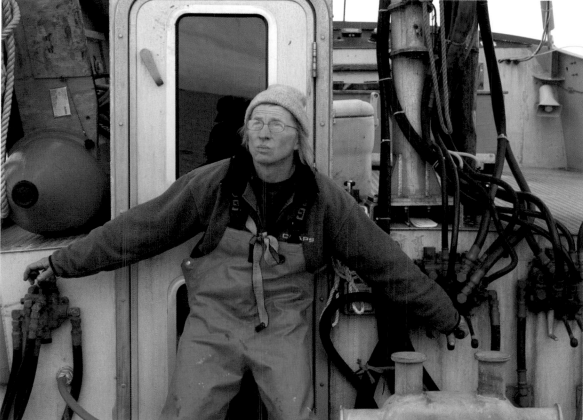

CORDOVA

No greens fees: Marc Perron laid out his own four-hole course on the mudflats of the Copper River Delta. The avid fisherman from Dietrich, Idaho, brought two irons—one long, one short—to kill time while waiting for the king salmon season to open.

Photo by Marc Lester, Anchorage Daily News

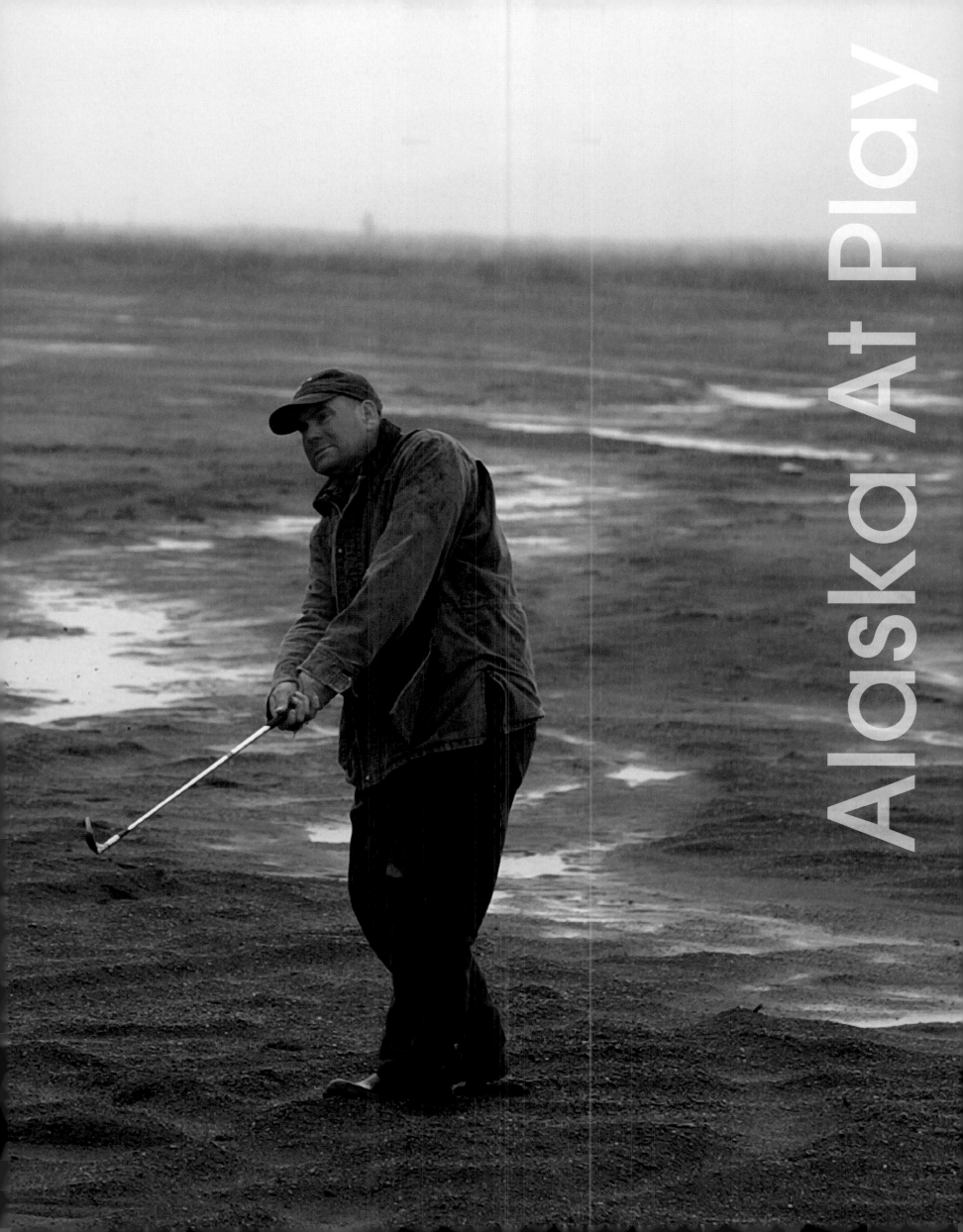

Alaska At Play

DENALI NATIONAL PARK
Most climbers who aim for the high peaks of
Denali National Park in central Alaska first fly to
Kahiltna Glacier base camp at 7,200 feet. Behind
the clouds is the technically difficult and seldom
climbed Mt. Foraker.
Photos by Anne Raup, Anchorage Daily News

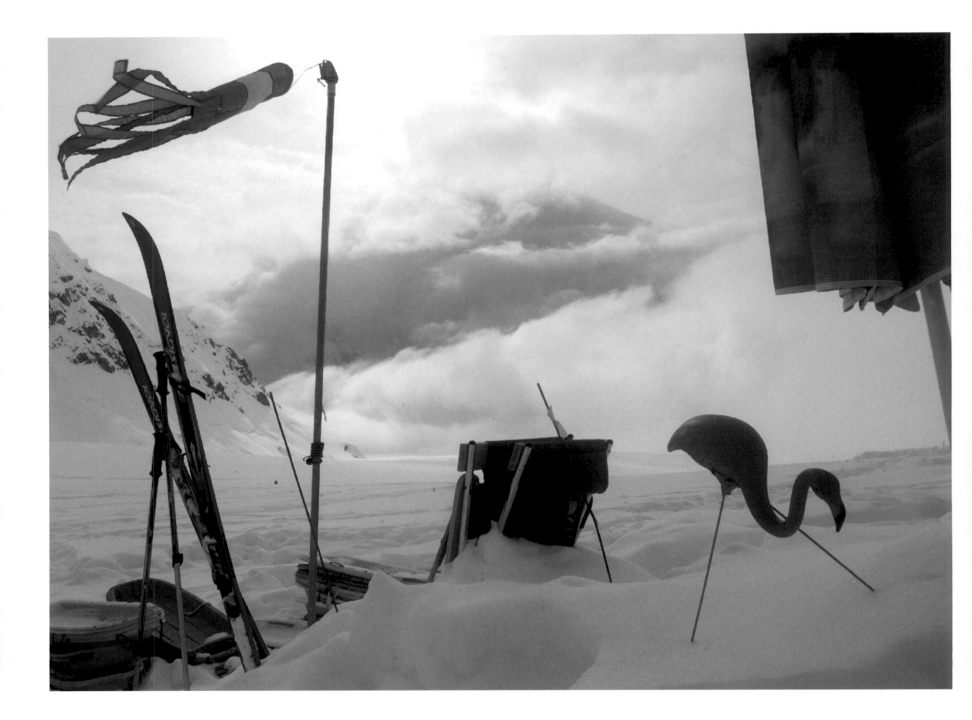

DENALI NATIONAL PARK
Geologist-turned-teacher Paul Davis had hoped
to climb the highest mountain in North America,
20,320-ft. Mt. McKinley. But he began to feel sick
only hours from the summit and had to retreat.
Of Davis's four-man team, only 68-year-old Ted
Choate reached the summit.

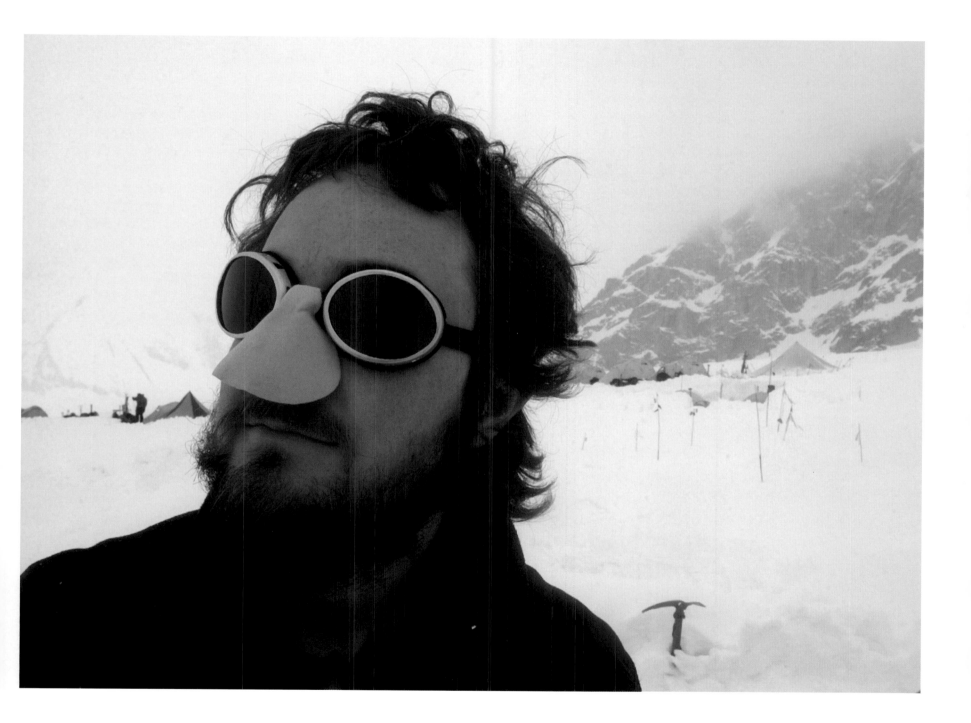

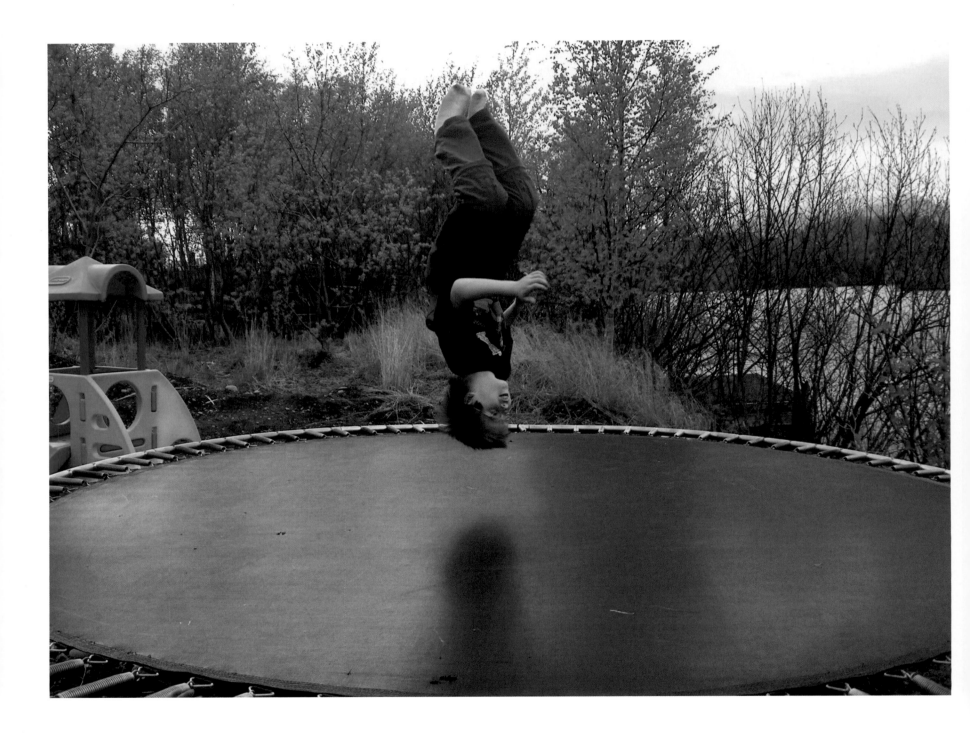

COTTONWOOD LAKE

Twelve-year-old Don Seals flips for mom's camera. His parents, David and Laurel Seals, both 70s refugees from the Lower 48, raise their six kids in a log cabin on Cottonwood Lake, an hour from Anchorage. David defines the Alaska dream as "a beautiful chunk of property with a million-dollar view, where kids can grow up right."
Photo by Laurel R. Seals

KOTZEBUE

When the ice thaws, the young daredevils of Kotzebue "water skip" modified snowmobiles across Swan Lake. If the speed drops below 30 mph, the machine will sink. Duane Henry, 16, had to borrow his from a friend after his dad forbade him from taking the family's new Polaris 500 anywhere near the water.

Photo by James Mason

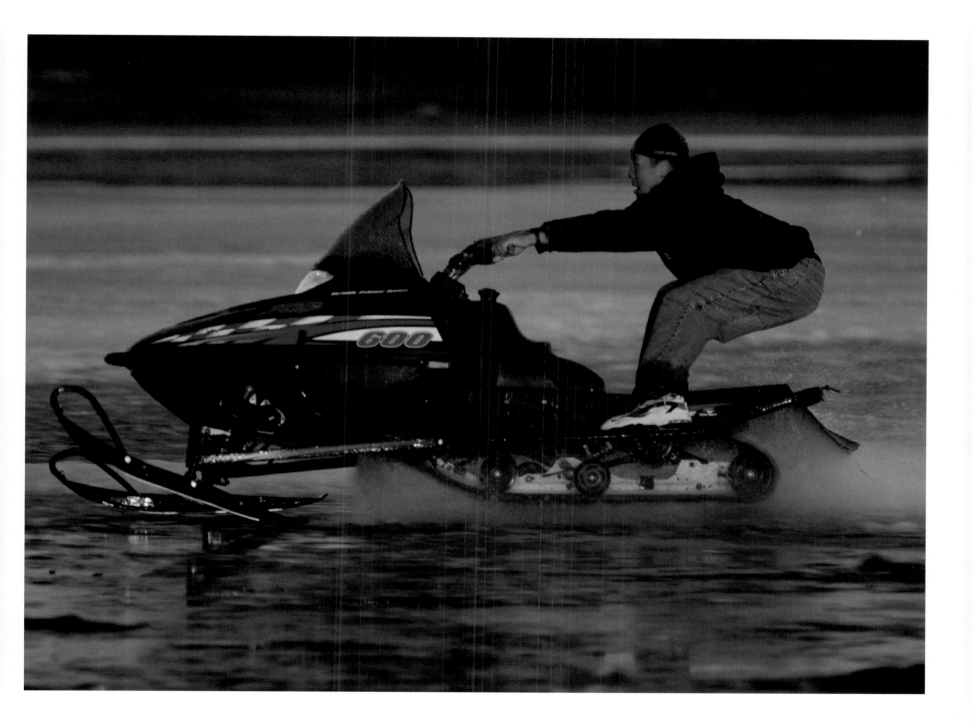

CLARENCE STRAIT
Hula-hooping on the aft deck of the ferry
Columbia, Heather Craig and Brock Thomas
of Tucson cruise through the shimmering
Clarence Strait, a leg of Southeast Alaska's
Inside Passage. The street-performing duo,
known as Pyroluscious, plans to twirl in every
ferry stop—Wrangell, Petersburg, Juneau,
and Haines—on the way to Skagway.
Photo by Mike Yoder,
The Lawrence Journal-World

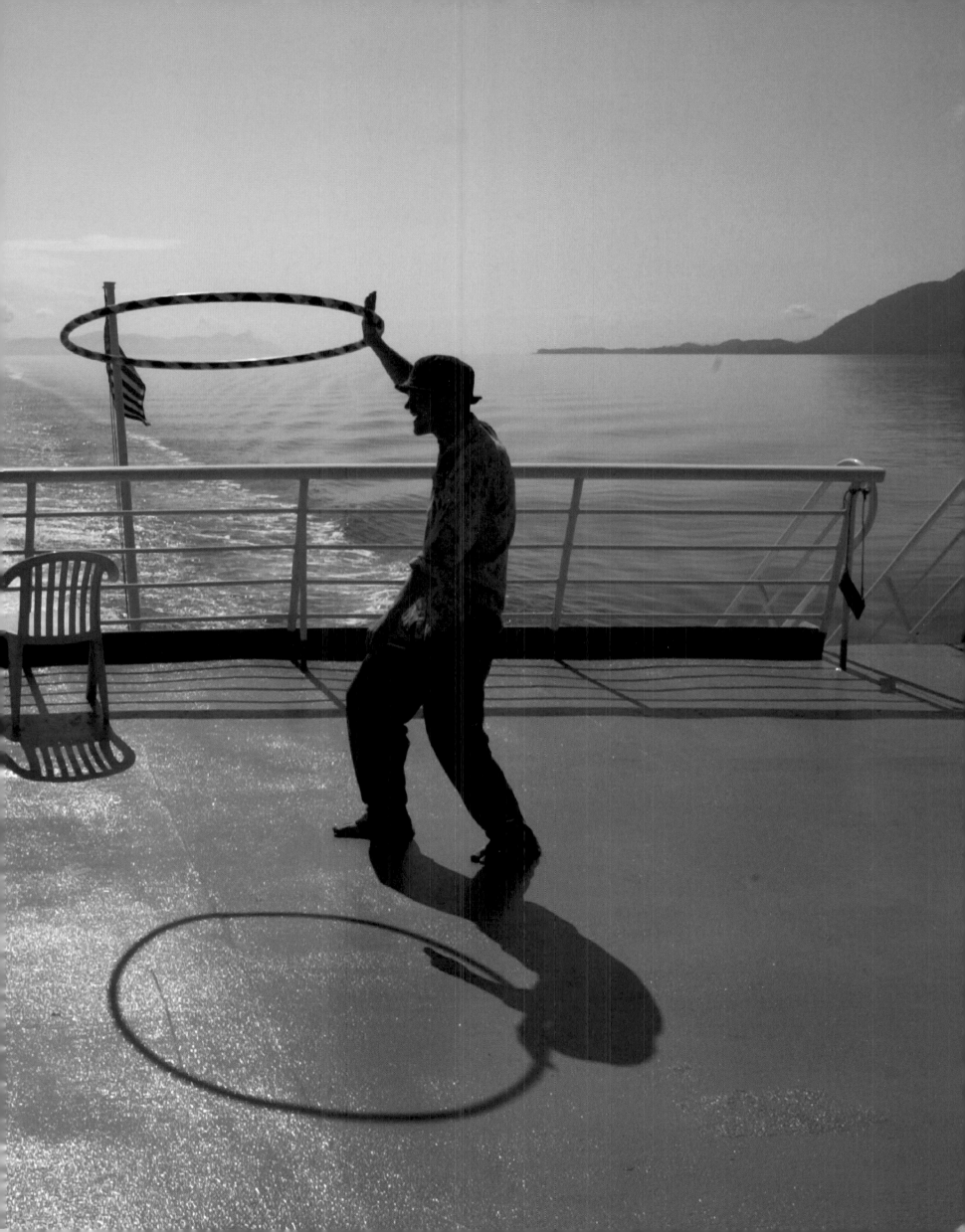

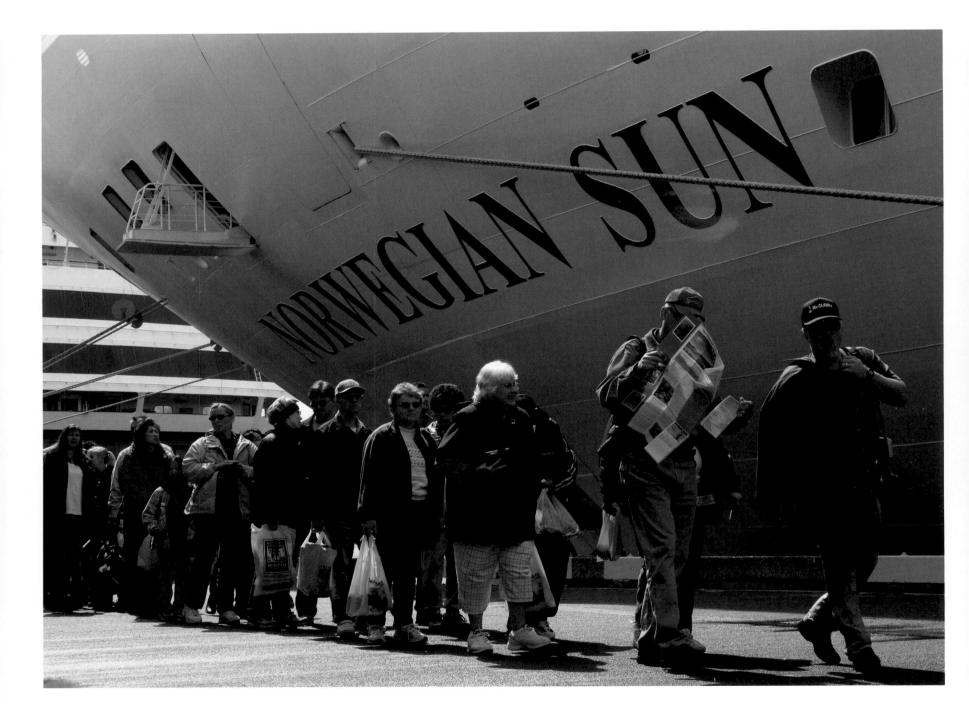

KETCHIKAN

"We had industrial salmon canning," says
Dave Kiffer of historic Ketchikan, "then we had
industrial timber harvesting, and now we have
industrial tourism." Ketchikan, pop. 8,000 or
so, now gets 800,000 seagoing tourists a year.
What do they do? For one thing, they buy jewelry
from dozens of foreign-owned businesses that
come—and go—with the cruise season.
Photo by Hall Anderson

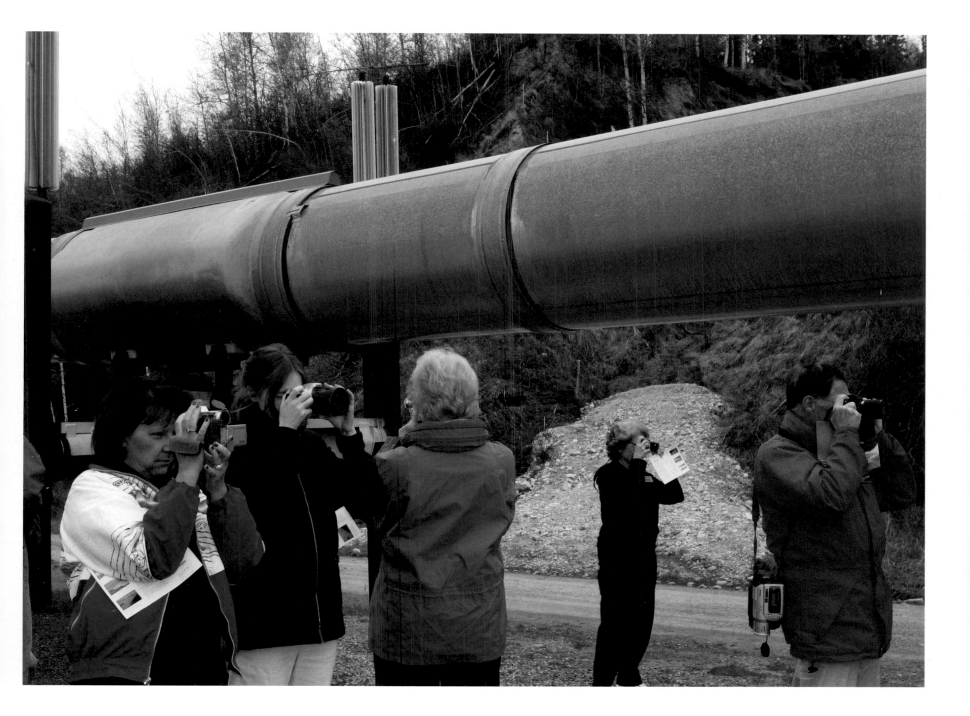

FAIRBANKS

Shutterbugs: Buses deposit 150,000 tourists a year at the Fox Visitor's Center, just north of Fairbanks, to see the Trans-Alaska Pipeline. Half of the 800-mile pipeline is above ground because of permafrost. Funniest question at the center: "What time do you turn on the northern lights?"
Photo by Charles Mason Photo, Corbis

KWETHLUK
In this town's old, predominantly Yup'ik settlement on the Kuskokwim River in western Alaska, third graders play stickball during recess. About 60 of the town's residents hold commercial fishing licenses, but in recent years declining fish populations have seriously affected the largely subsistence economy. Salmon, moose, and caribou are the staples of the local diet.
Photo by Clark James Mishler

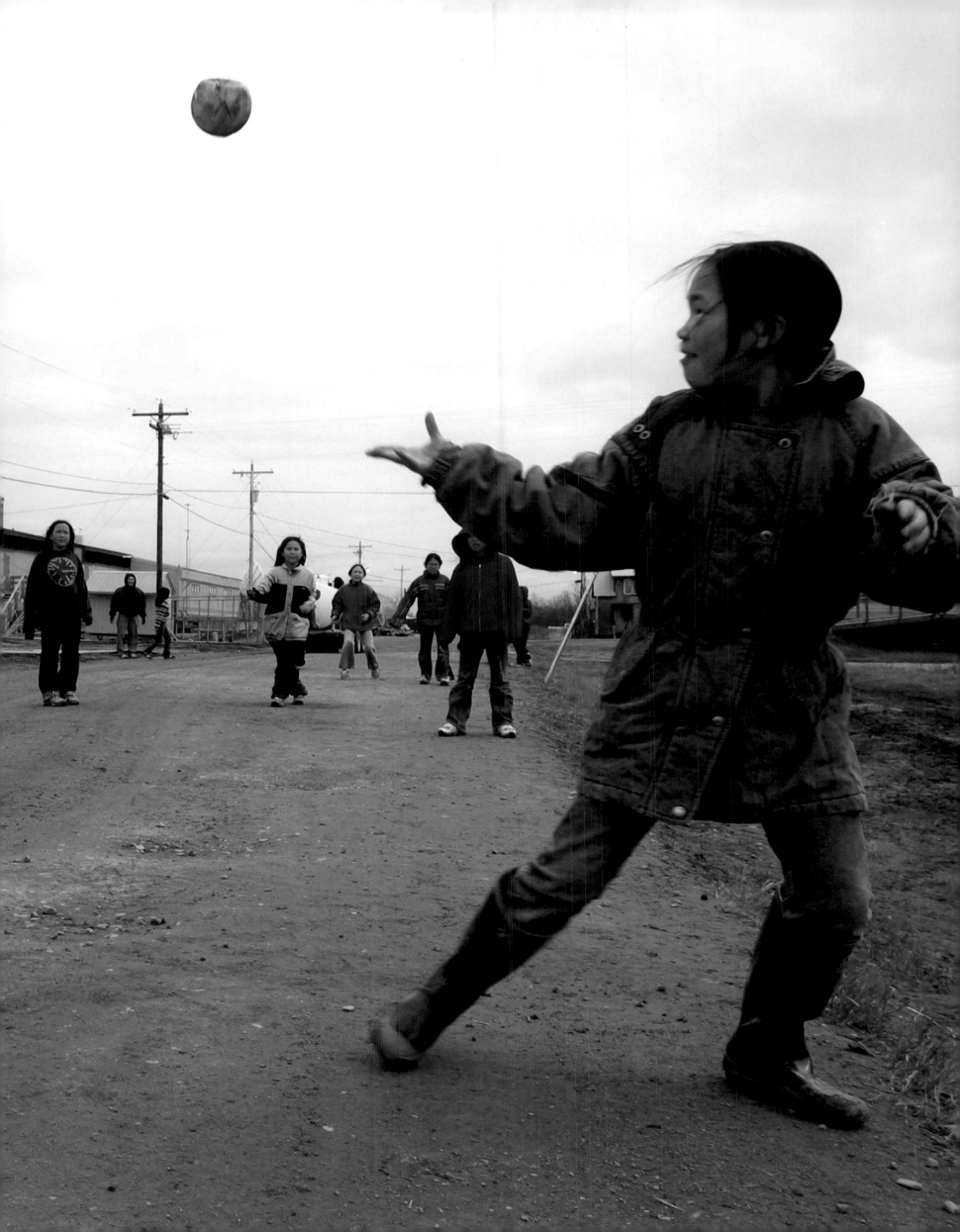

NINILCHIK

Clam diggers read the low-tide mud in Cook Inlet for doughnuts, dimples, and keyholes—openings left by the necks of meaty razor clams. Between April and July, an estimated 25,000 diggers disperse across the tidal flats between Clam Gulch and Whiskey Gulch to dig up more than a half-million clams.

Photos by Richard J. Murphy,
Anchorage Daily News

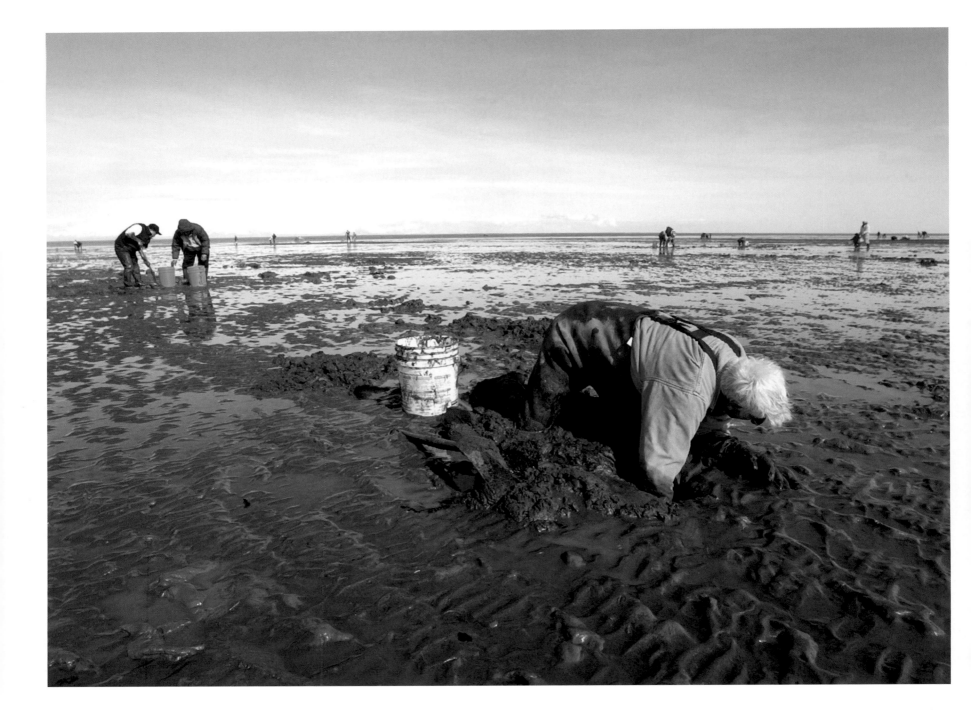

NINILCHIK

Ah, shucks: Glen Paris shows off his recently excavated prize, an adult razor clam big enough to make a pot of Alaska clam chowder. Beaches near Ninilchik are packed with razors but nabbing one isn't always easy: The mollusks can burrow at a rate of an inch per second.

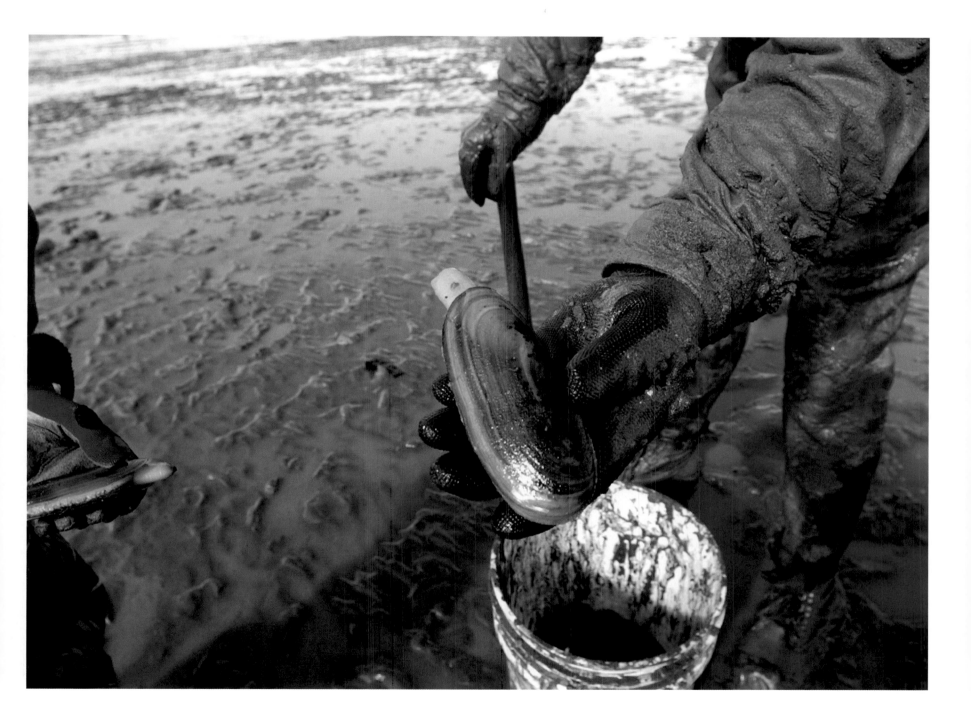

ANCHORAGE

Ultralight pilot Rob Stapleton mounted his camera on the wingtip of his aircraft to fly near Knik Glacier, 23 miles from downtown Anchorage. His challenge was to operate the camera's tiny remote with heavy mittens (he had to ditch one), grip the cold metal control bar, and angle the craft away from the sun so the infrared would work.

Photo by Robert Stapleton, Jr.

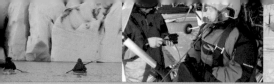

MT. BLACKBURN

After a snowstorm forced climbers to abandon their trek up Mt. Blackburn, they pitch in to rotate the plane sent to pick them up. The per-person cost of their thwarted adventure, including the flight, meals, and a night at Ultima Thule Lodge? $990.
Photo by Jeff Schultz

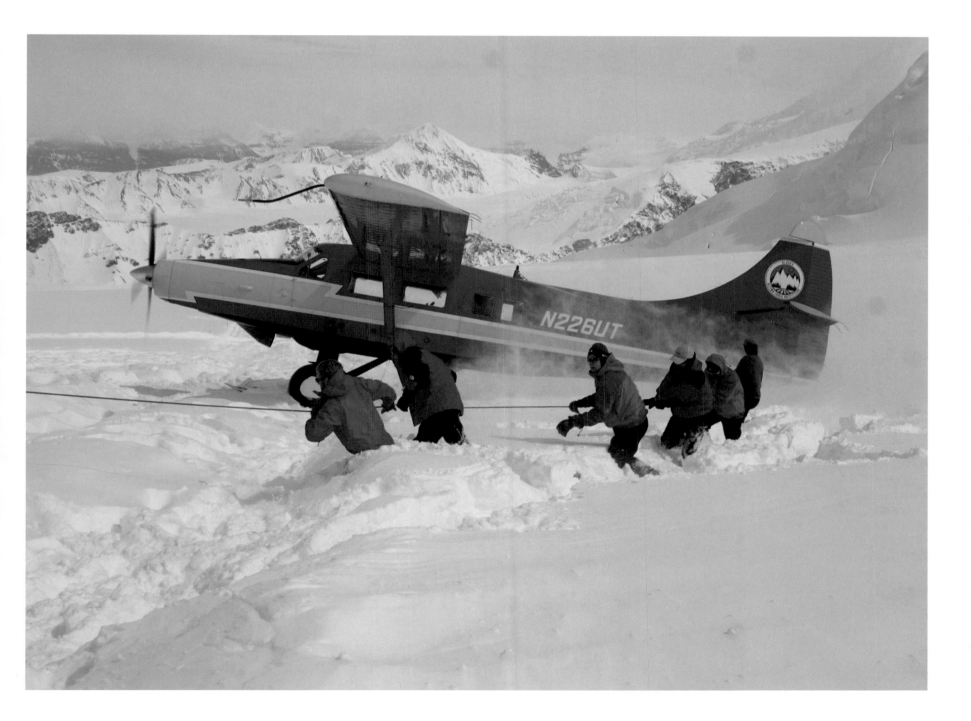

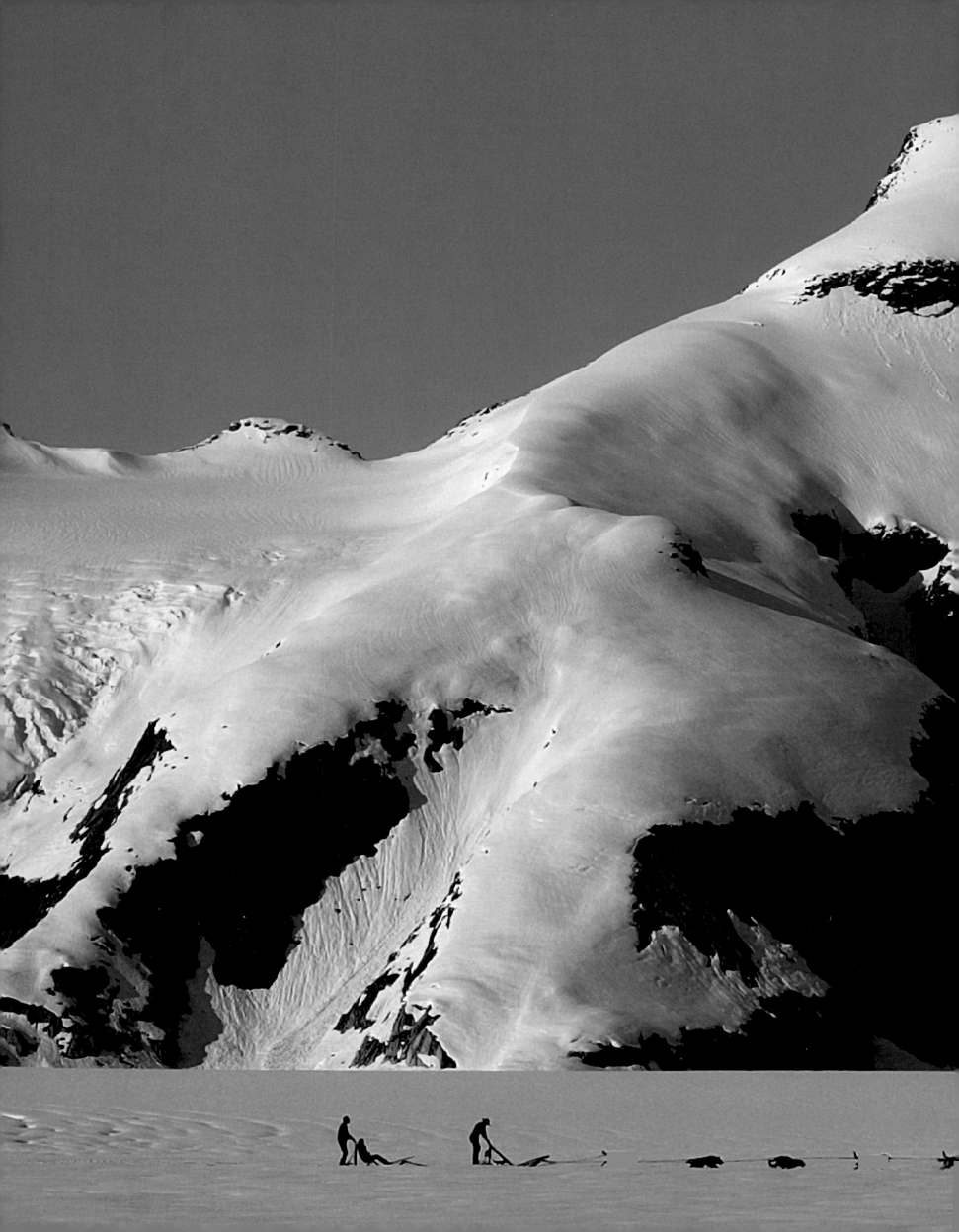

PORTAGE VALLEY
Furniture designer Mark Wedekind explores
an ice cave near the toe of Byron Glacier,
50 miles south of Anchorage. Ice caves form
when water drains under a snowfield and
opens passages for air to circulate. Caves can
collapse without warning. "You want to be
ready to bolt," Wedekind advises.
Photo by Evan R. Steinhauser,
Anchorage Daily News

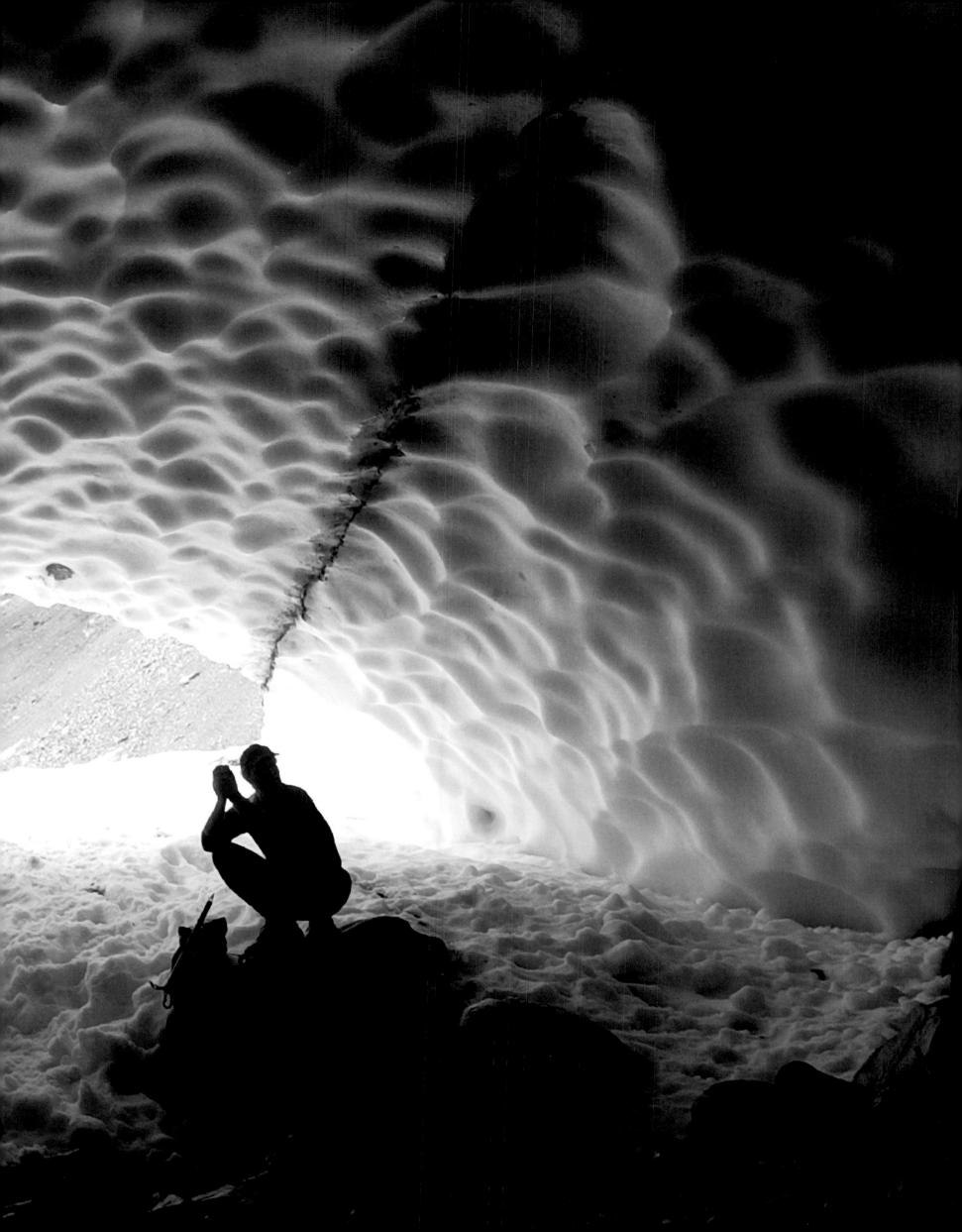

DENALI NATIONAL PARK

For the 10-week summer climbing season.
Lisa Roderick lives on Kahiltna Glacier in Denali
National Park. As manager of the glacier's base
camp, the Connecticut native works closely with
the pilots who ferry climbers between the town
of Talkeetna and the camp. Off season, off gla-
cier, she's a masseuse.

Photos by Anne Raup, Anchorage Daily News

DENALI NATIONAL PARK

Chilled: Austrian Konrad Scheiber tried to reach
the summit at Denali, but his partner's altitude
sickness forced a retreat. Scheiber waits for a
plane to fly the unsuccessful expedition back to
Talkeetna from base camp. Bad weather meant a
wait of 11 hours. *Verdammt*!

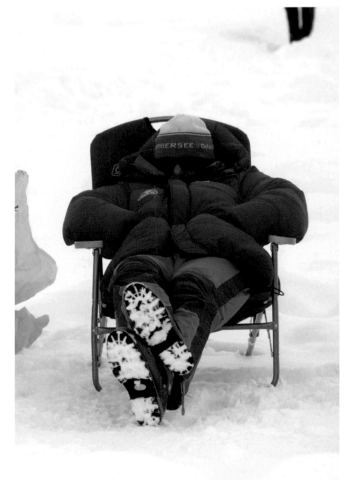

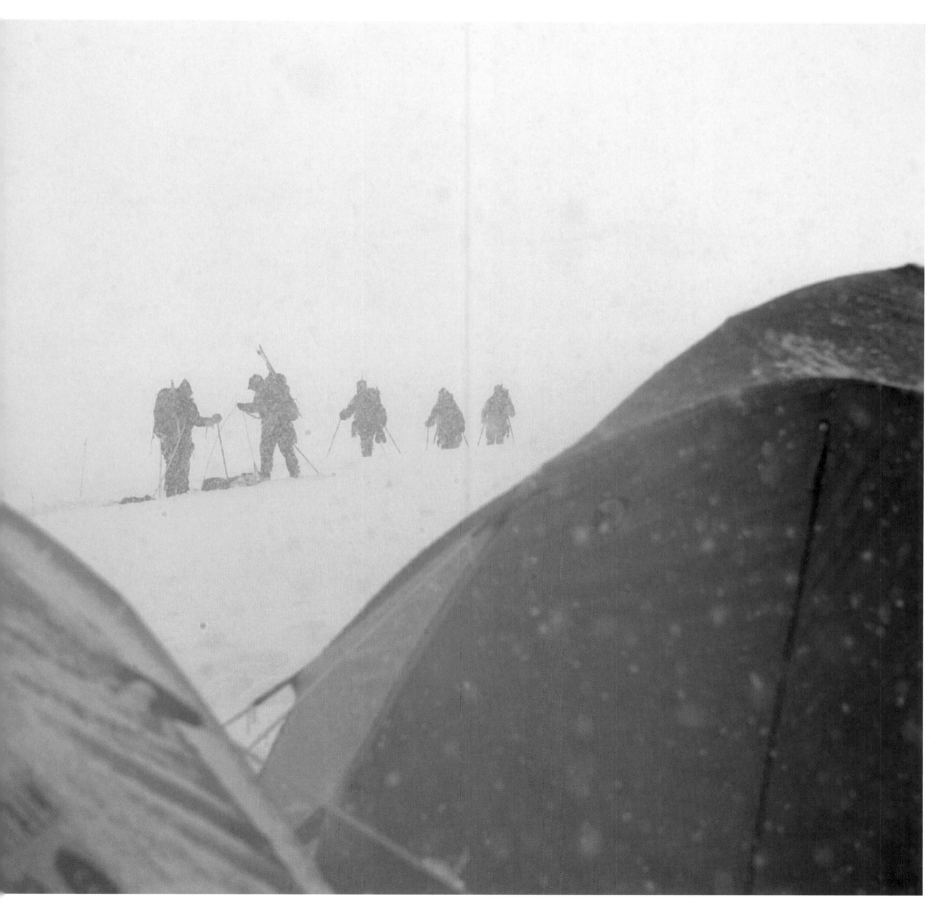

DENALI NATIONAL PARK
Not even near-whiteout conditions at Denali base camp could persuade this climbing party to sit tight for another day—after all, they came to conquer. In this case, their quarry is the top of Mt. McKinley, whose common name, Denali, translates from Athabascan as The High One.

PORTAGE

A slippery fingerling: The tiny, smelt-like hooligan measures just 10 inches at maturity. The fish spawns April through June along the bottom of the glacier-formed Twenty Mile River near Portage. Most locals prefer the fish whole and deep fried.
Photo by Bill Roth,
Anchorage Daily News

JUNEAU

Herring bits, a bobber, and a nimble wrist rewarded Frank Miller with five freezers full of salmon in 88 days. Miller gave the entire catch, smoked and packaged, to a neighboring Tlingit clan as part of a potlatch to honor his deceased grandmother. Miller's generosity reflects his place within the Awk-Kwan tribe: He will soon become its chief.
Photo by Michael Penn

PORTAGE

Prime Sanchez and Alfred Gaviola come out every year to dip net for hooligan. They share this Cook Inlet spot with harbor seals and even Beluga whales. The hooligan run on the rising tide. When it departs, a few end up stranded on shore, providing a free meal for eagles, foxes, and coyotes.
Photo by Bill Roth,
Anchorage Daily News

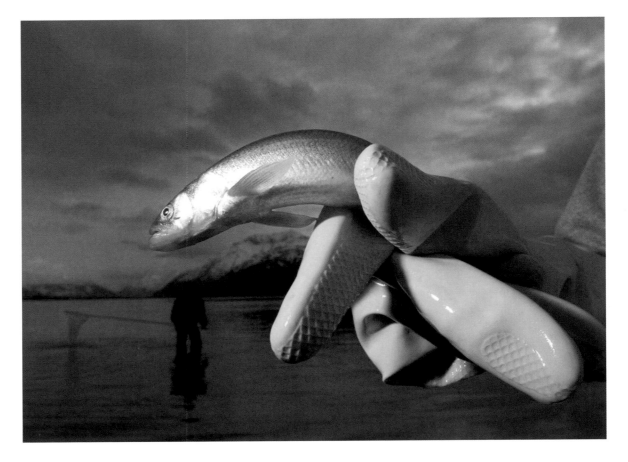

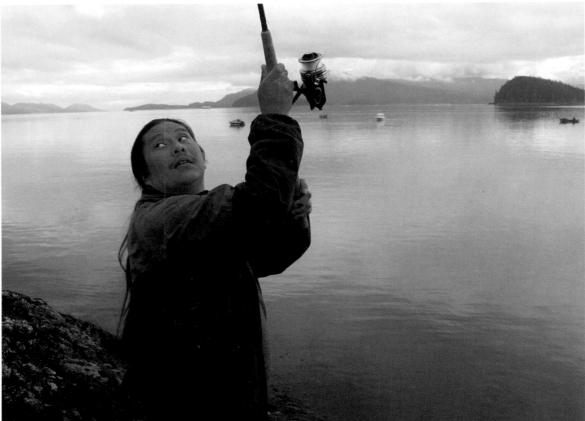

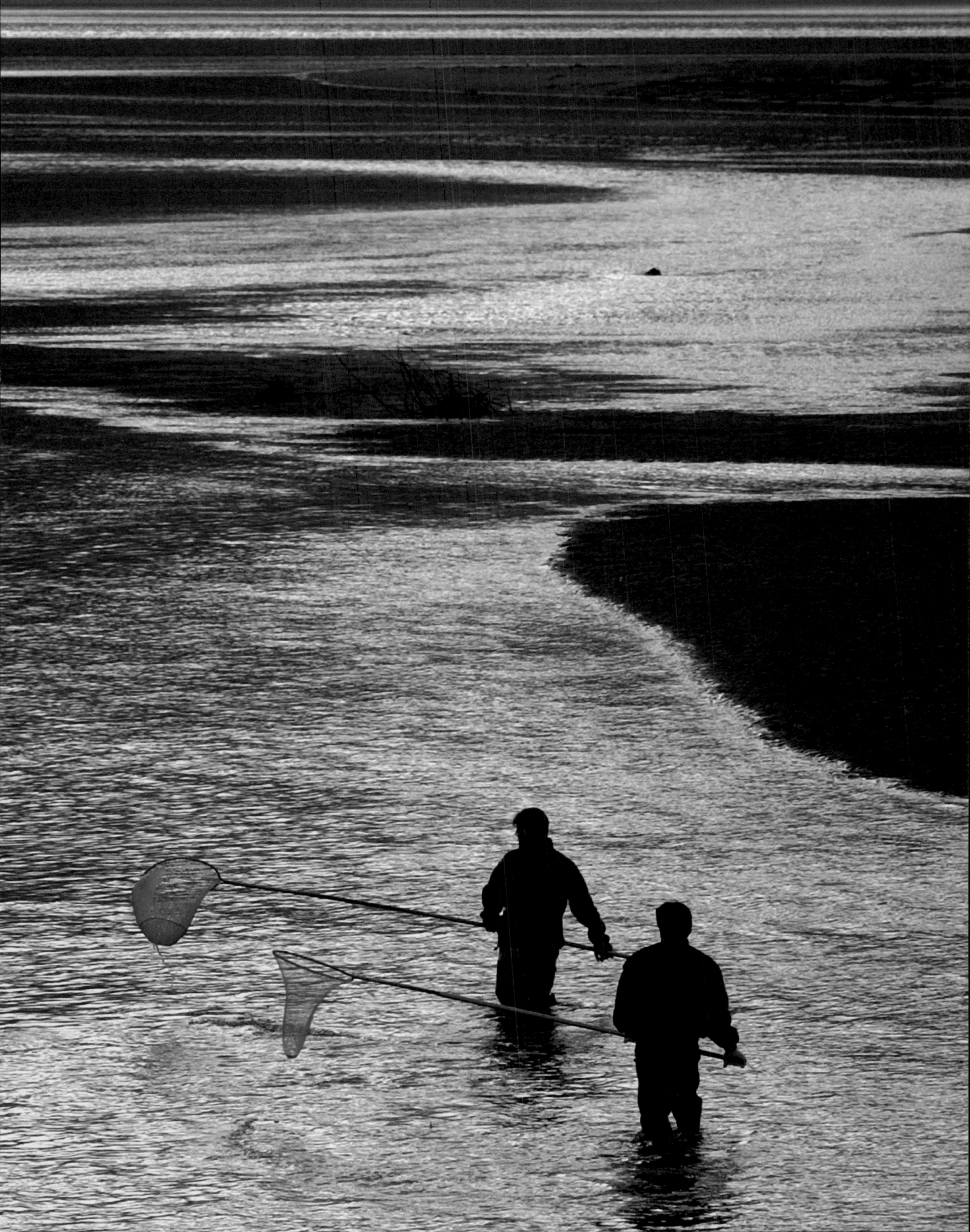

ANCHORAGE

At his post-work workout at Powerhouse Gym, machinist Dan Mayhak, 54, takes his triceps to the edge with 60 pounds on the E-Z curl bar. Dan's goal is a national Masters championship—then to turn his success into a new career as a motivational speaker. Years ago, he suffered from alcoholism and depression. Bodybuilding, he says, helped him to climb out of it.

Photo by Marc Lester, Anchorage Daily News

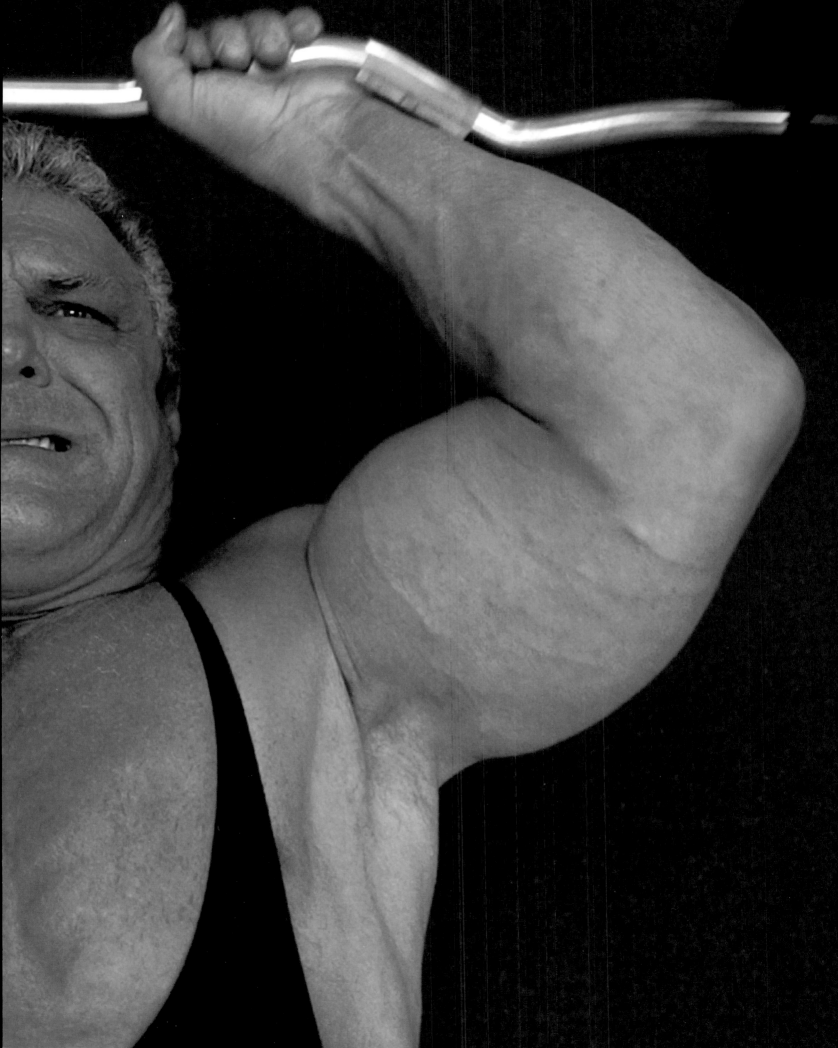

ANCHORAGE

Neighborhood kids Billy, Jefferson, and Johnny Moua shoot hoops in the parking lot at the St. Innocent Russian Orthodox Cathedral, built in 1993. Inside, contemporary challenges include linguistics: Services are in English, the liturgy is in Slavonic, and the hymns are sung in Aleut, Yup'ik, and Tlingit.

Photo by Anne Raup, Anchorage Daily News

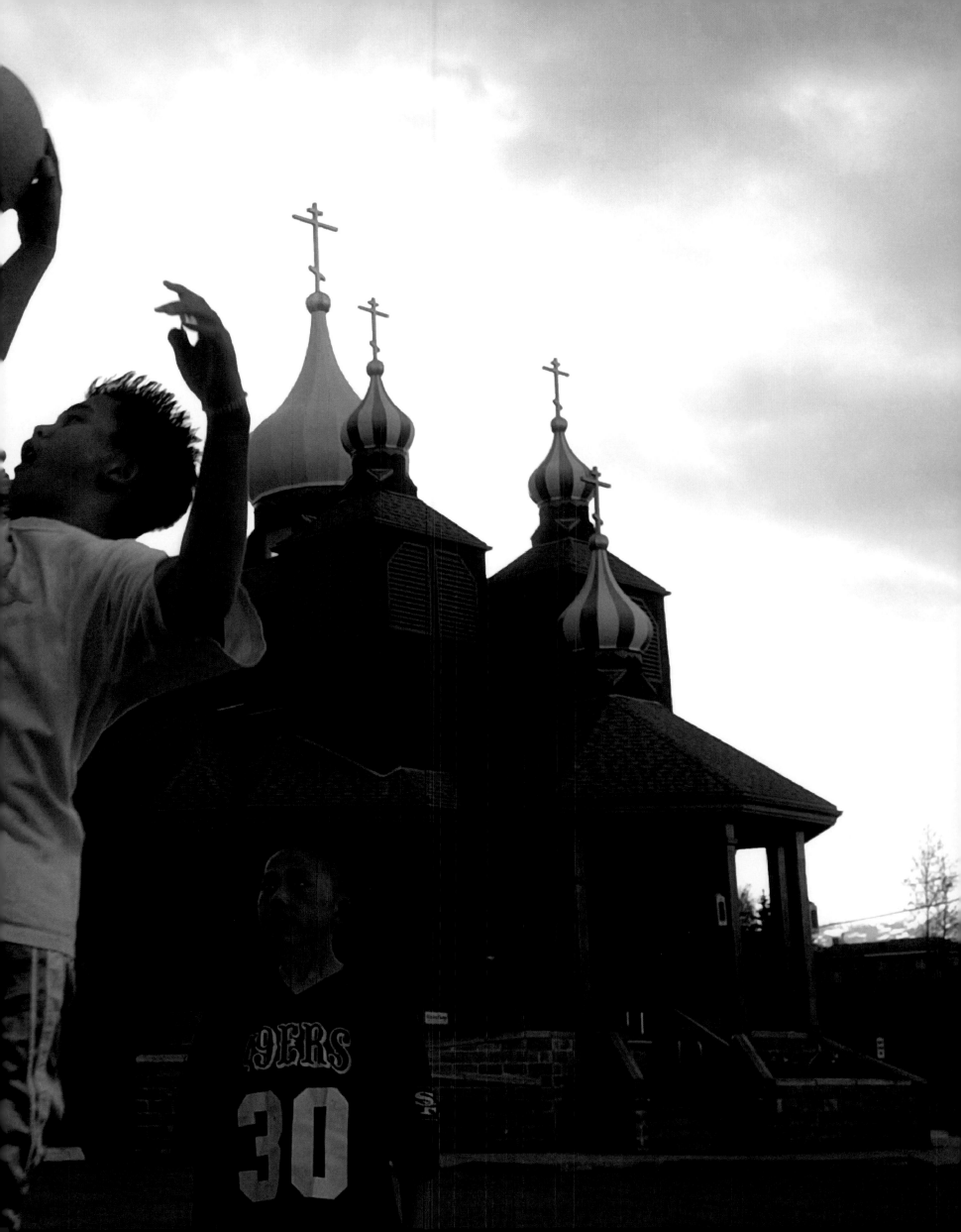

FAIRBANKS

Gun-lovers of all stripes turn out for the state Department of Fish and Game's annual Kids Day. Ed Trump (aka Brass Pounder) tamps birdseed into his antique muzzle loader for the Cowboy Action Shooting group demonstration. CAS members, armed with Old West personae and aliases, compete at shooting matches all over the lower 48. "We have a blast," Trump says.
Photo by Charles Mason Photo, Corbis

FAIRBANKS

Shooting birdseed at balloon targets, Donovan Albert, 11, learns to handle a muzzle loader under the tutelage of Richard Miller (aka Judge Yukon Hatch) during Kids Day. Donovan's first gun was a present from his uncle when he was 7.
Photo by Charles Shepherd

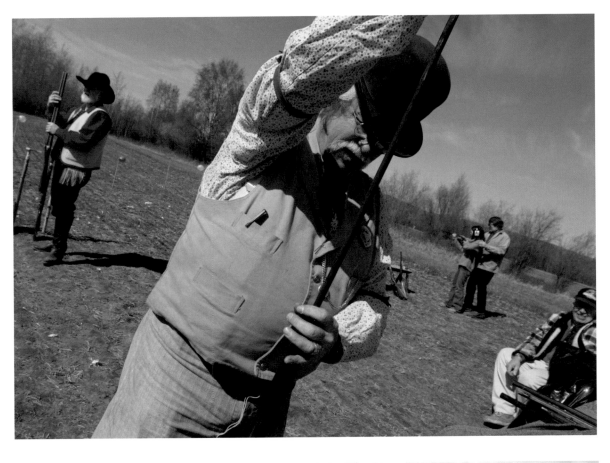

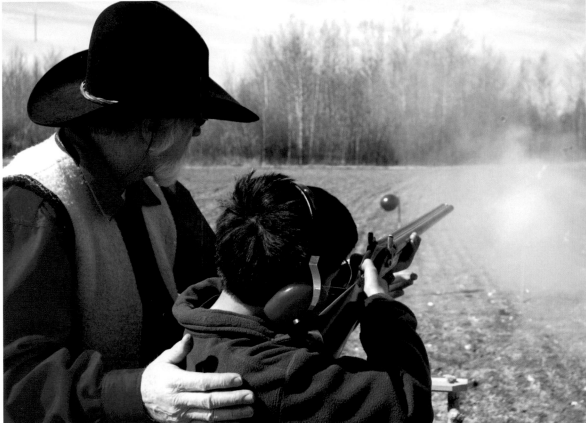

Gaylen Searles (aka the Wind Drifter)
patterned his Cowboy Action character after
his grandfather, a marshal in west Kansas.
Photo by Charles Mason Photo, Corbis

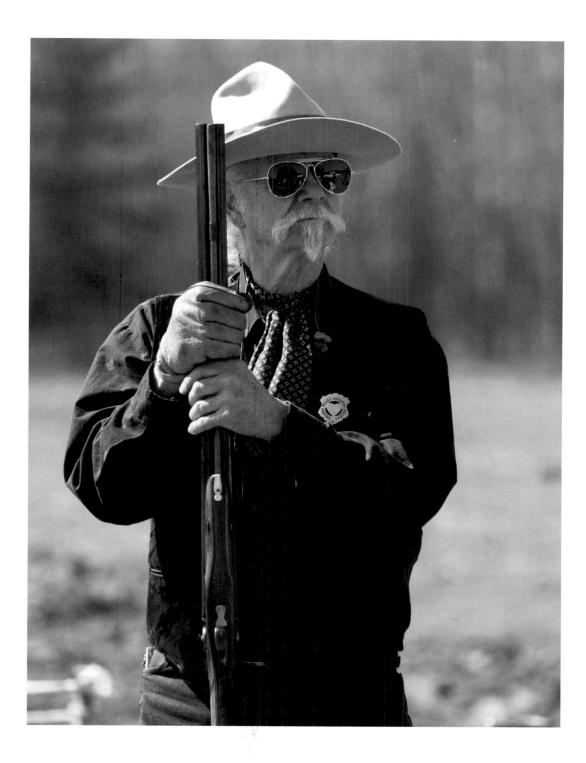

BARROW

The Presbyterian Church congregation shifts into high gear every Sunday night during "singspiration." Some of the songs are in English, but mostly they're in Inupiaq, like the service.

Photo by Luciana Whitaker

Reason To Believe

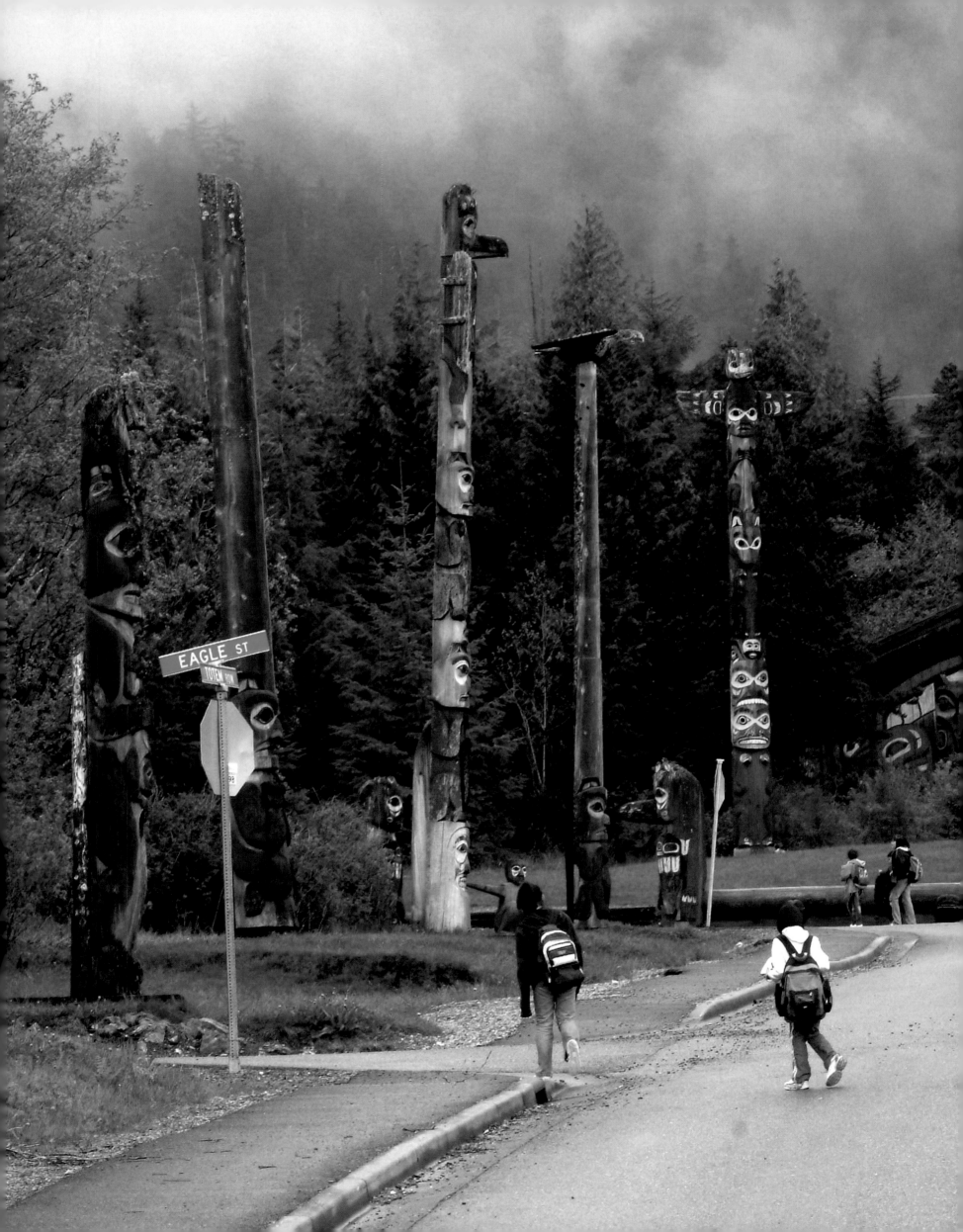

SAXMAN

In a Tlingit village south of Ketchikan, 24 totem poles endure another rainy afternoon in the world's largest totem pole park. Most of the poles are replicas carved by Tlingit men hired by the U.S. Civilian Conservation Corps during the Depression. For their priceless work on each foot of totem pole, the artisans were paid 24 cents.

Photo by Hall Anderson

JUNEAU

Leonard Johnson and Puanani Maunu wear lei made by the bride's Hawaiian relatives. Johnson's Tlingit relatives prepared the reception's fresh salmon and heart-shaped potato salad. The couple connected through their love of nature. "She likes to paint landscapes while I fish," Johnson says. "It's a beautiful life."

Photo by Michael Penn

BIG LAKE

Michael, Eve, Kade, and Kolten Brueggeman attend Sunday services at Big Lake Baptist Church. The couple homeschool their two boys. "Somebody else having the boys for seven hours a day, it just didn't seem right," Eve says.

Photo by Fran Durner,
Anchorage Daily News

JUNEAU

Dusk settles into the fjords of Gastineau Channel as a hiker takes a breather at Father Brown's cross, built by a local priest in 1908.

Photo by Michael Penn

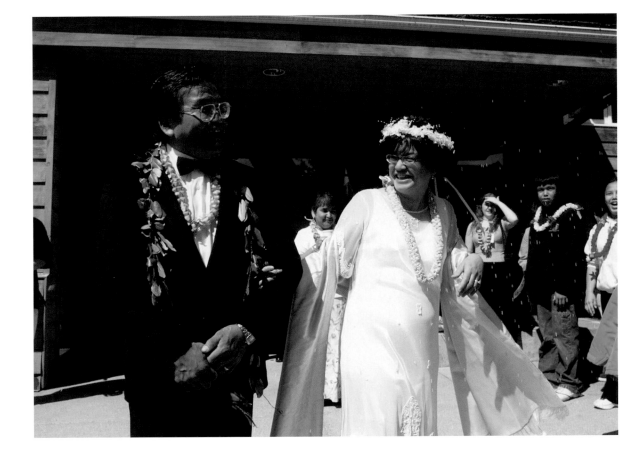

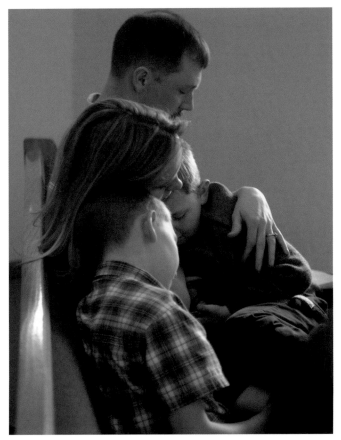

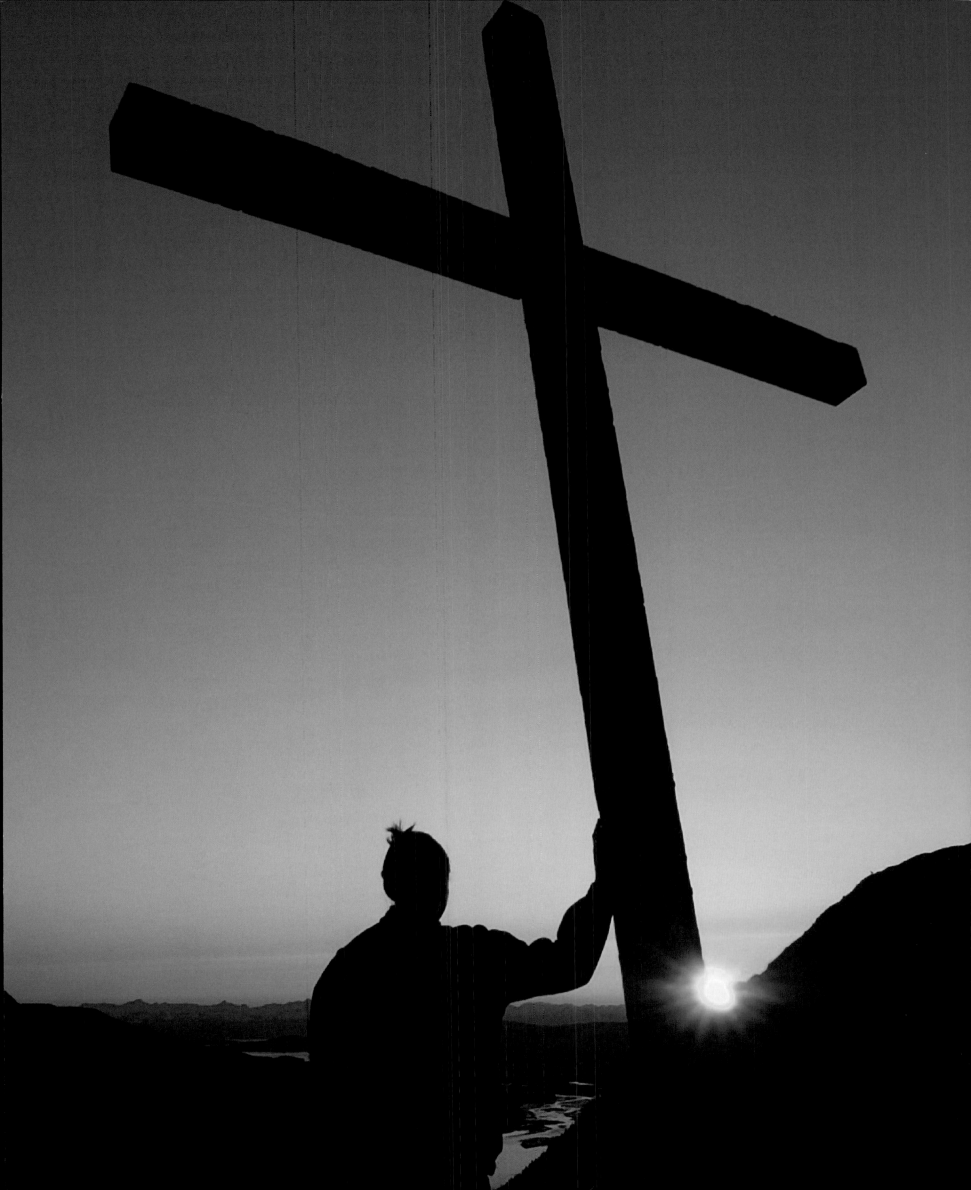

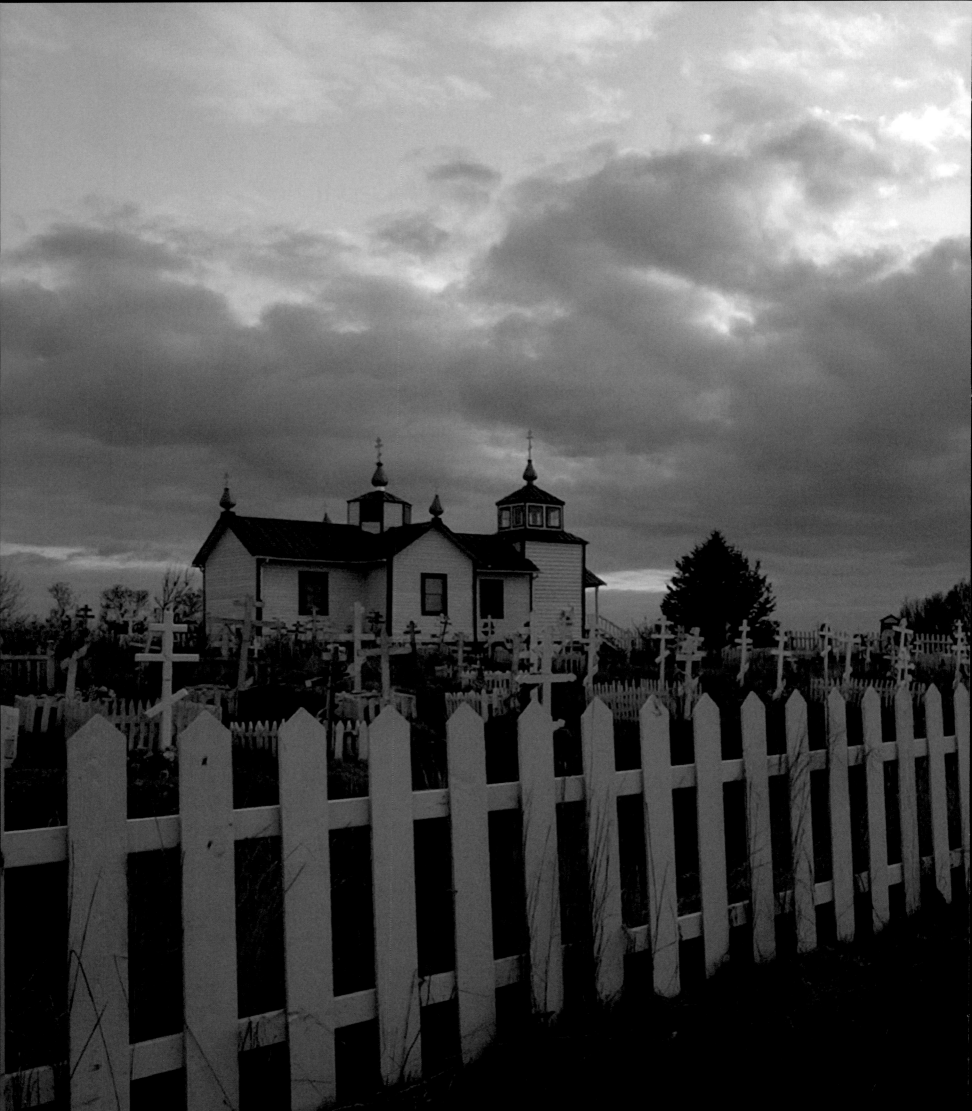

NINILCHIK

A century's worth of sunsets have piled up behind the wood-frame Church of the Transfiguration of Our Lord, built on a bluff above Ninilchik village. The seaside town's first settlers were a Russian Orthodox missionary, Grigorii Kvasnikoff, and his wife Mavra, a Russian-Aleut, who are buried in the churchyard. Russian is still sometimes heard among the 566 living descendants of the Kvasnikoffs.

Photo by Richard J. Murphy,
Anchorage Daily News

KWETHLUK

Jared Nicolai, 10, altar boy at St. Nicholas Orthodox Church, takes his duties seriously. For one thing, the priest is his uncle.

Photos by Clark James Mishler

KWETHLUK

Known as Father Martin to Kwethluk's Russian Orthodox community for 20 years, Martin Nicolai is also the father of five. His bishop has arranged for the pastor and his family to move 600 miles south, to teach and preach on Kodiak Island. A native of Kwethluk, he knows that Kodiak's big-city life will require adjustment.

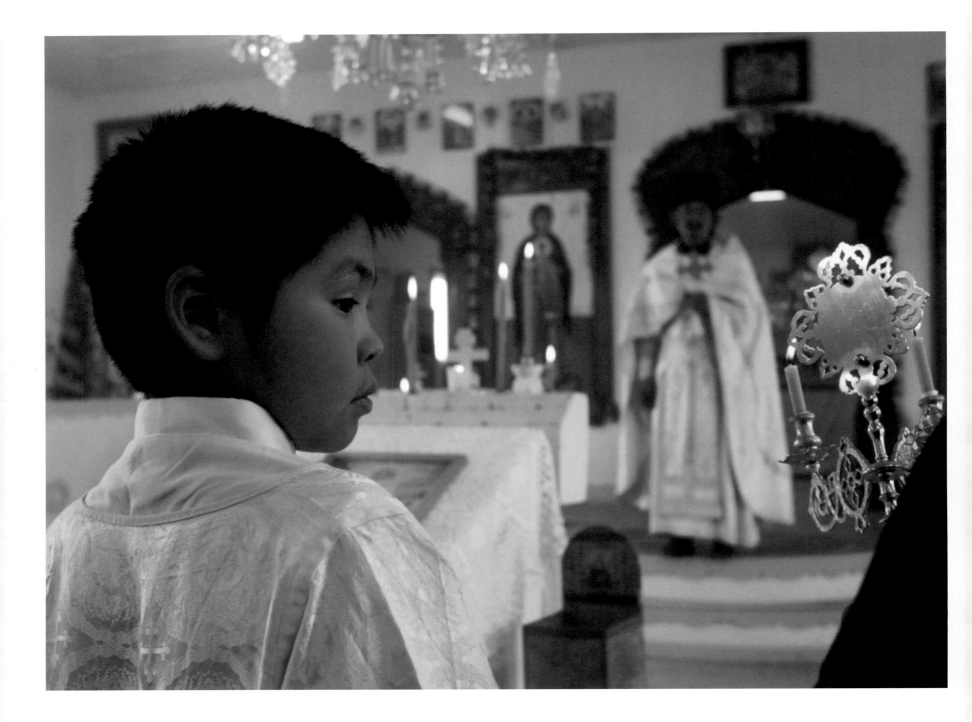

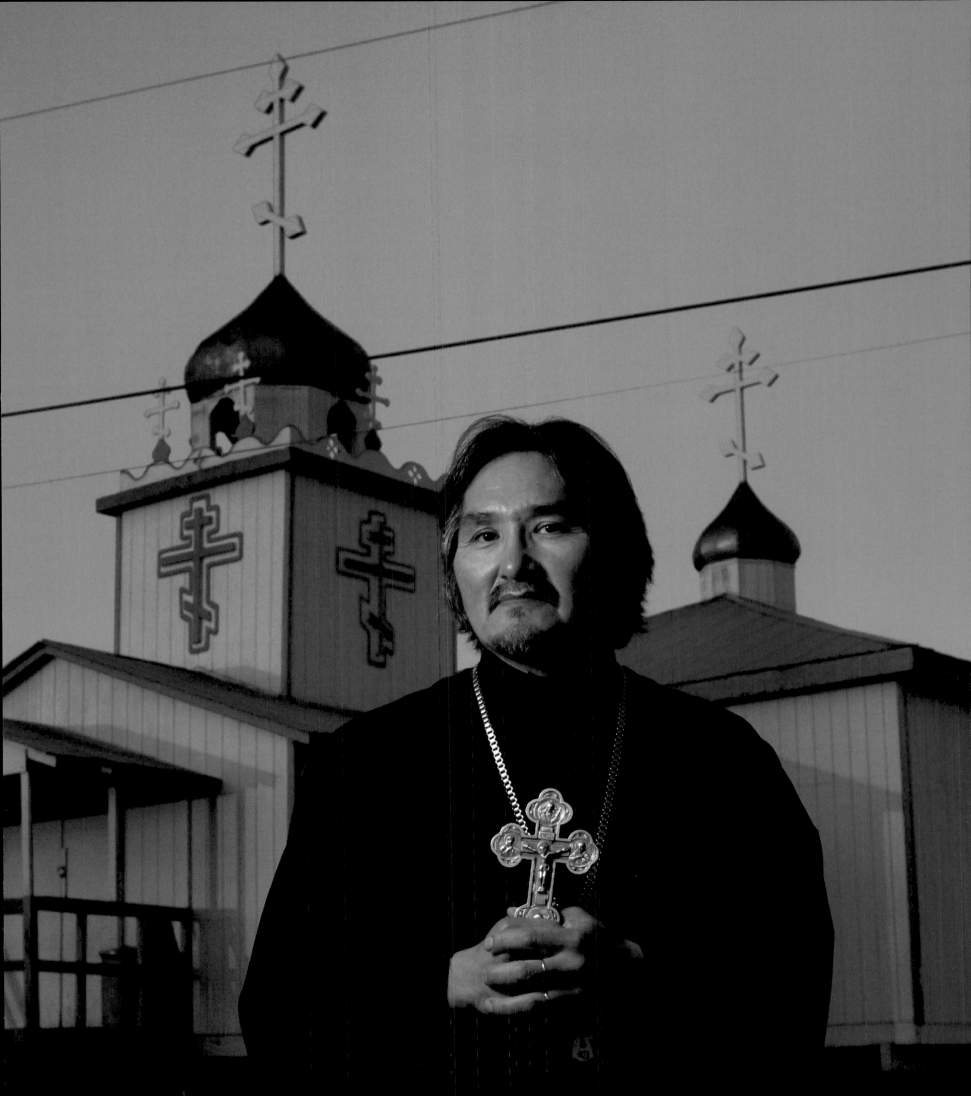

Teacher Kathy Alonzo emphasizes citizen-
ship with her second graders at Anne Wien
Elementary School. "A lot of us have come from
other places, and we learn to watch out for each
other," says Alonzo, noting that, for many people,
Alaskan towns function as families.
Photo by Charles Mason Photo, Corbis

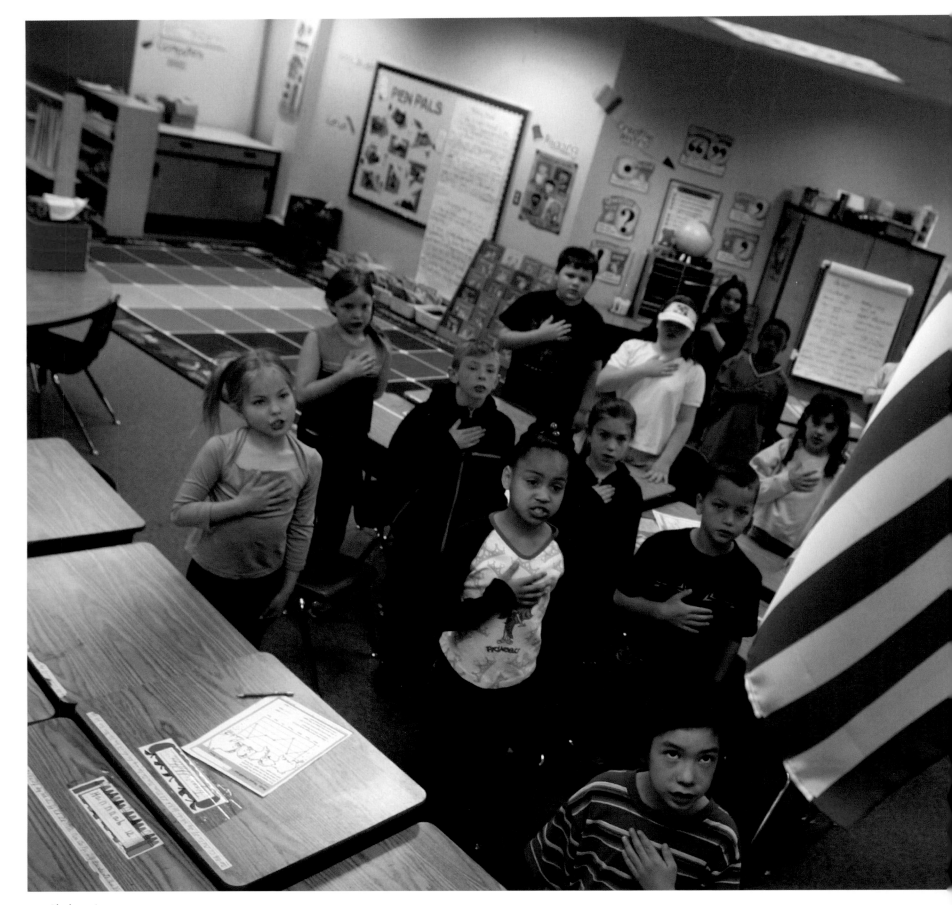

Tourist Elsa Pardo de Agiss visits a dog camp
on Norris Glacier. Several hundred Iditarod sled
dogs spend the summers in this planned canine
city—complete with igloo houses and waste
disposal service. Pardo de Agiss, a Mexico City
software manager, is looking forward to her ride
across the glacier in a dog sled.
Photo by Michael Penn

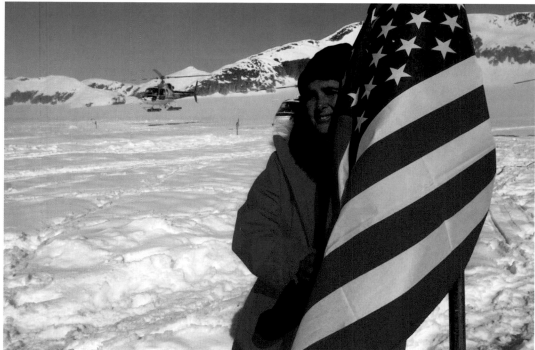

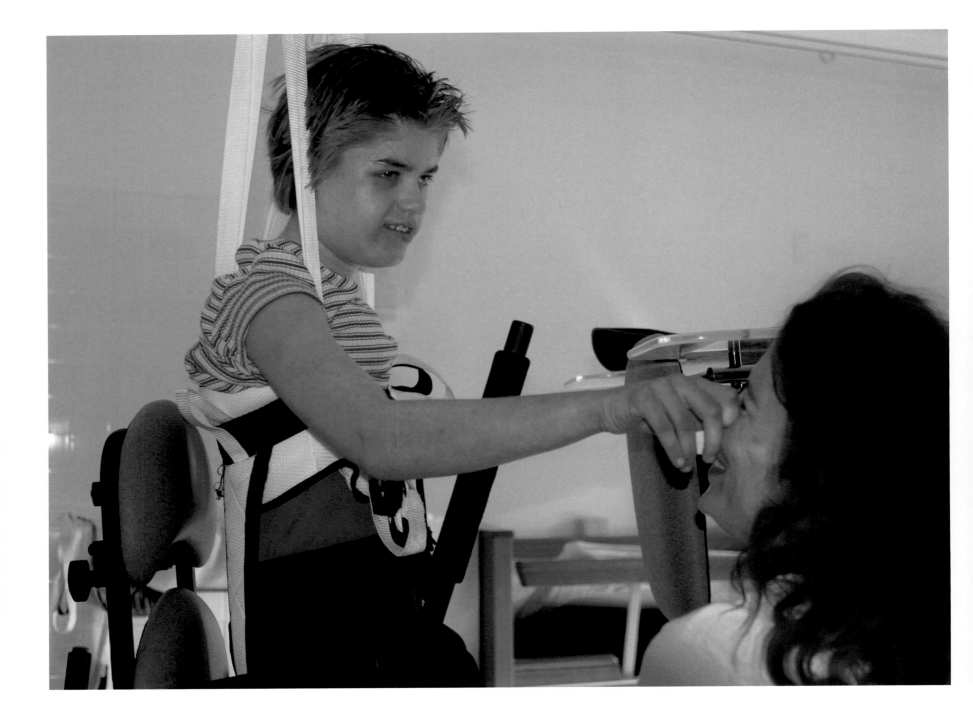

ANCHORAGE
When Hannah Schultz, 12, underwent brain surgery at age 5 to lessen her intractable seizures and instead ended up in a coma, doctors suggested her parents prepare a funeral. Thirty days later, Hannah awoke but has not walked or talked since. She communicates through clicking sounds, bear hugs, and, here exercising with mother Joan, playful snorts.
Photos by Jeff Schultz

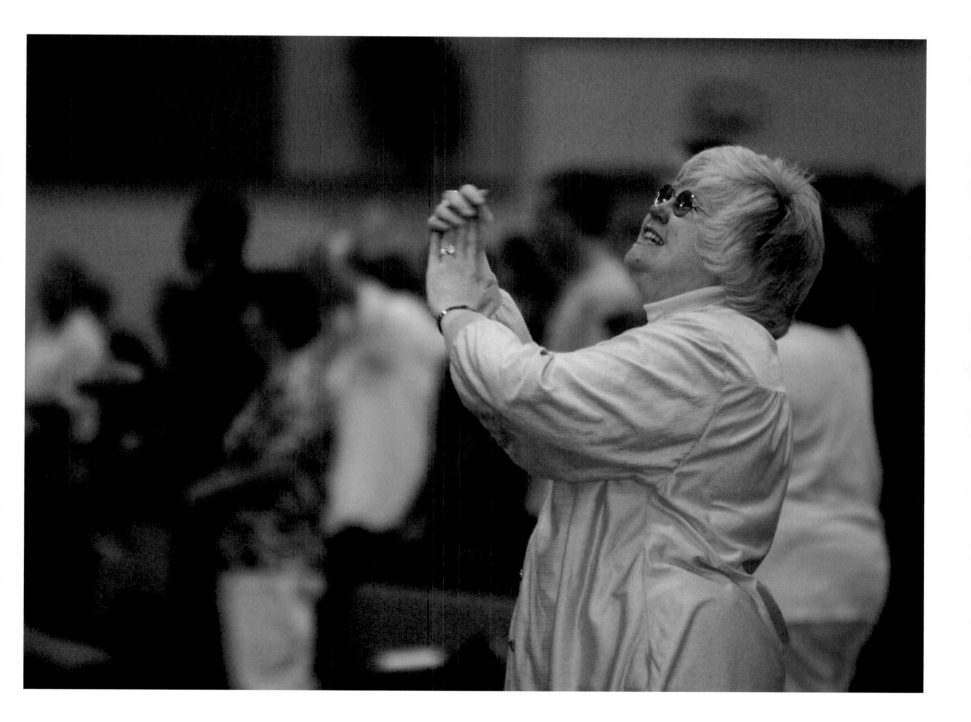

ANCHORAGE

Maggie Snow joins the evangelical congregation of Abbott Loop Community Church in what Pastor Rick Benjamin calls an aerobic style of worship. "Lots of clapping and raising of arms, but no Holy rolling on the ground," says Benjamin. He fears this would be too much for most Alaskans, about 10 percent of whom attend church.

KETCHIKAN
The Seizure Sisters' performance of "It's Raining on Prom Night" wows the crowd at the Saxman Tribal House's Monthly Grind, a variety show. Admission is $5 or a home-made dessert.
Photo by Mike Yoder,
The Lawrence Journal-World

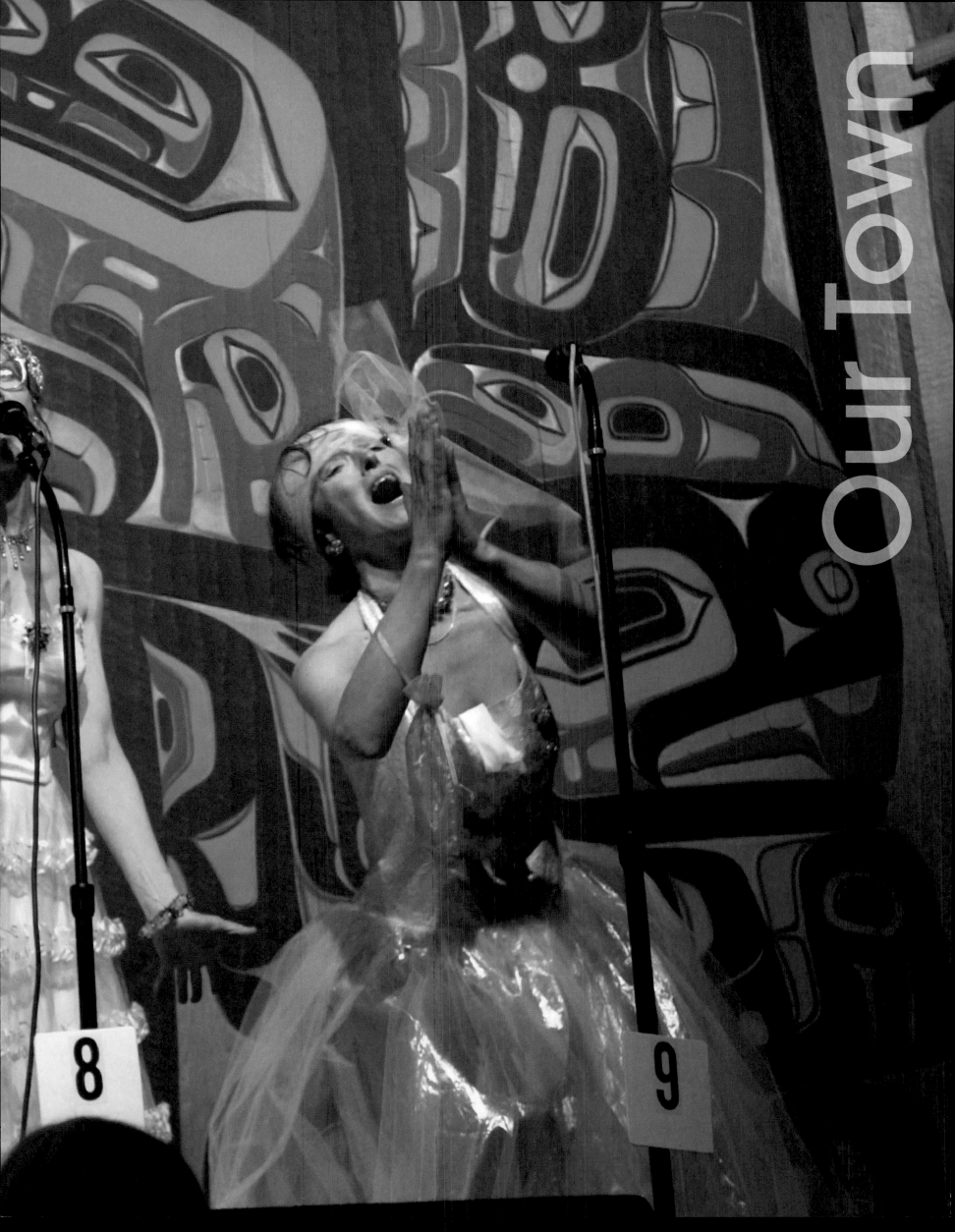

ANCHORAGE
On a flightseeing trip, pilot Kevin McCabe wings beneath the Chugach Mountains to the east and over the mirrored Atwood office building and the tri-towered Captain Cook Hotel in downtown Anchorage. With 260,000 people, Anchorage is home to 40 percent of Alaskans.
Photo by Jeff Schultz

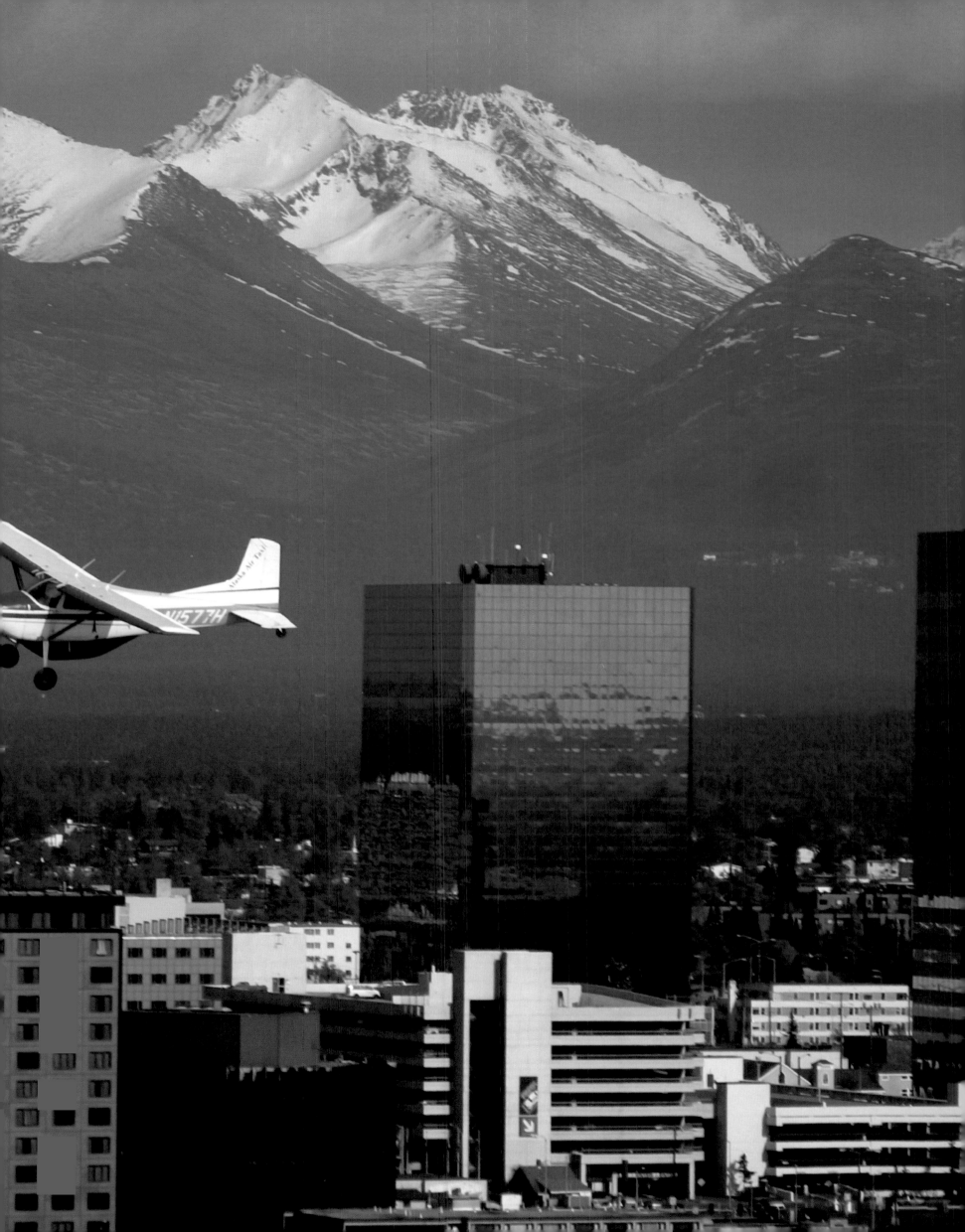

Rite of passage: Purple-gowned Arnasagaq Olick
sits, more or less patiently, amid fellow Head
Start graduates in the Yup'ik town of Kwethluk.
After the ceremony, the entire town shows
up for a potluck. Parents raise money for this
celebration all year long—and cherish the gowns
as mementos. Statewide, approximately 3,650
children are enrolled in Head Start.
Photo by Clark James Mishler

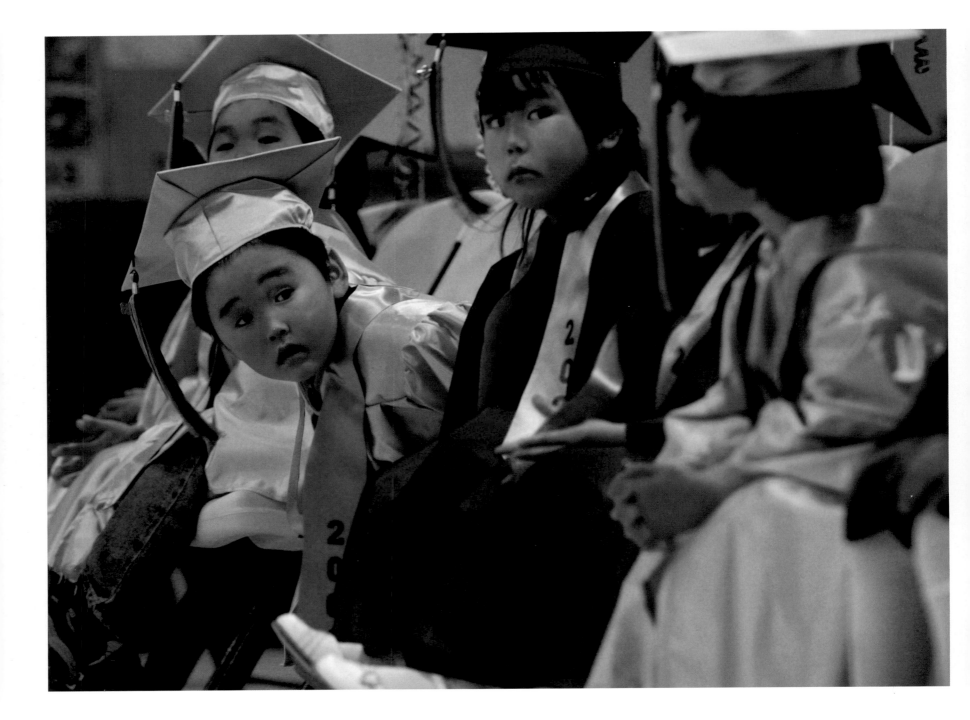

KOTZEBUE

J.R. Swanson, Iris Lie, and Hans Hansen lead the 25 students of Kotzebue's class of 2003 into the gym for graduation. Kotzebue, on the Bering Strait 26 miles north of the Arctic Circle, has approximately 3,500 residents—two fewer now that Hans and Iris are attending college in Colorado.
Photo by James Mason

ANCHORAGE

The diversity of Anchorage is evident in the kindergarten class of Williwaw Elementary School. Home to dozens of native Alaskan groups, the city is also a destination for Samoan, Tongan, and Philippine immigrants. "We don't have issues with discrimination like other areas do. Everyone's a different color here," says teacher Jacqui Gorlick.

Photos by Evan R. Steinhauser,
Anchorage Daily News

ANCHORAGE

Using visual cues to discuss sunny weather works well for educator Jacqui Gorlick, whose students speak 19 different languages. Some are bilingual, but many must learn English in school. "A number of my kids come from cultures that don't have a written language," says Gorlick, who uses storytelling and other techniques to teach them.

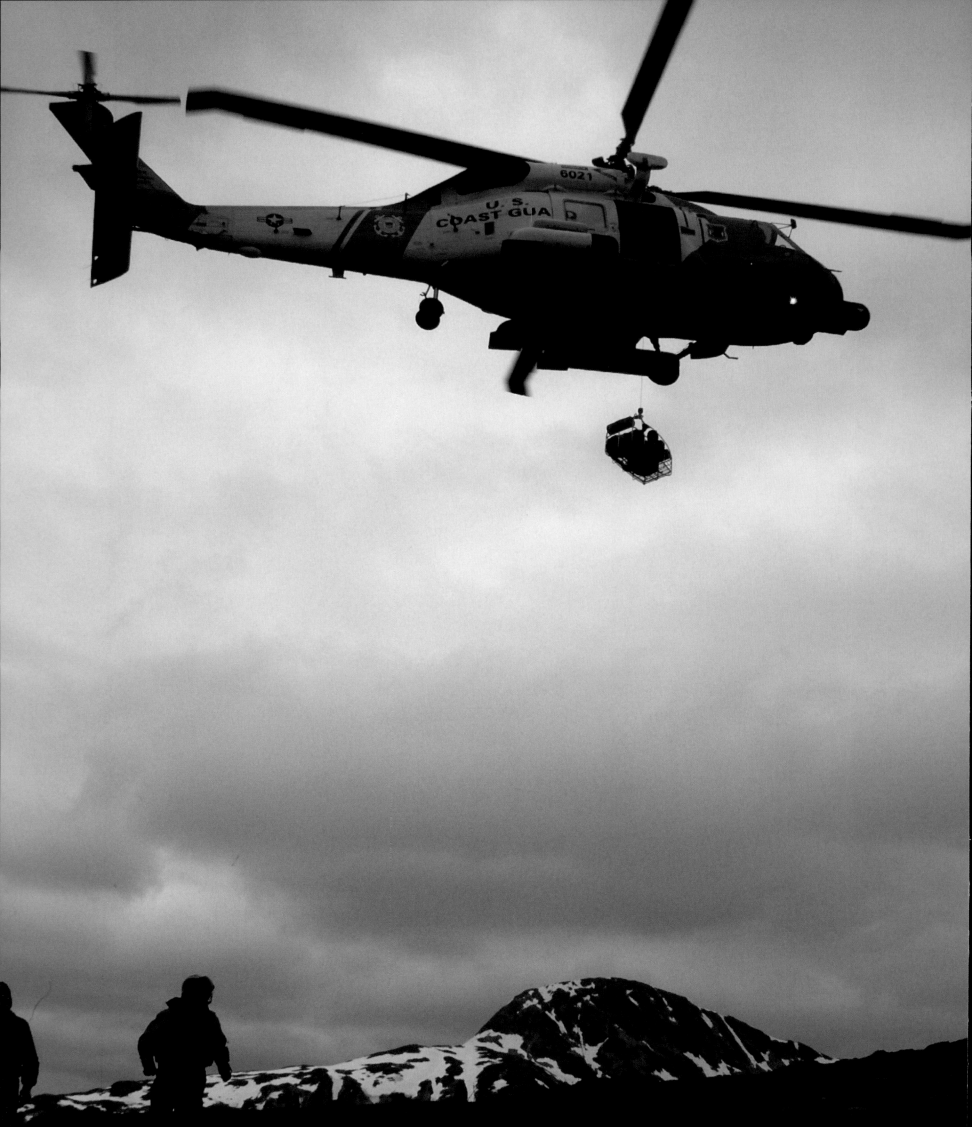

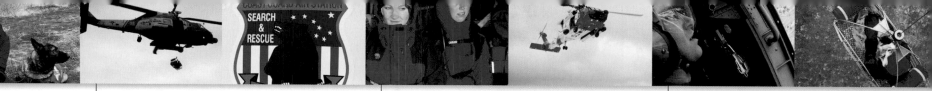

KODIAK ISLAND

The Kodiak Island Search & Rescue group trains weekly and holds major exercises four times a year, aided by the local Coast Guard command center. Because most of the terrain prohibits landing, the crew on this Jayhawk practices hovering and hoisting a volunteer and her rescue dog.

Photos by Mark Farmer, topcover.com

KODIAK ISLAND

Tricia Logan and Annette Ecret train to become certified Search & Rescue handlers with their dogs Cayenne and Nicholae. Like most SAR dogs, both are "air scent" trained. When landing in remote areas, they can pick up a human scent up to a quarter mile away.

KODIAK ISLAND

Petty Officer Jeff Breidenbach often accompanies the Search & Rescue team on practice runs. The SAR crew holds Avalanche Awareness classes and distributes radio transceivers, called "peeps," to backcountry hikers and skiers.

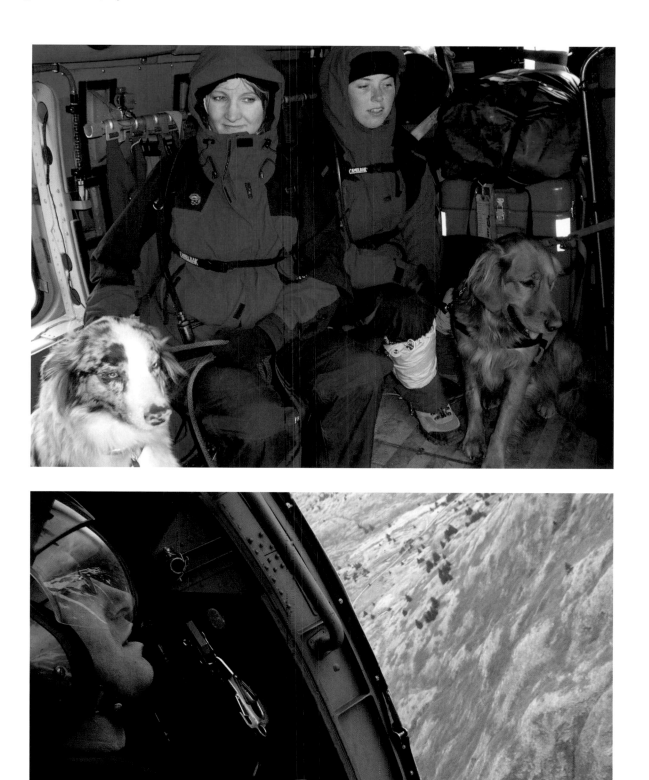

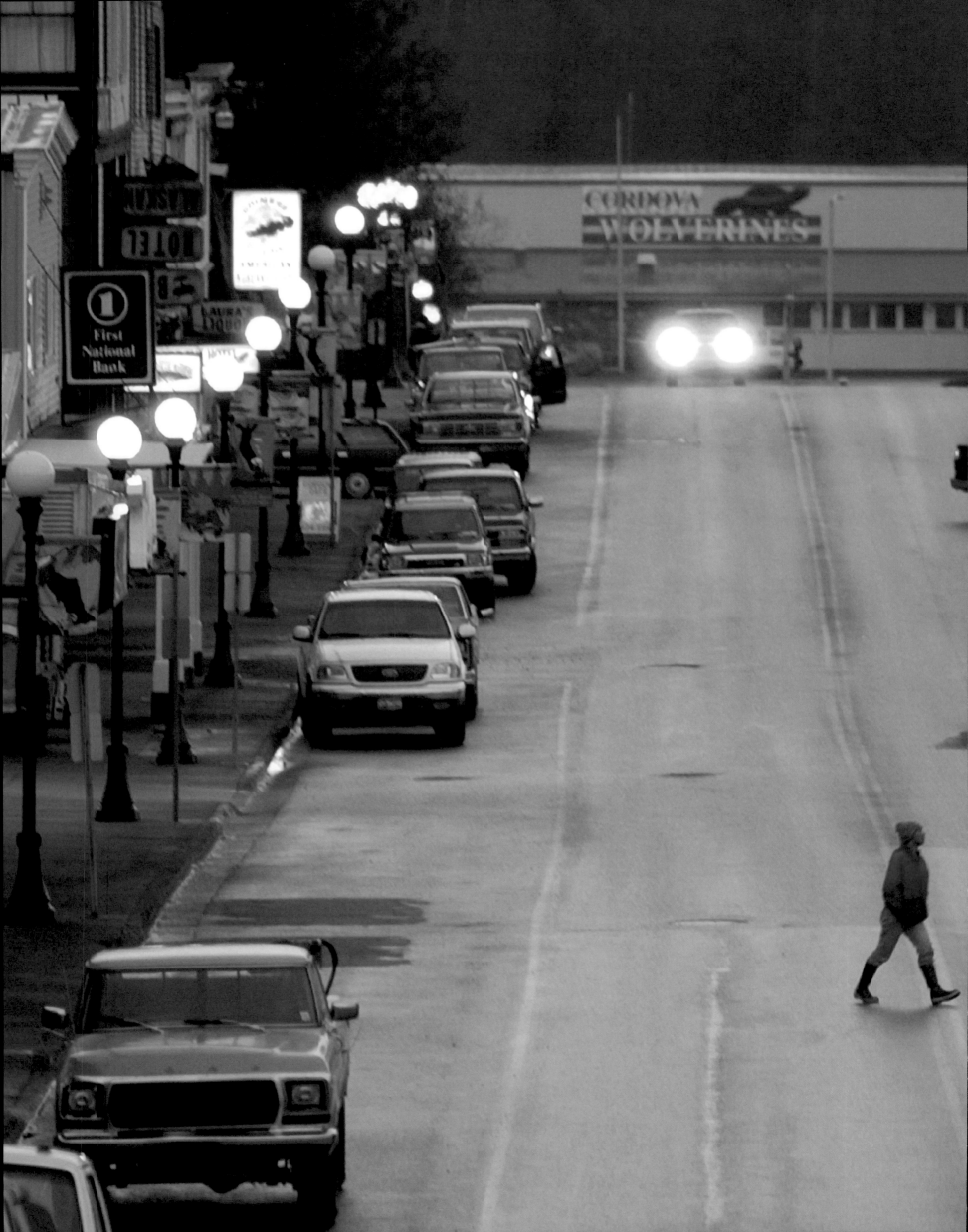

WELLS FARGO

WELLS FARGO ATM

43°

CORDOVA
Outrageous fortune: Founded in 1906, the town of Cordova has been ruled in turn by the copper industry, the oil industry, and the commercial fishing industry, all of which have been fickle masters. Devastated by fires in 1963 and 1968, the downtown has been rebuilt twice.
Photo by Marc Lester, Anchorage Daily News

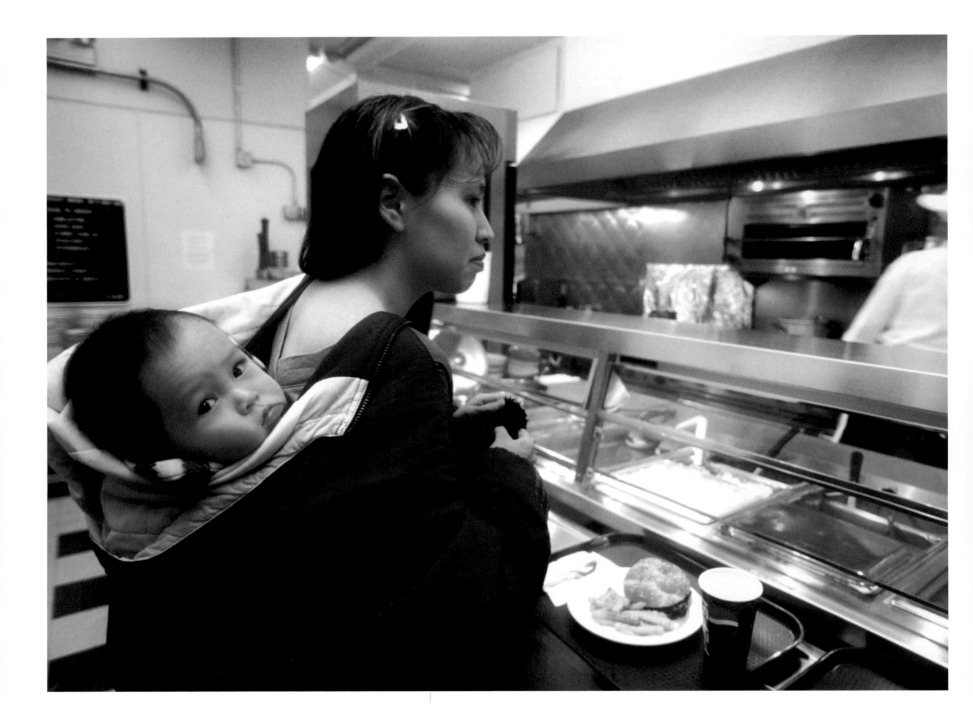

BARROW

The only way to travel: Michelle Weyiouanna carries son Esau, 11 months, in traditional Inupiaq style. A scarf under his legs keeps him from falling out of her jacket. Mother and child are at the Ilisagvik College cafeteria to have lunch with dad, a development officer at the college.
Photo by Luciana Whitaker

TALKEETNA

Like a taxicab on rails, the Hurricane Turn flag-stop train picks up and drops off passengers wherever they want along a 55-mile stretch of roadless wilderness between Talkeetna and Hurricane Gulch. The last of its kind, the train is a way of life for backcountry homesteaders like Sassan Mossanen who jumped off at mile 241.
Photo by Stephen Nowers, Anchorage Daily News

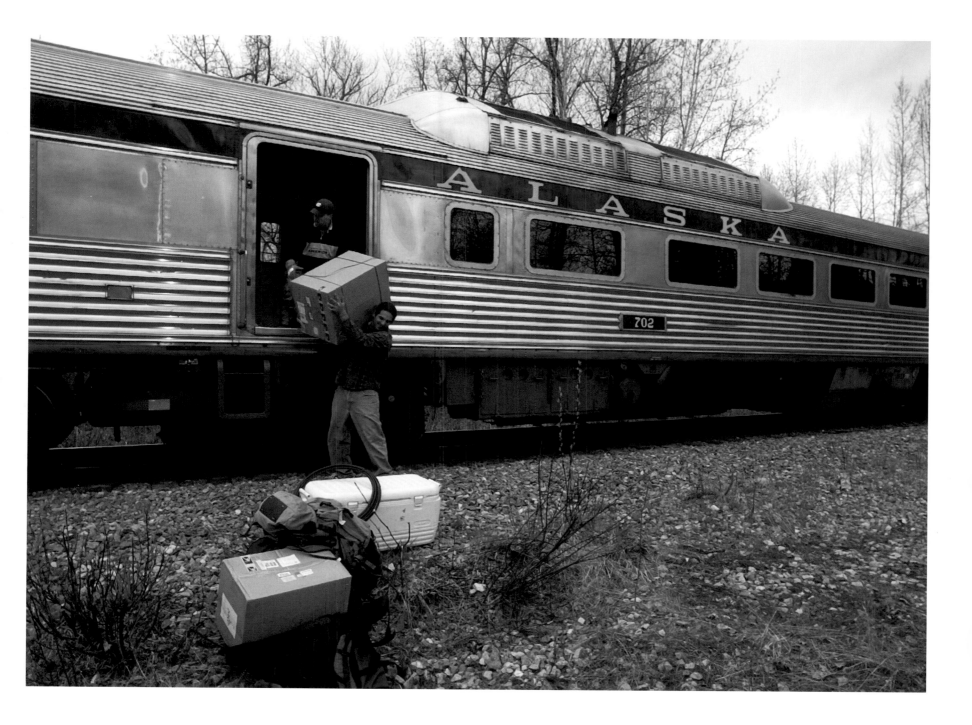

Insulated cold-weather gloves are a fisherman's best friend in staving off open water windchill. In the afternoon sun, microfiber fleece linings dry quickly on the clothesline.
Photo by Jim Lavrakas, Anchorage Daily News

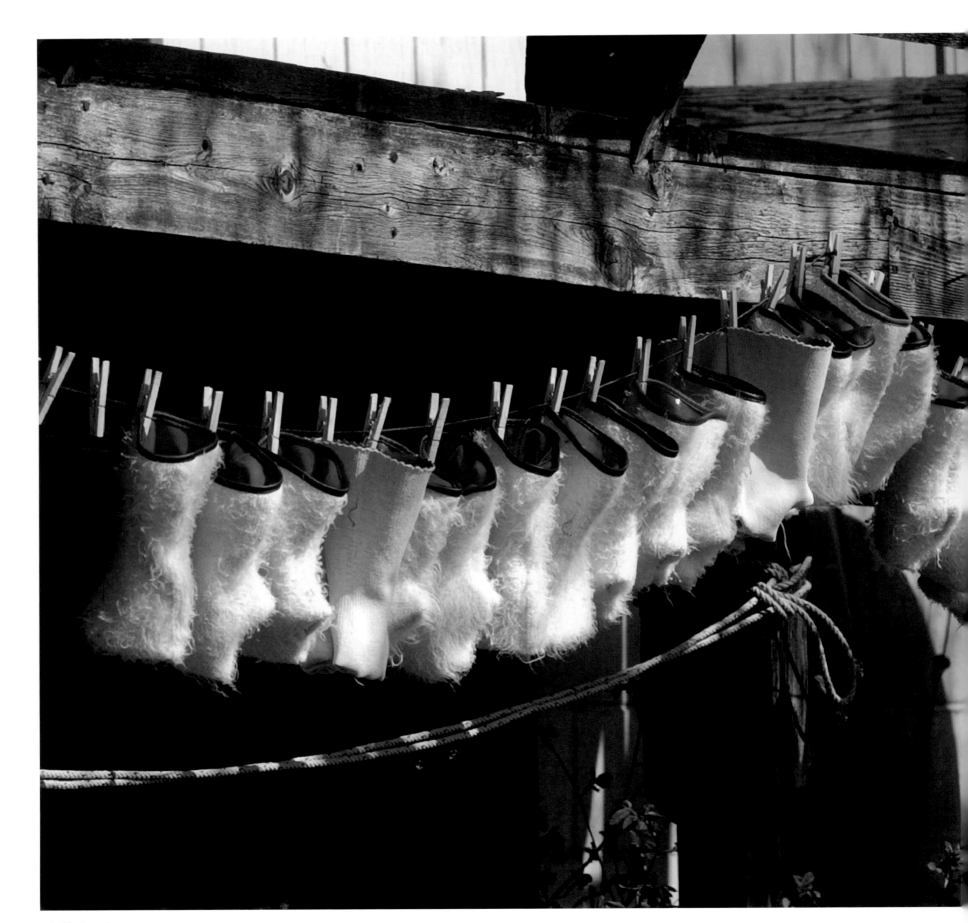

SELDOVIA
Mind your manners! Once Seldovia acquires sidewalks and a health department, coffee house and gift gallery The Buzz will be able to enforce its signage.
Photo by Jim Lavrakas, Anchorage Daily News

TALKEETNA
A four-holer haven sitting on Talkeetna Road features a fishy in-joke. Dollys refer to Dolly Vardens, part of the char family of fish, while chums are an abundant variety of salmon.
Photo by Anne Raup, Anchorage Daily News

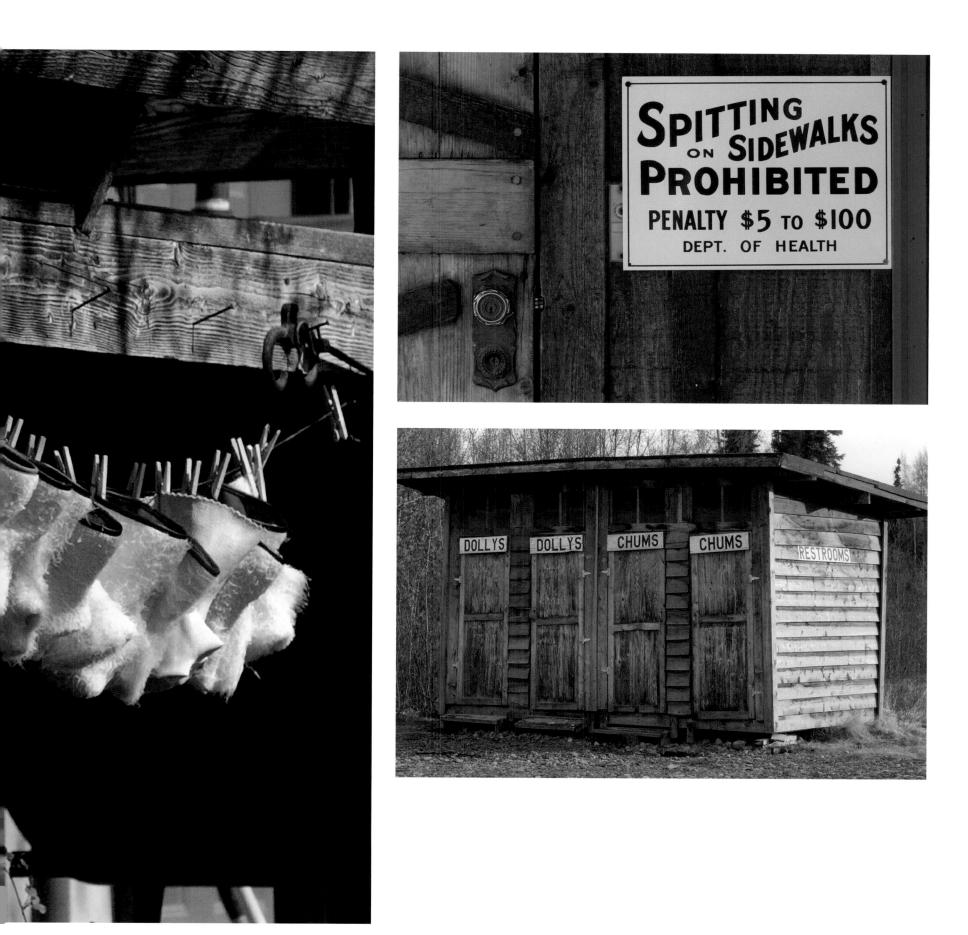

ANAKTUVUK PASS

James and Anna Nageak play snertz, a fast-paced group version of solitaire, with Rachel Riley and Doris Hugo. A village of 360 in the Brooks Range, Anaktuvuk Pass is two hours by plane from Fairbanks, where James taught for eight years at the University of Alaska. Does he miss the city? "You can't get sushi here," he says.

Photo by James H. Barker

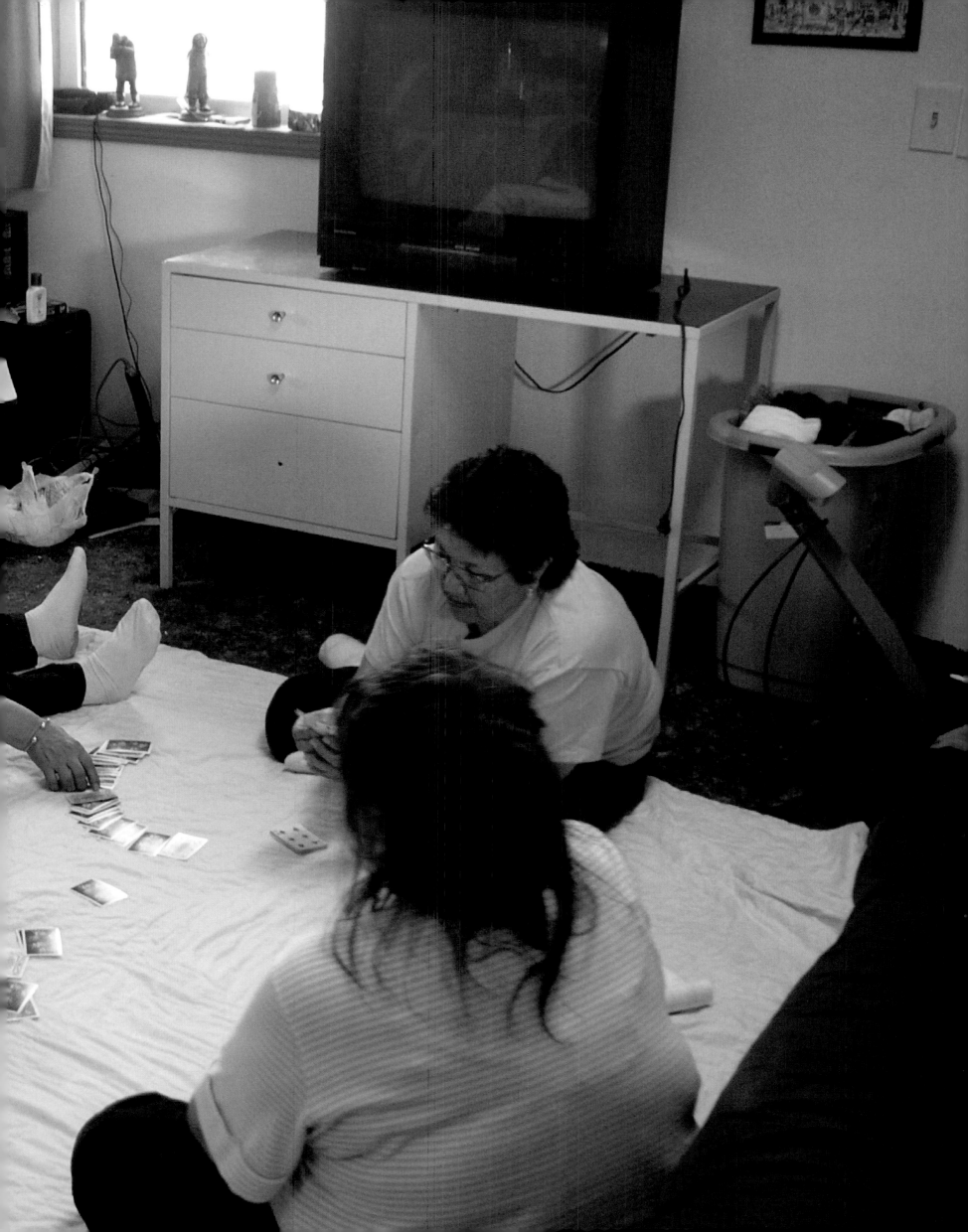

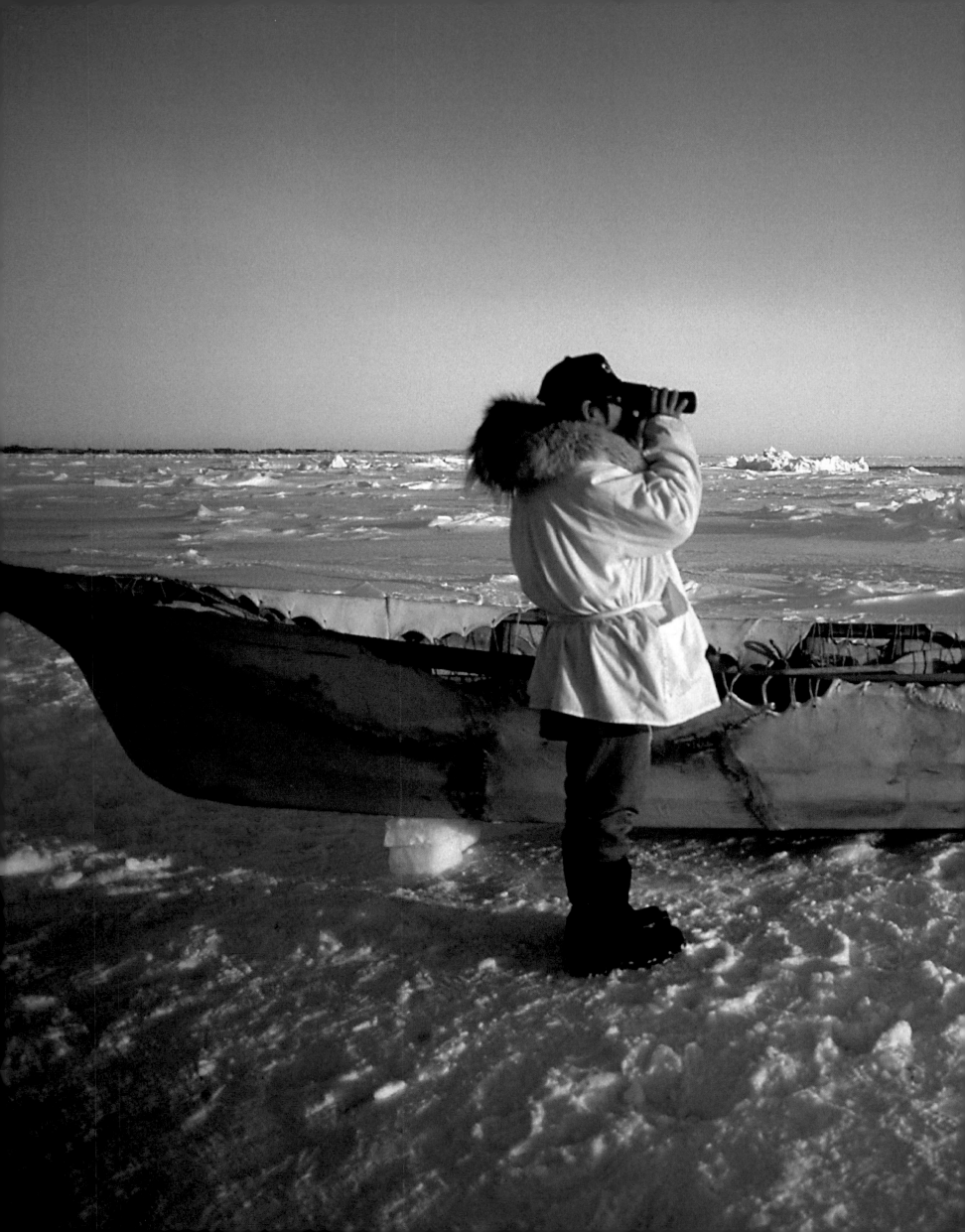

BARROW

The hunt: *Umialik* (whaling captain) Charles Hopson spots blows from shorefast ice on the Chukchi Sea. Once a bowhead whale is sighted, Hopson and his six-man crew paddle their 28-foot, seal-skin umiaq out for the kill—as their Inupiat ancestors did for centuries during the spring whaling season. "Without the hunt," says Captain Hopson, "we would cease to exist."

Photo by Luciana Whitaker

BARROW

Inch by inch, a bowhead whale is dragged onto the ice by ropes and pulleys—and horsepower from the Inupiat community. The Inupiat are allowed 22 whales a year in subsistence hunts; the bowhead population has increased 41 percent since it was first protected in 1937.

Photos by Luciana Whitaker

BARROW

The Inupiat slice muktuk from a 35-foot whale using a long-handled blade called a *fugaun* and a hook called a *niksik*. It takes about four and a half hours—and all the Inupiat in Barrow—to butcher a whale this size.

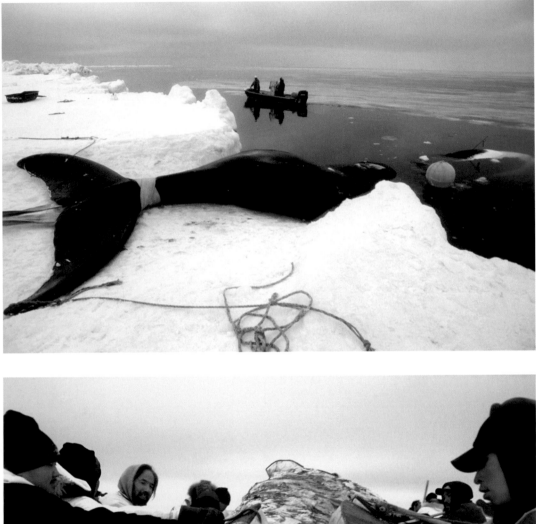

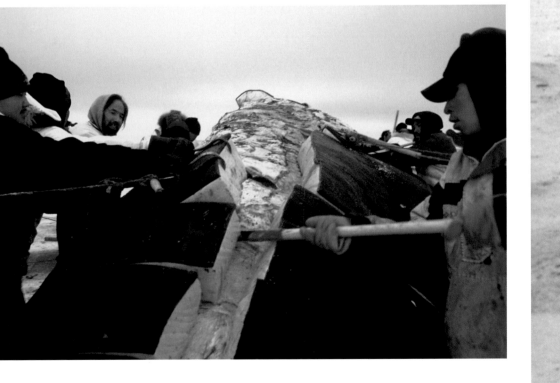

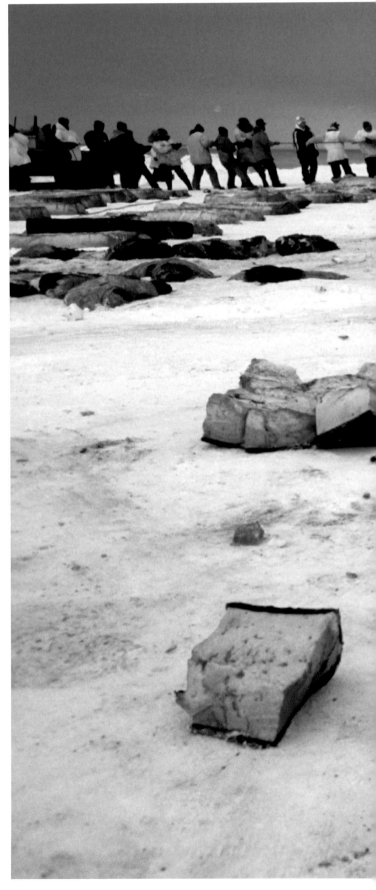

BARROW

The spoils: Footlong chunks of muktuk await
distribution. Everyone who helps Captain Edward
Itta with the whale gets a share; more for the
crew, less for the haulers and cutters. Nothing
is wasted. The ribs are pulled apart to get at the
meat, and Inupiat artists carve figurines from
rib bones.

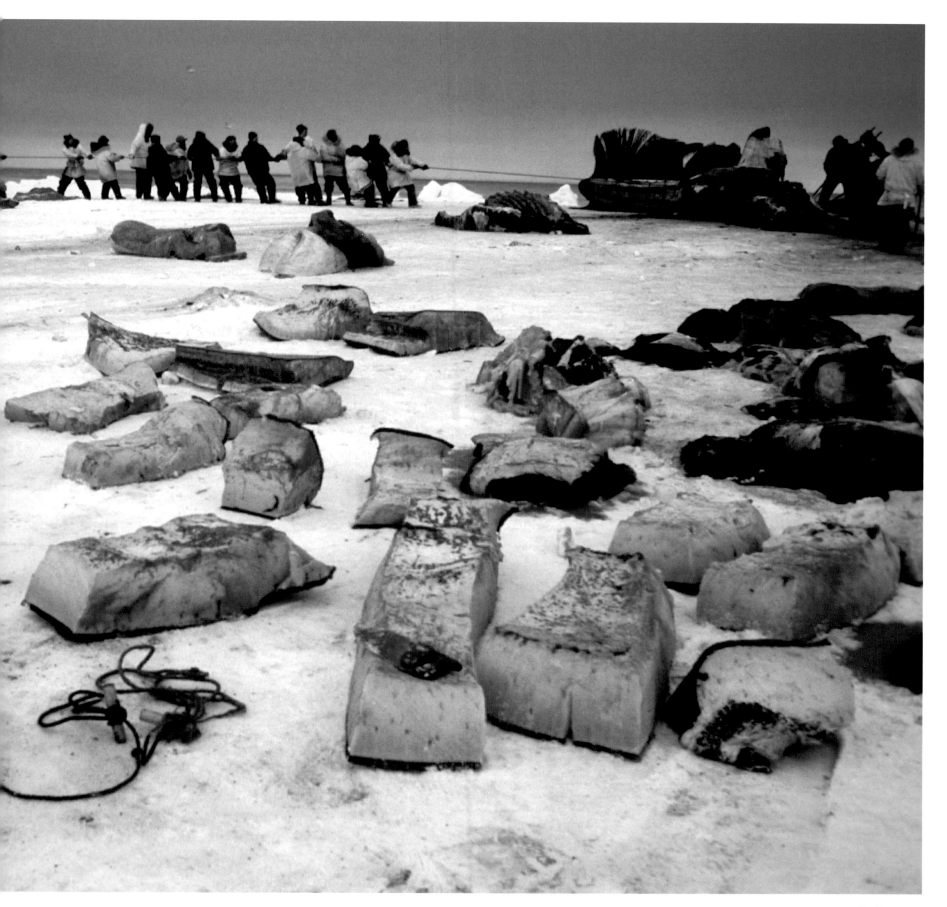

The feast: Denise Varner stirs a pot of muktuk in Captain Edward Itta's garage. Meat, flipper, intestine, heart, and kidney—everything is cooked and served within 24 hours of the kill.
Photos by Luciana Whitaker

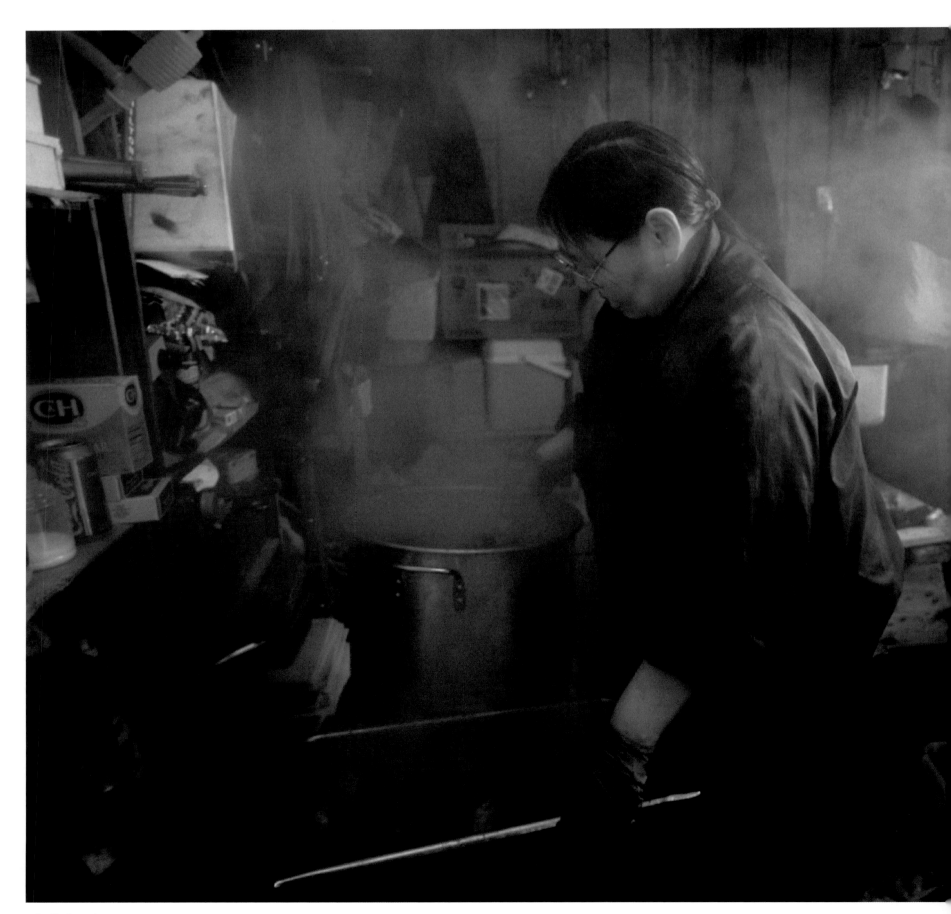

BARROW

Deep freeze, Inupiat style: After the feast, Price Itta stores raw leftovers in a traditional ice cellar dug by hand 25 feet into the permafrost. Most of this meat and muktuk will be served later at Nalukatak, the festival that marks the end of the spring whaling season.

BARROW

Before the feast, Captain Edward Itta's family members raise their hands in *kuyanak* (thanks) that his crew was blessed with a whale.

ANCHORAGE
In a world of white, color is cultivated. Operations manager Linda English tends to some of the 85,000 annuals at the Anchorage Municipal Greenhouse. The city uses the blooms to brighten its buildings and parks in flower baskets hung from streetlamps and in the spectacular L Street hillside flower mosaic.
Photo by Fran Durner, Anchorage Daily News

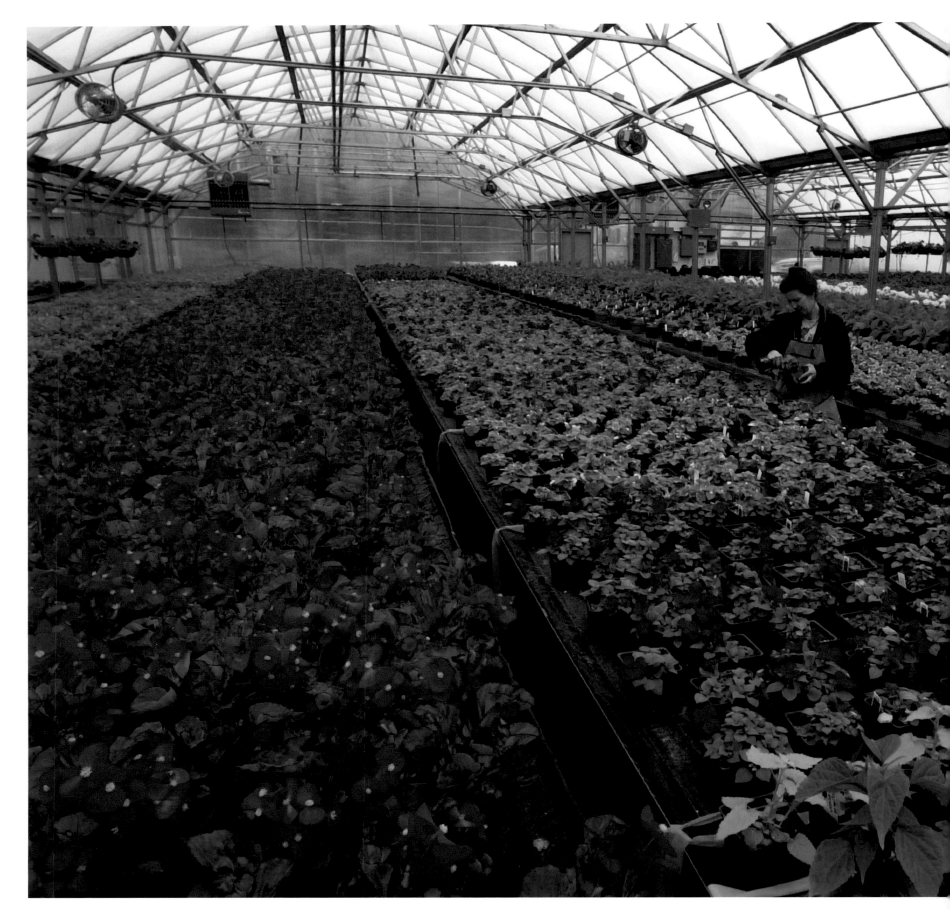

FAIRBANKS

Each spring, hordes of people descend on the Georgeson Botanical Gardens' annual plant sale at the University of Alaska Fairbanks. Zechariah Hobbs buys peppers, eggplants, and every available type of tomato for his garden.
Photo by Charles Shepherd

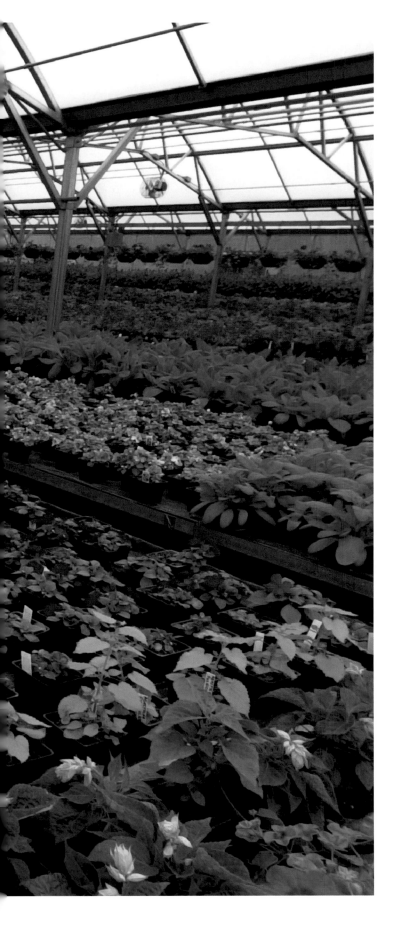

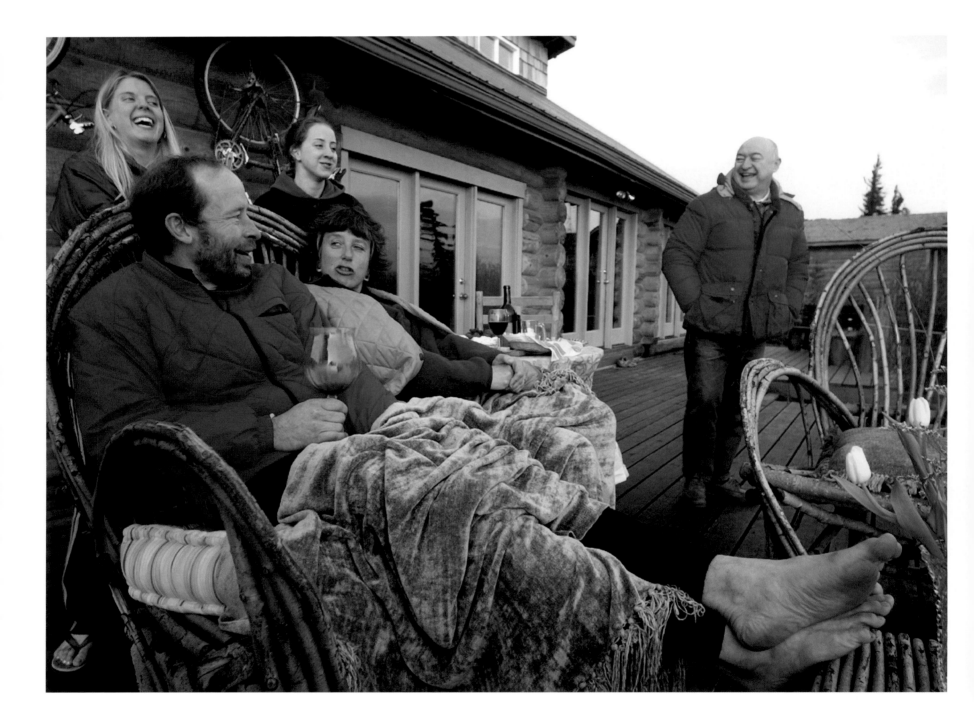

ANCHORAGE

Traffic jams in Minnesota led Craig Medred (barefoot) to escape to Alaska in 1973. His custom-built home in Anchorage's hillside section has views of Cook Inlet and four mountain ranges. Despite down jackets in May and winds so strong they strip the paint off the window frames, the newspaper editor says he wouldn't live anyplace else.
Photo by Richard J. Murphy,
Anchorage Daily News

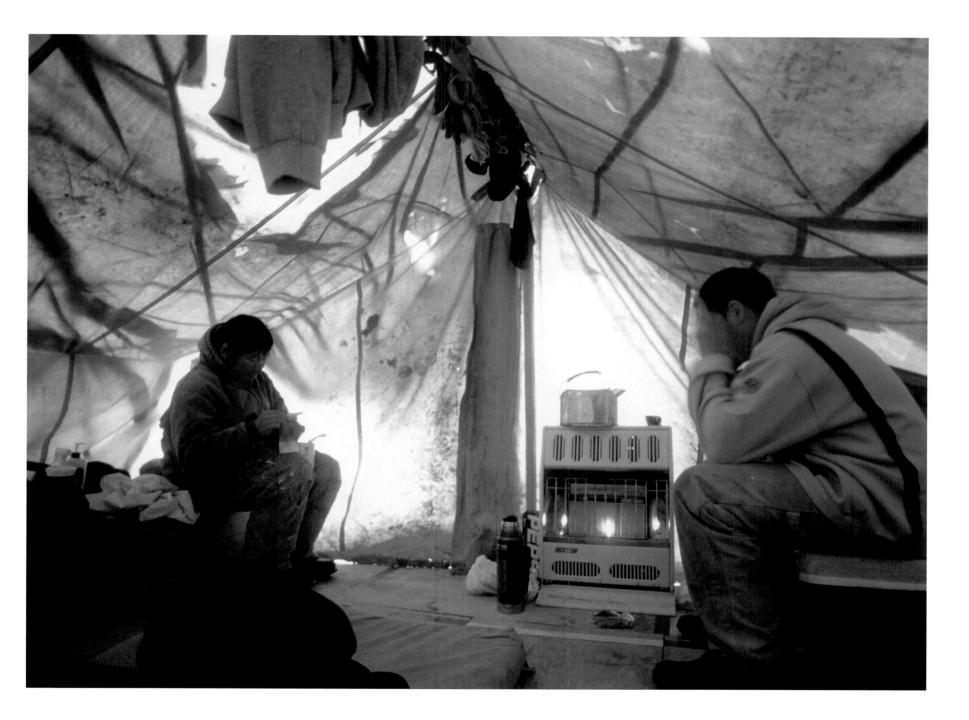

BARROW

It's May 13, 12:05 a.m.—the sun has been up for three days and will not set until August 2. Stacey Hopson and his cousin Perry, members of the *Hopson 1* whaling crew, wake for their 12-hour shift spotting whales and monitoring changing ice conditions. Crews live on the ice for up to a month when whales are running.
Photo by Luciana Whitaker

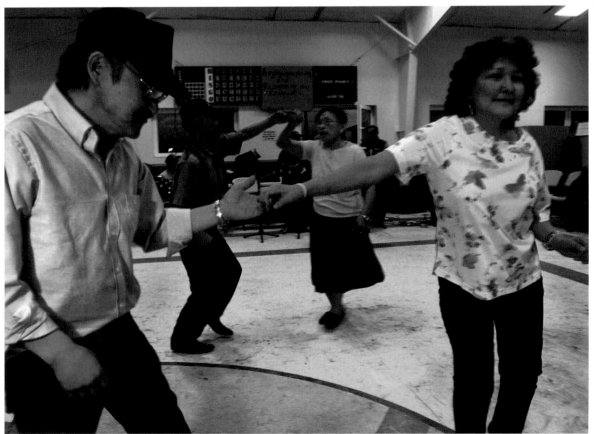
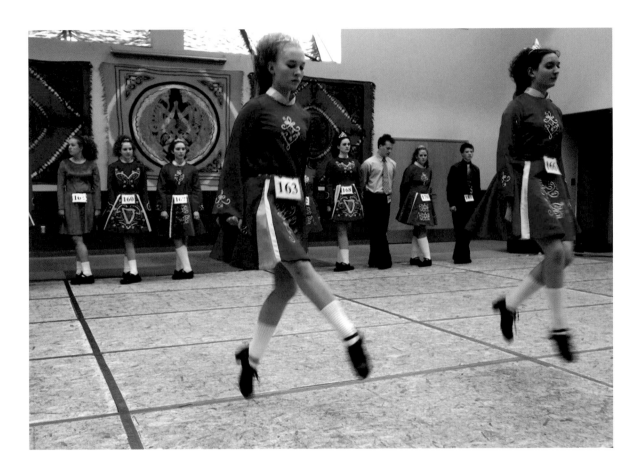

ANCHORAGE

Catching air: At An Tri'u Feis, an Irish dance competition, Claire Hopkin, 14, of Eagle River and Katie Torpy, 15, of Anchorage dance an Irish reel and a treble jig, respectively. According to Katie, dancers avoid looking at each other during solos. "Otherwise," she says, "you start to do the other's steps."

Photo by Marc Lester, Anchorage Daily News

KWETHLUK

A country-western fiddle dance draws out-of-towners like Margaret Ayapan from Bethel, who keeps the rhythm going with Moses Anvil, Jr., from Napaskiak. Ayapan's husband accompanied her that evening, but he doesn't dance.

Photo by Clark James Mishler

ANCHORAGE

Luke Topkok, 14, performs sequences of a raven dance passed down through generations of Inupiat from the whaling village of Kingikmuit. Luke and the Kingikmuit Dancers of Anchorage are trying to revive their culture by interpreting their lives through traditional lenses. "We need Inupiaq songs about waiting for a paycheck or sitting in traffic," explains troup founder Tungwenuk Nothstine.

Photo by Bill Roth, Anchorage Daily News

ANCHORAGE

Got my mojo working: Donald Hill, born and raised in Anchorage, fronts Joey Fender's Rebel Blues band on stage at Blues Central.

Photo by Marc Lester, Anchorage Daily News

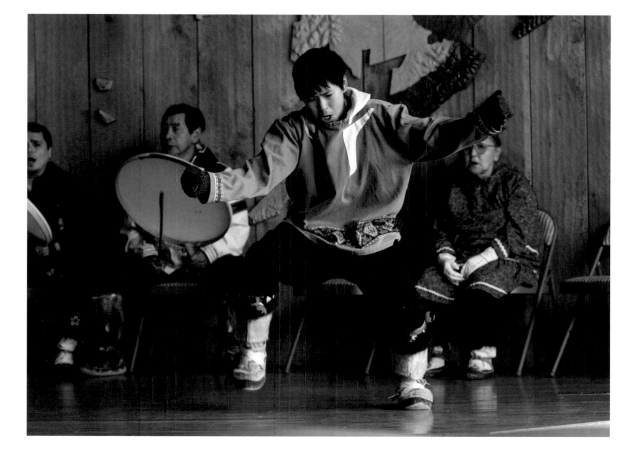

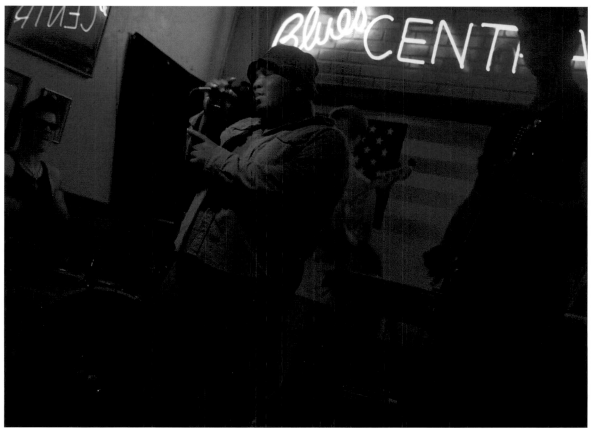

How many friends does it take to get ready for
a prom? One to do hair and two to hang out.
A.J. Dimond High School senior Zoe Durner-Feiler
(front left) was elected to the Prom Court, an
honor that goes to those with the highest grade
point average. The only disinterested party:
the dog.
Photo by Fran Durner, Anchorage Daily News

KWETHLUK

Big night, small town. The only boy to graduate in 2003, Thaddeus Yohak-Fisher had no competition when he was elected prom king at Ket'acik & Aapalluk Memorial School. Prom queen Pamela Jackson was one of four senior girls. And there weren't a whole lot more students at the prom itself. Detentions for tardiness prohibited a number from attending.
Photo by Clark James Mishler

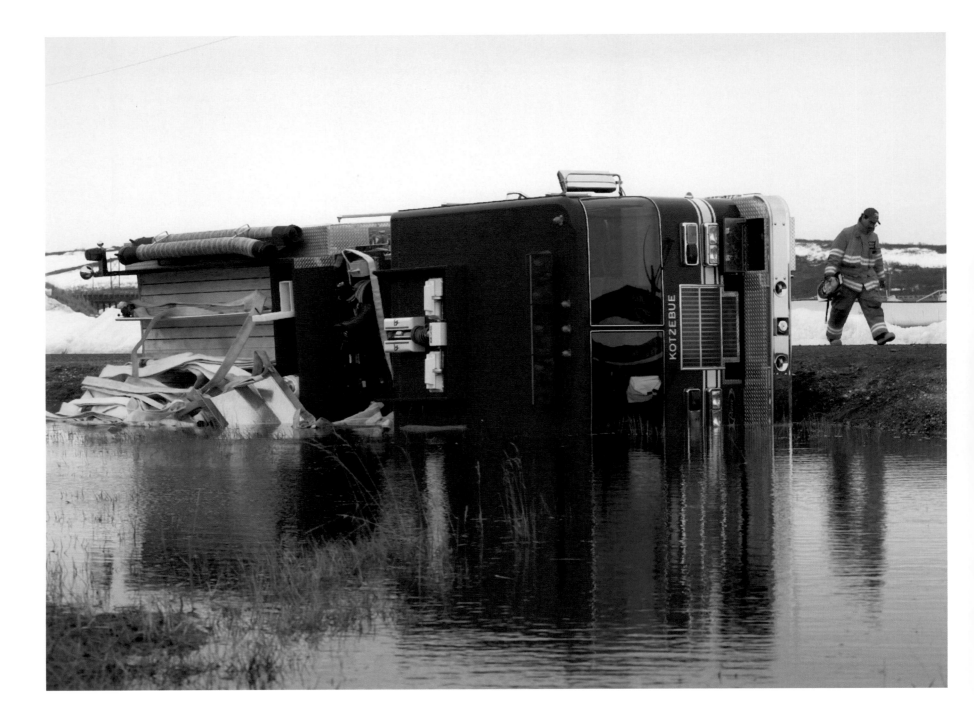

KOTZEBUE

On its way home from a call, Engine 7 slipped off a rain-softened causeway and into the lagoon. The crew was unhurt, and Engine 7 was back on the job within 24 hours. Just 18 months earlier, the $248,000 rig was driven from the factory in Wisconsin to Seattle, and then barged 3,000 miles to Kotzebue to replace the town's 30-year-old clunker.
Photo by James Mason

KWETHLUK

Fishermen work together on a welcome seasonal challenge: freeing a fishing boat from its winter nest to launch it into the defrosted spring.
Photo by Clark James Mishler

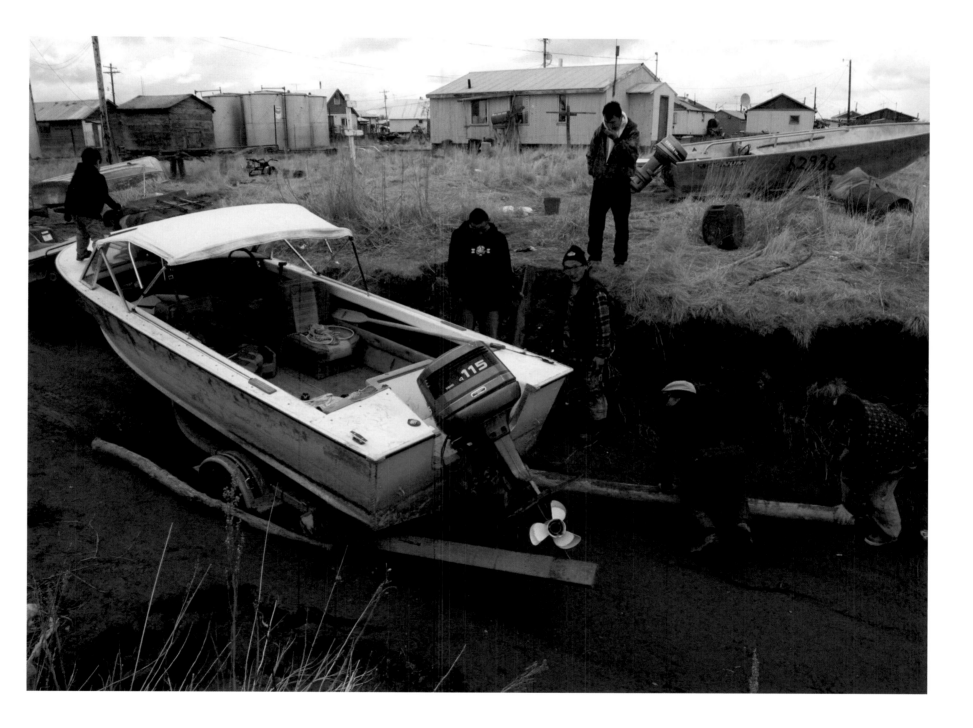

ANCHORAGE

Hunter 1, bear 0: Knight's Taxidermy delivers a stuffed grizzly on Arctic Boulevard. Russell Knight says he handles around 300 bearskins a year. Most of them become rugs. About 25 get the full treatment, at a cost of $5,000. Customers want the "shock power" of a standing eight-footer, Knight says. "They want to be praised for their kill."

Photo by Robert Stapleton, Jr.

JUNEAU

Hiker Iris Korhonen found claw marks on nearly every tree in this alder grove near Peterson Creek. Naturalists believe bear sows send their young up the slender saplings while they do errands to protect them from male adult bears, the primary predators of cubs.

Photo by Michael Penn

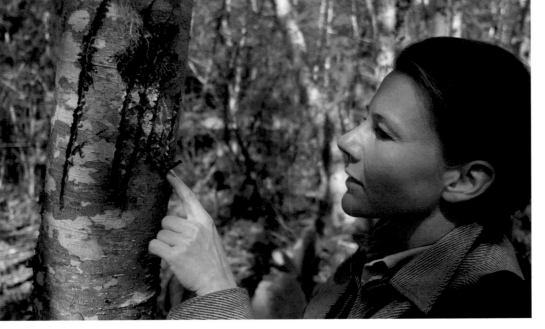

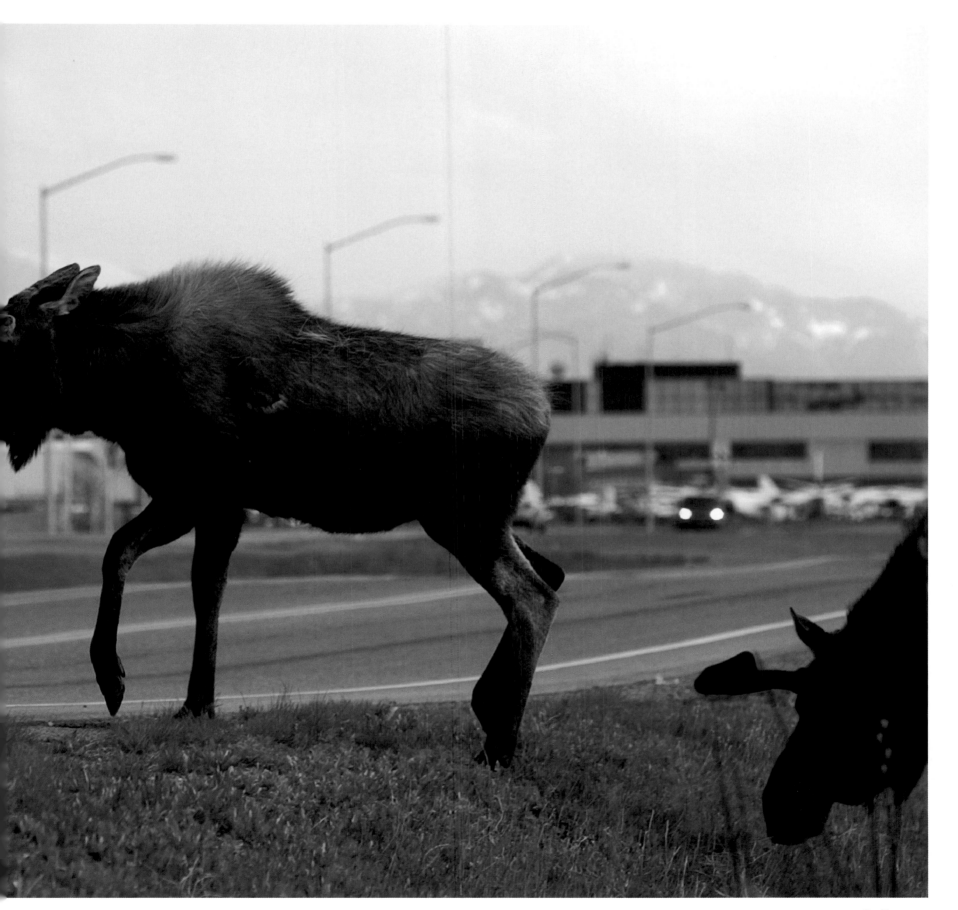

ANCHORAGE

How does a moose get to the other side of the road? Any way it wants. Cloven traffic is so common (some 800 moose live in greater Anchorage alone), drivers simply stop and wait. They also know to factor in extra time to get to the airport, and to beware of any moose with its ears back. This big bull is not happy.

Photo by Bill Roth, Anchorage Daily News

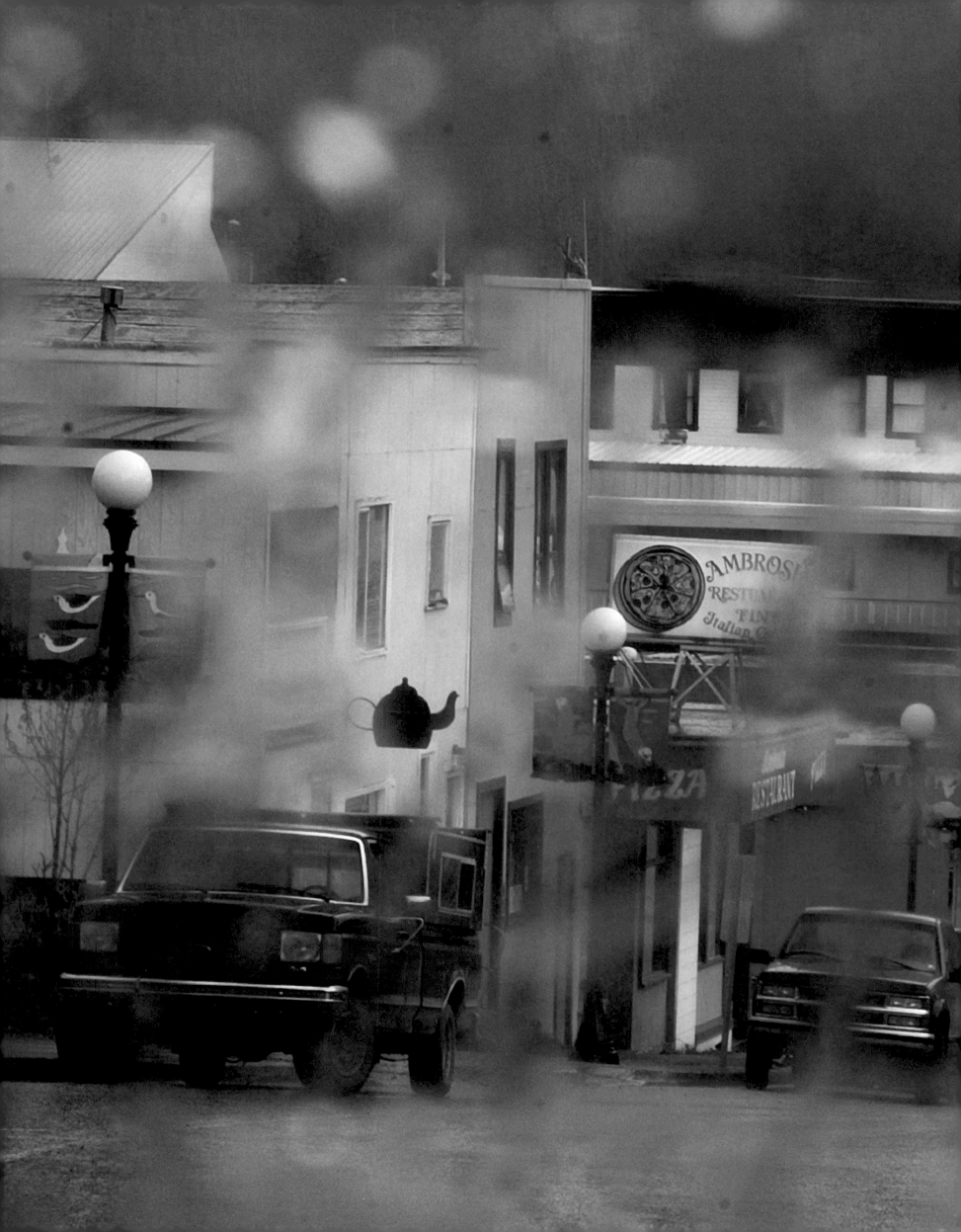

CORDOVA
On the Gulf of Alaska's northern edge, the town holds the state's record for rainfall in a 24-hour period: 14.13 inches on December 29, 1955. Hemmed in by mountains to the north and east, the broad gulf and its warm ocean currents spawn a near-constant barrage of wet and wooly North Pacific storms.
Photo by Marc Lester, Anchorage Daily News

KNIK GLACIER
The rusticated surface of Knik Glacier camouflages pilot Gary Landes's low-flying Piper PA-12. The Landes family operates the Anchorage-based Airglas Engineering Co., the world's largest manufacturer of airplane and helicopter skis, essential for landing on snow and ice.
Photo by Bill Roth, Anchorage Daily News

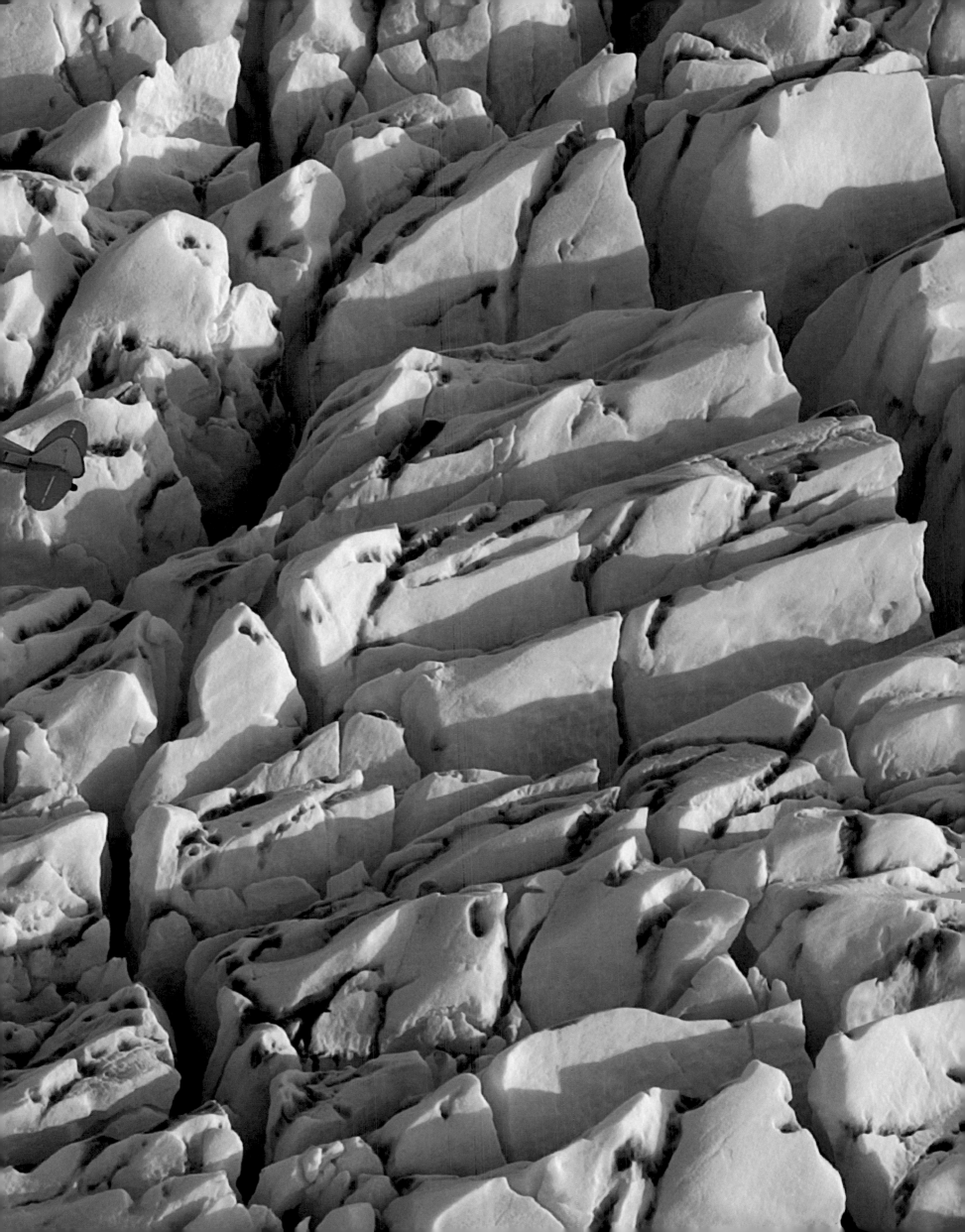

CORDOVA

Commercial fishing can be a lonely business. The Alaska Fishermen's Camp, once a cannery, offers respite for fishermen from the solitary hours spent on their one-man boats. Here, fishermen can grab a hot shower, catch some shut-eye in the bunkhouse, and do their laundry. Evenings are spent playing pinochle, mending nets, and swapping stories.
Photo by Marc Lester, Anchorage Daily News

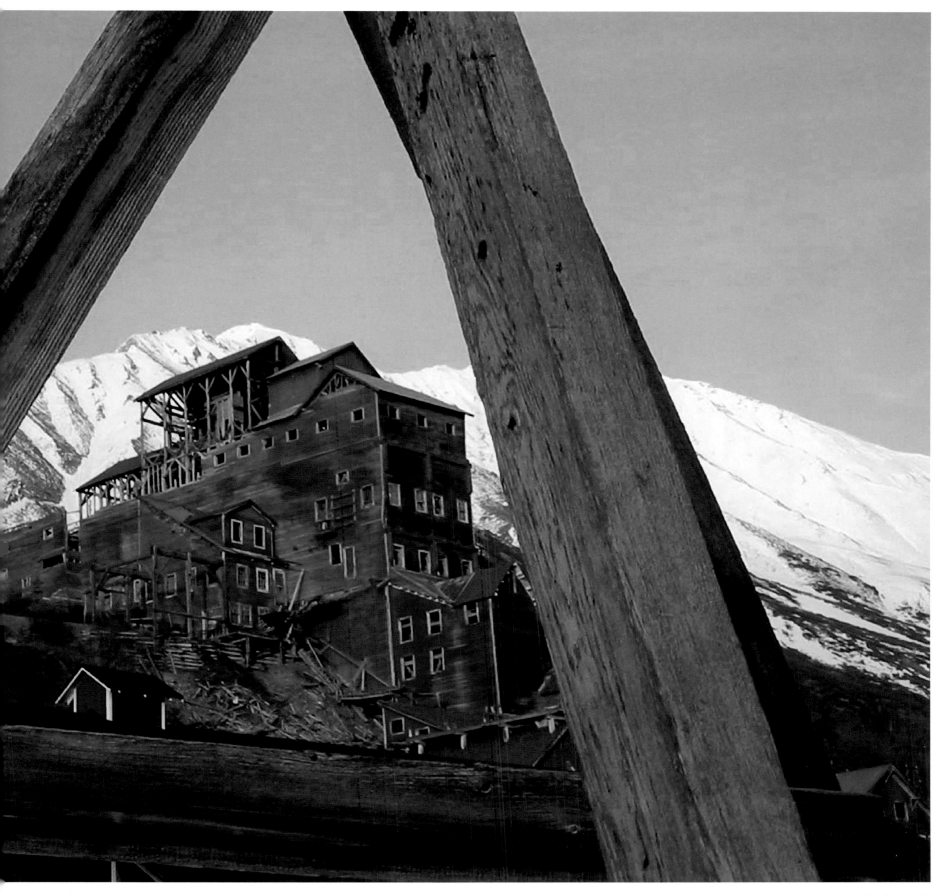

KENNICOTT

In 1900, what looked like a patch of green grass turned out to signal one of the richest patches of copper ore ever discovered. The Kennecott Mine Company was formed with financial backing from the Guggenheim brothers and J.P. Morgan. More than 600,000 tons of copper were processed from 1911 to 1938, when the mines closed due to falling prices.
Photo by Sam M. Flack

PRUDHOE BAY

Bonanza: In 1968, oil was discovered on the North Slope at Prudhoe Bay, which prompted the construction of the 800-mile Trans-Alaska pipeline in 1974. Despite challenges by environmentalists and land disputes by Native Alaskans, the pipeline was completed in three years and now delivers nearly seven million gallons of crude oil each week to the Pacific port of Valdez.

Photo by Judy Patrick

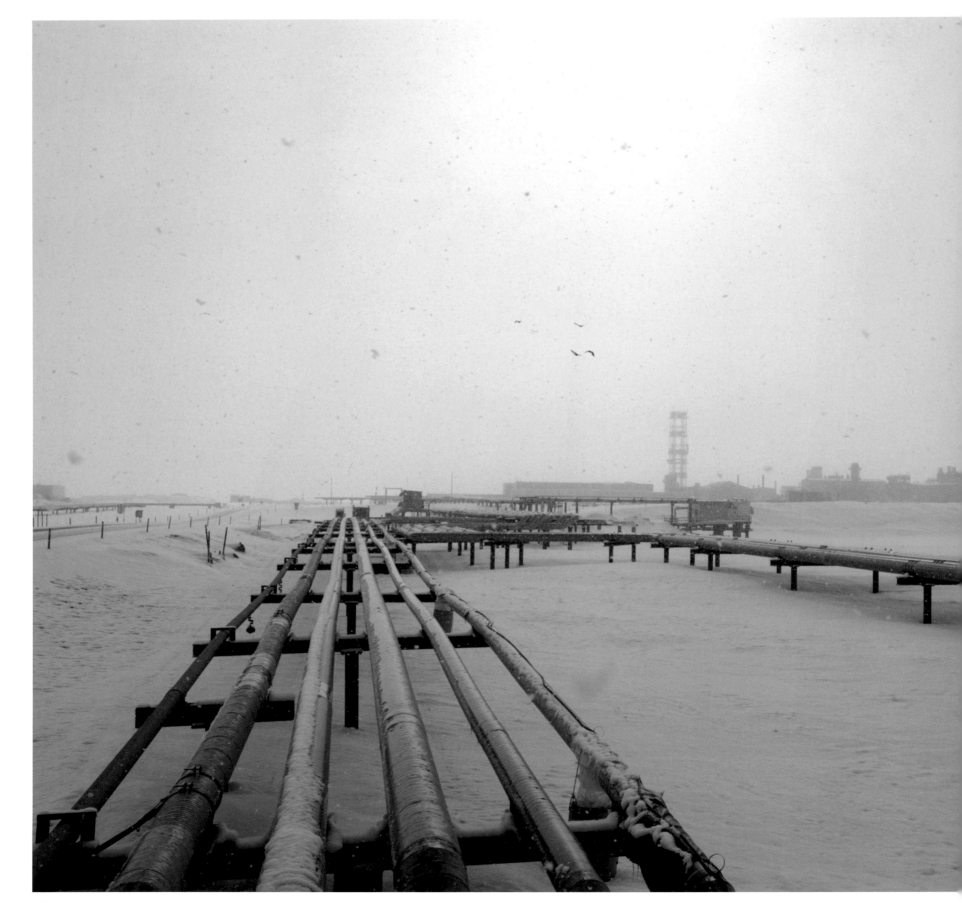

DENALI NATIONAL PARK
The Sanctuary River flows for 25 miles into the Teklanika River. Unlike Denali's glacier-fed waterways, which are often starved of water in winter, the Sanctuary runs strong year-round, offering a safe haven to schools of grayling. In the Spring, the river's headwaters are a prime birthing ground for caribou.
Photo by Robert Hallinen, Anchorage Daily News

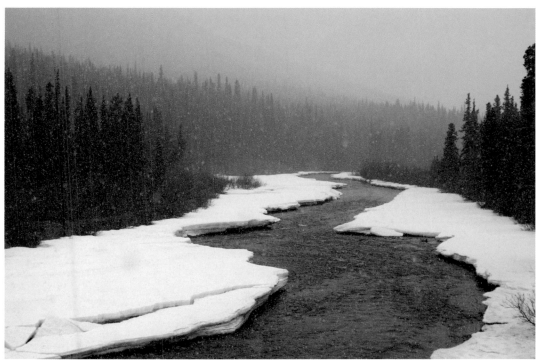

JUNEAU

Southeast Alaska's maritime climate and coastal mountains create ideal conditions for glacial formation. The snow and ice of the 1,500-square-mile Juneau Icefield spawn the great glaciers that flow down to the coast, including the Mendenhall, the Herbert, the Taku, and the Eagle.

Photos by Michael Penn

JUNEAU

The rapidly receding Mendenhall Glacier bunches and cracks as it flows past Mt. Ballard. Since 1948, Southeast Alaska's climate has warmed by 1.6 degrees, causing the glacier to accelerate its retreat. If the trend continues for several centuries, Lake Mendenhall—located at the glacier's terminus—may be all that's left of the 13-mile-long ice flow.

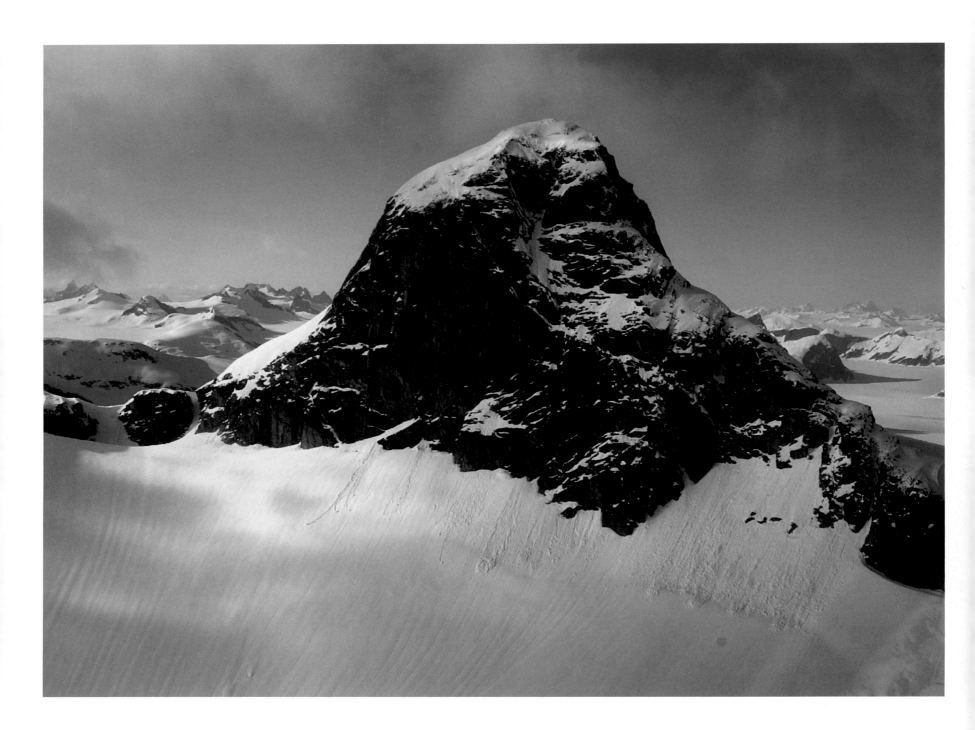

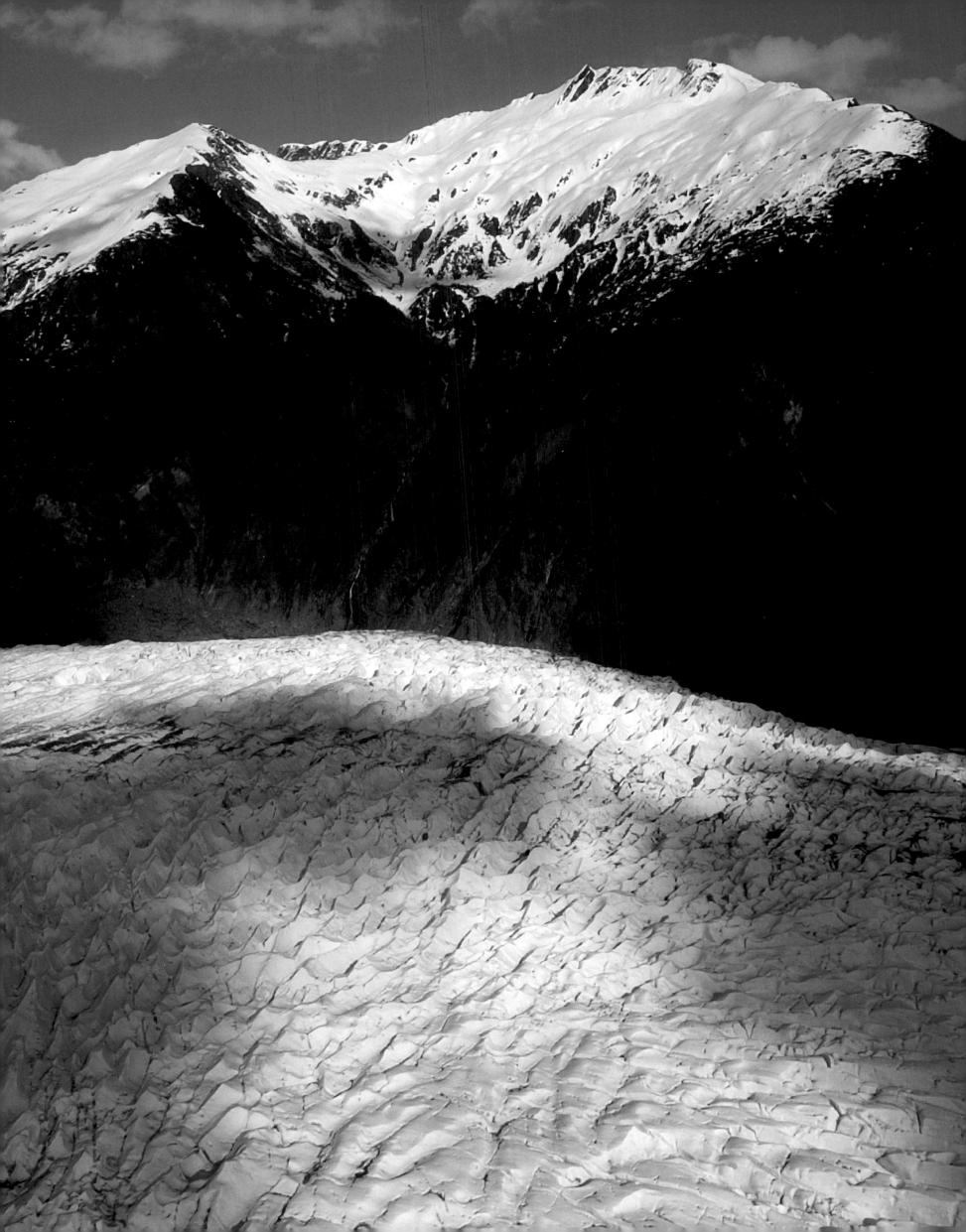

DENALI NATIONAL PARK
In Alaska's oldest national park, cars are permitted along only the first 30 miles of road. As big as Vermont and as accessible as wilderness in Alaska gets, the park welcomes nearly 300,000 visitors a year.
Photo by Robert Hallinen,
Anchorage Daily News

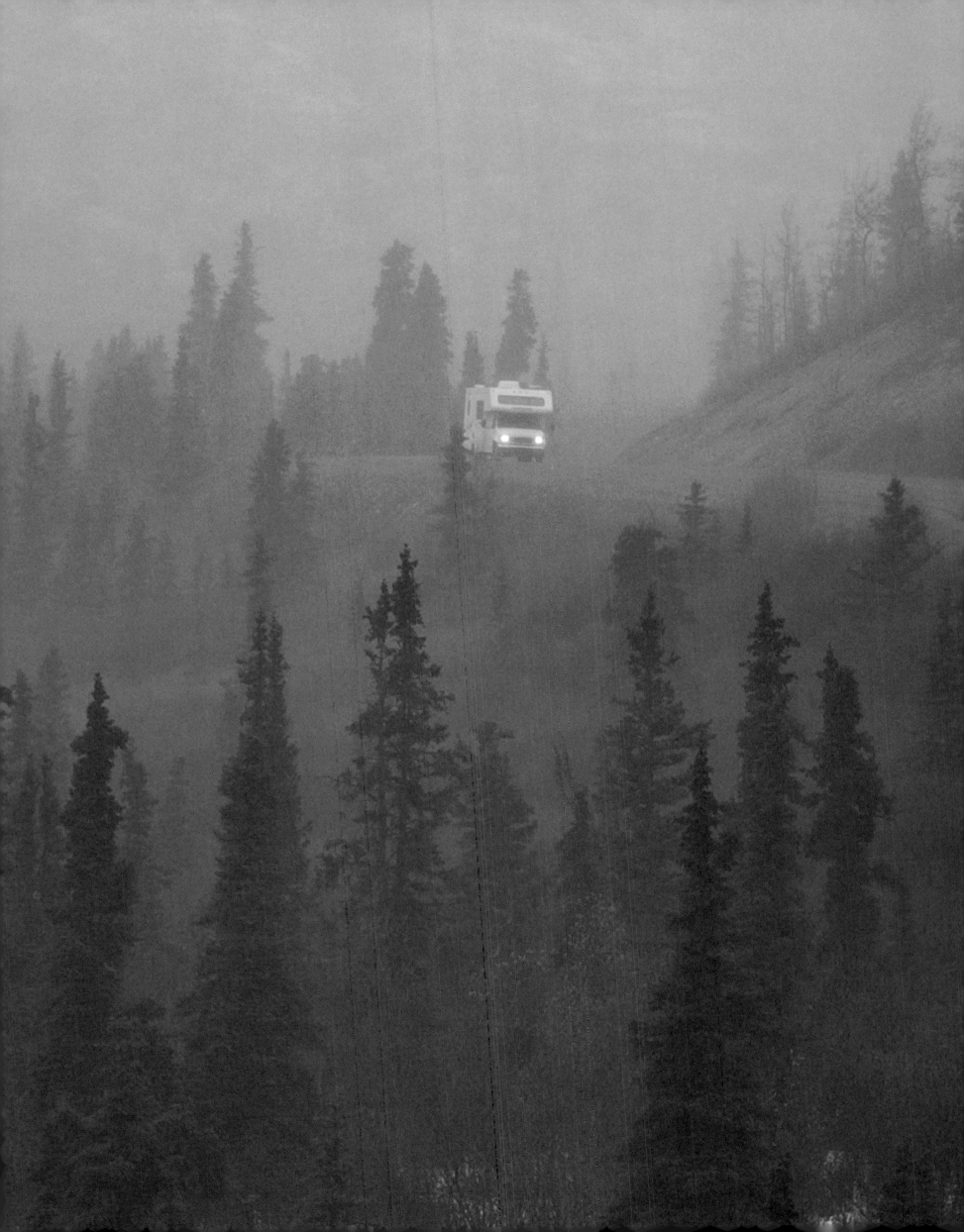

PORTAGE LAKE

Portage Lake, 45 minutes south of Anchorage, is famous for the icebergs that calve from Portage Glacier (far right) and float on the water like frozen ghosts. After a five-mile hike, Mark Wedekind, 40, lets his inner kid come out. And, no, he didn't fall in.

Photo by Evan R. Steinhauser,
Anchorage Daily News

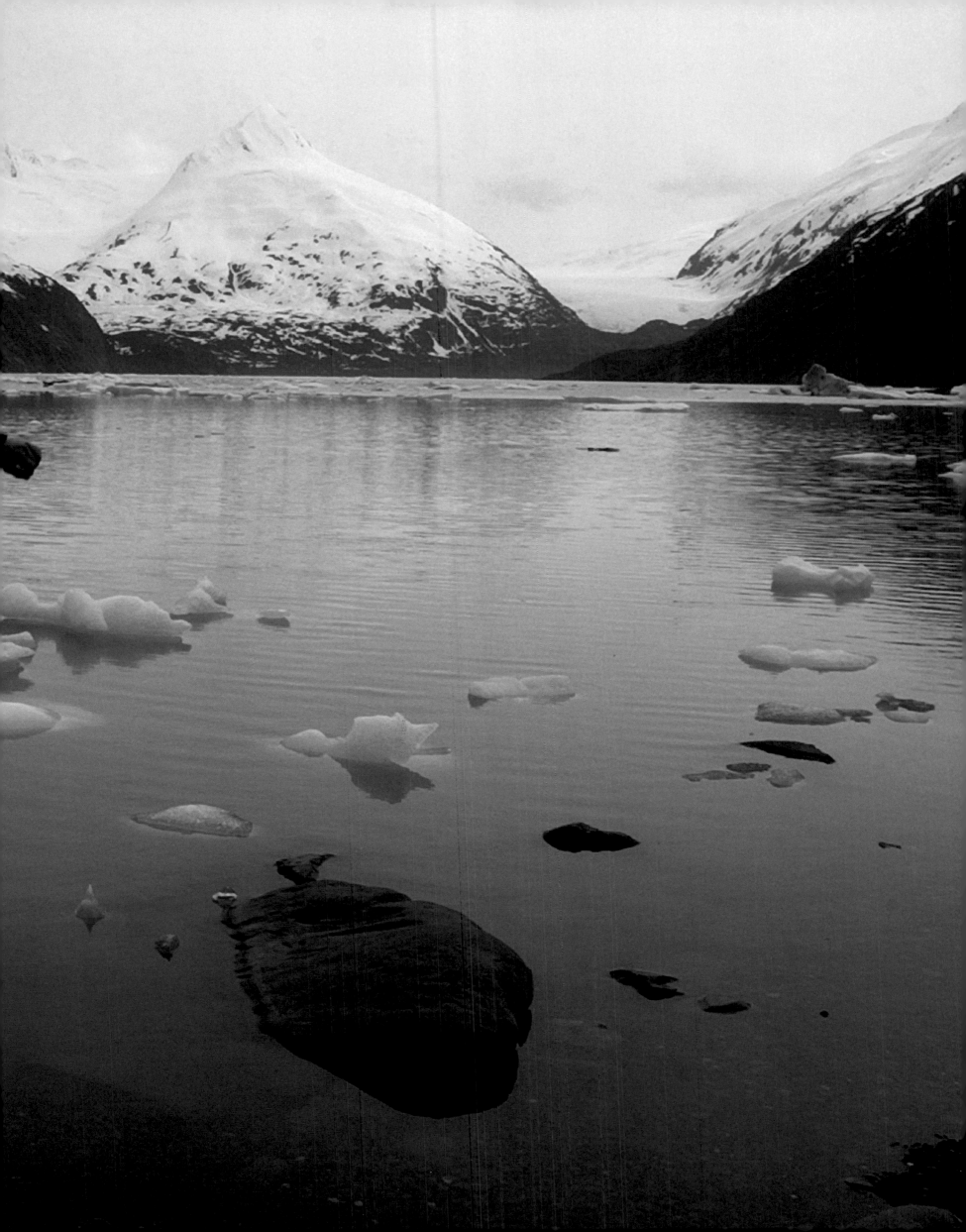

DENALI NATIONAL PARK

Rock and whitetail ptarmigan couples split up, leaving the moms to raise the chicks alone. But a willow ptarmigan, seen here, will stick with his mate through the summer to raise the family. The state bird of Alaska, the ubiquitous ptarmigan has a migration range that keeps it largely within the state.

Photo by Robert Hallinen, Anchorage Daily News

ANCHORAGE

Despite his majestic wingspread, Hal the bald eagle cannot fly. Since he was delivered to the Bird Treatment and Learning Center with a deep shoulder joint injury in 1989, the bird has lived with raptor trainer Kerry Seifert. The two of them travel throughout Alaska educating people about the lives of bald eagles.

Photo by Robert Hallinen, Anchorage Daily News

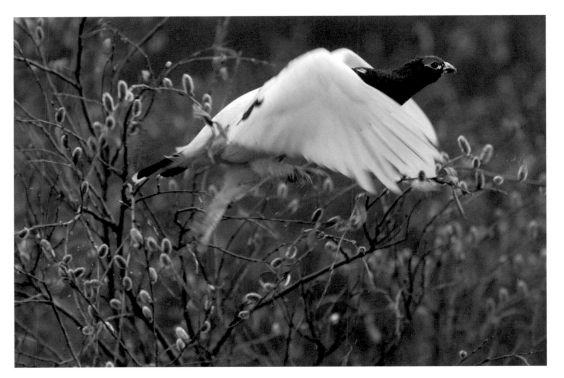

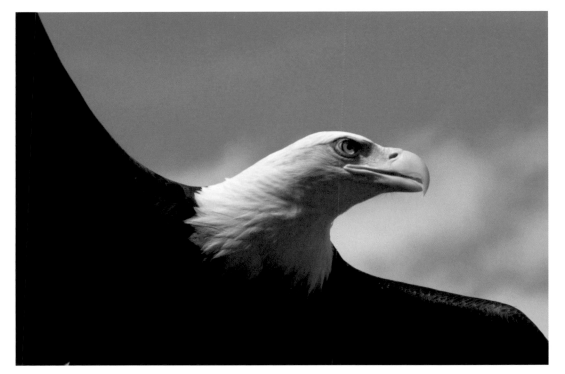

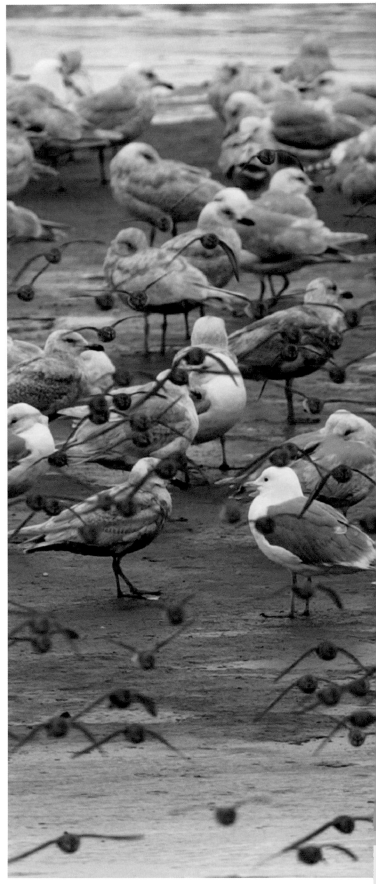

CORDOVA
During spring migration, as many as five million shorebirds—including these glaucous gulls and western sandpipers—rest and feed on the Copper River Delta.
Photo by Marc Lester, Anchorage Daily News

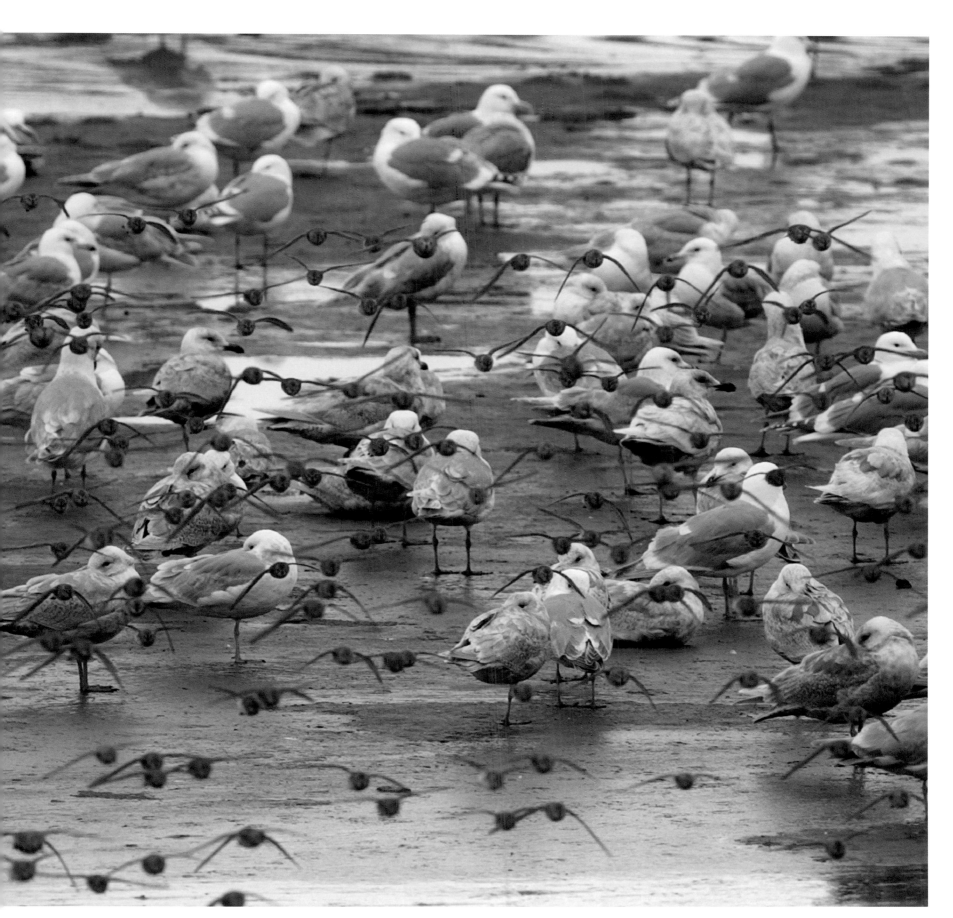

ANCHORAGE

Precarious perch: Although 50,000 Dall sheep
call Alaska home, they are rarely seen. One
good viewing spot is south of Anchorage,
on the rocky cliffs above Seward Highway. A
safe haven from predators, including humans
(hunting is prohibited), the sheep come here
in the spring for birthing.
Photo by Bill Roth, Anchorage Daily News

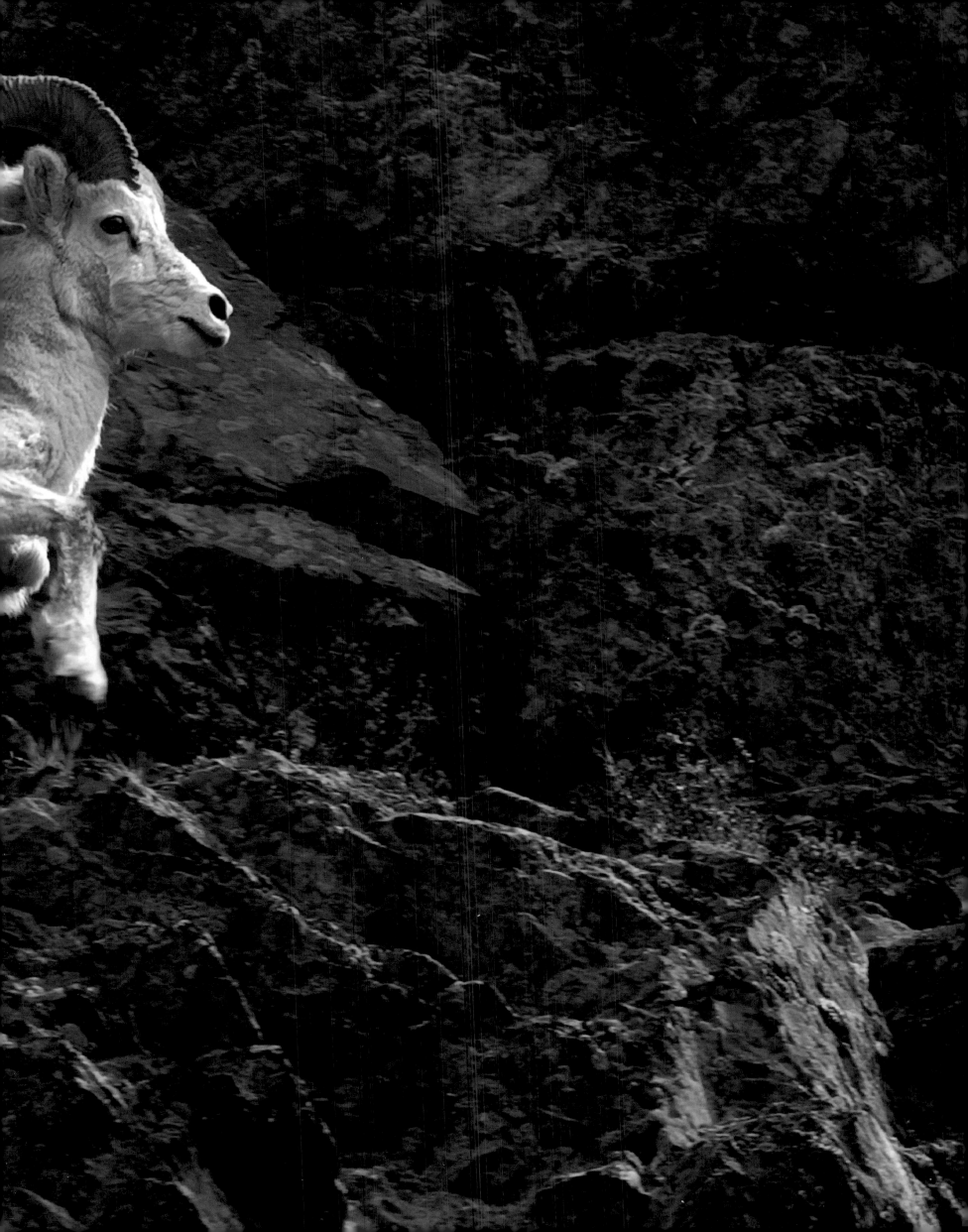

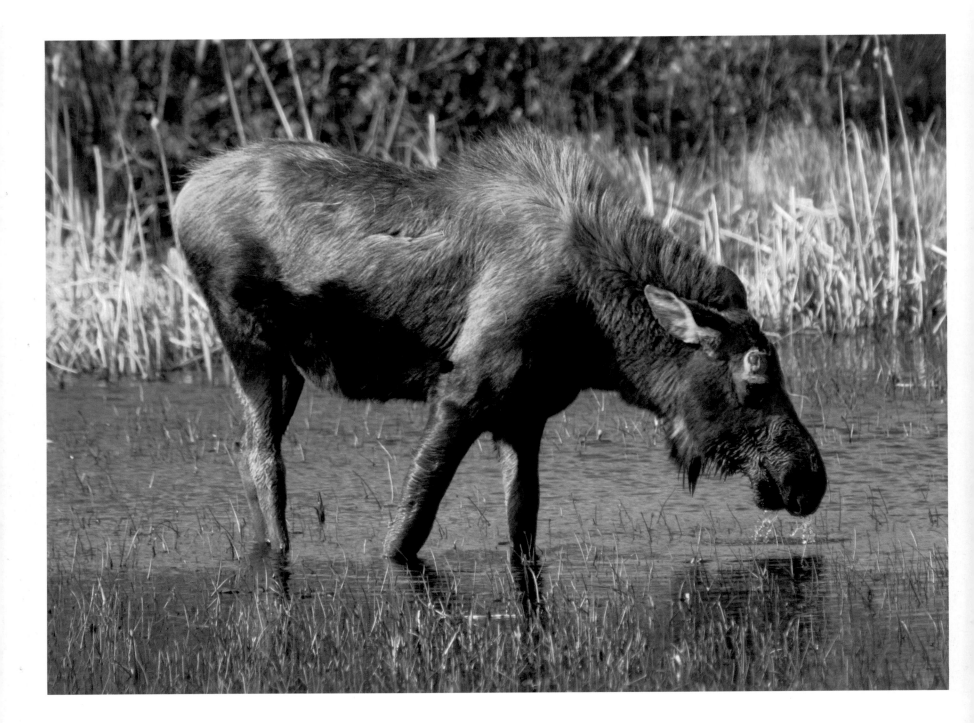

ANCHORAGE

Ecosystem engineers: Moose prune Alaska's landscape, especially in winter when they're reduced to munching woody twigs. A 1,000-pound cow will eat 10 pounds of frozen plant matter daily. In relatively urban Anchorage, the twig munchers go after private gardens. As one resident gardener offers, "They were here first."
Photo by Robert Stapleton, Jr.

DENALI NATIONAL PARK

Spring breakup: Female and male caribou migrate together in herds of up to 1,000 in the winter, but during spring the cows head for birthing grounds, and leave the bulls to wander by themselves.
Photo by Robert Hallinen, Anchorage Daily News

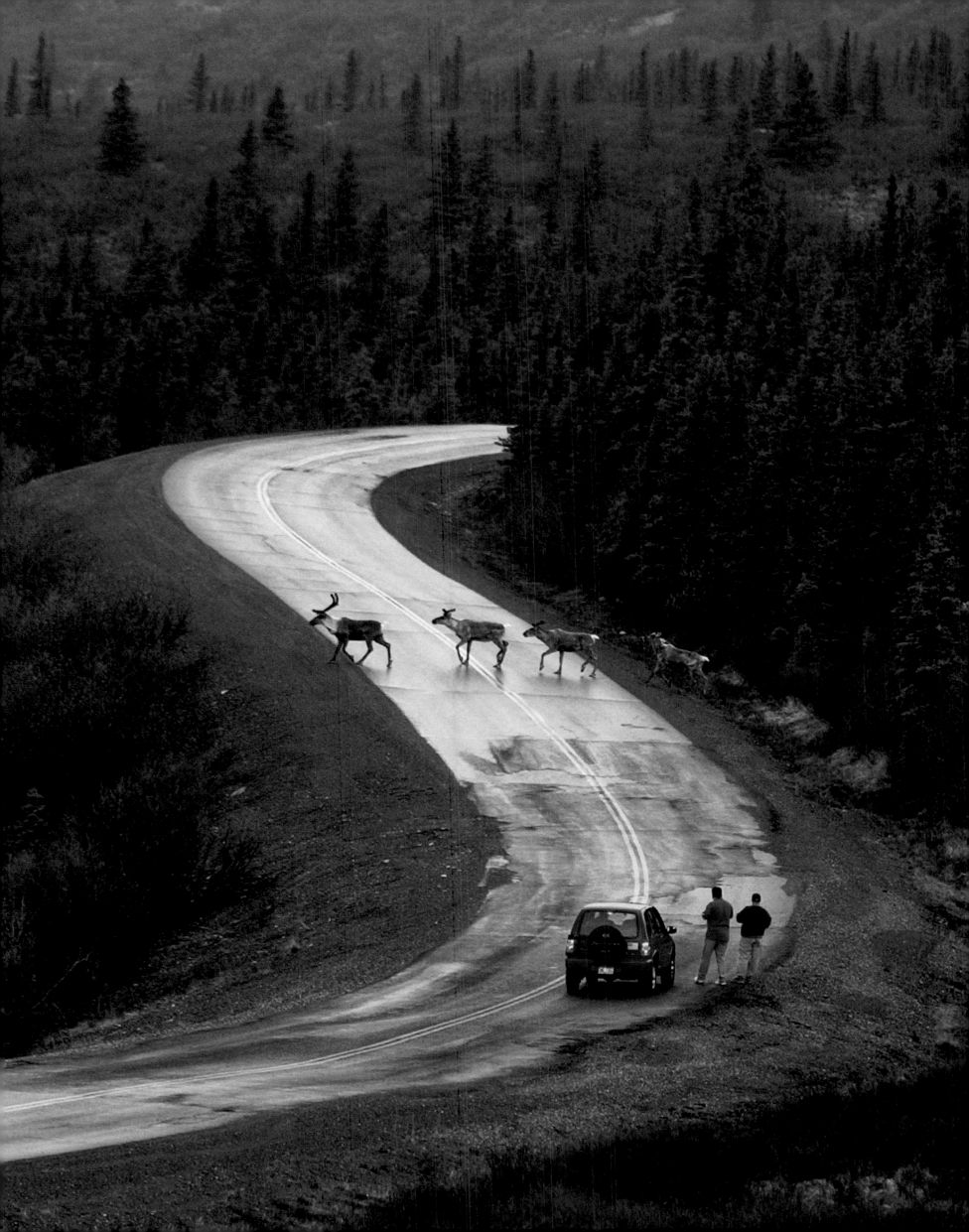

KETCHIKAN

In the spring and summer, the Ketchikan Yacht Club animates the Tongass Narrows, hosting races every Wednesday evening. The sloop *Possum Fargo*, close-hauled on a starboard tack takes a shakedown run. That's Allen Serwat on the foredeck.

Photo by Hall Anderson

JUNEAU

The Mount Roberts Tramway rises 2,000 feet above the Gastineau Channel, Douglas Island, and downtown Juneau. A former gold mining town, much of the Alaska capital's real estate is actually fill from mine tailings. At high tide, water can be seen seeping through the basement walls of several downtown buildings.

Photo by Michael Penn

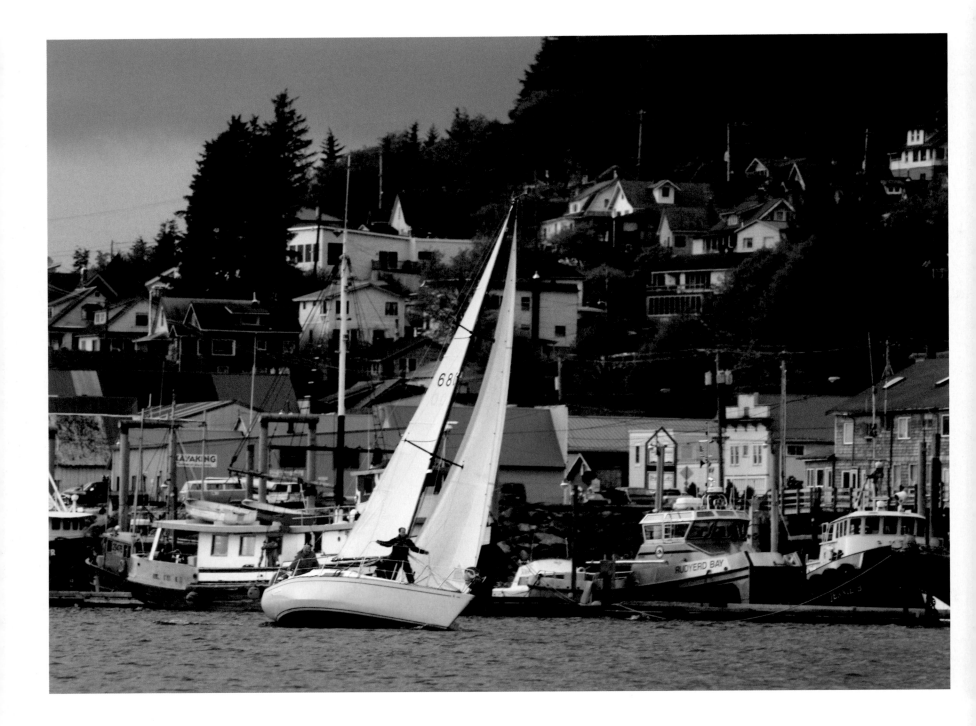

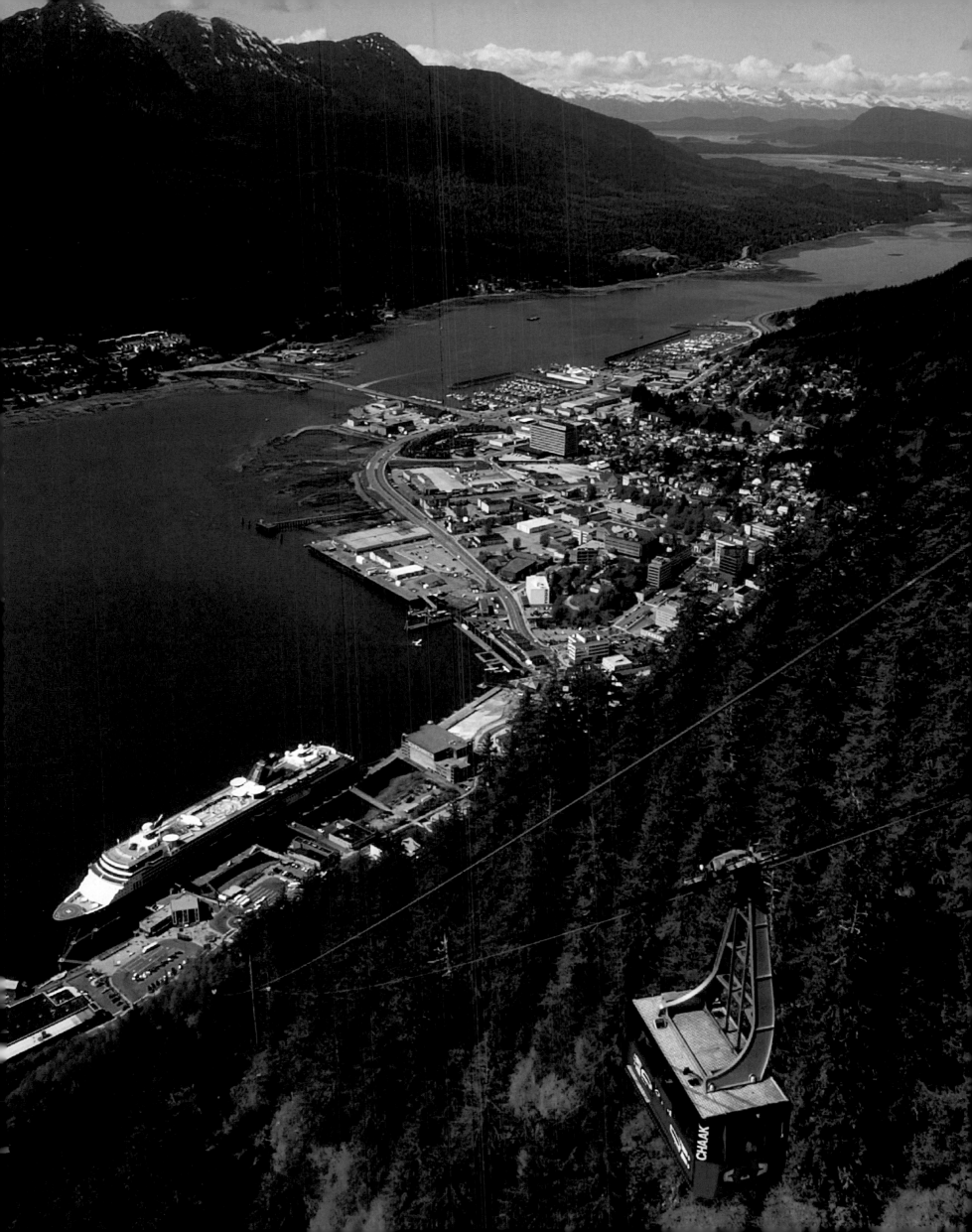

CHITINA
A stiff wind kicks up riverbank glacial silt
at the confluence of the Kotsina and Copper
rivers. Beyond the Chitina bridge, the
Chugach Mountains are barely visible
through the vaporous dust.
Photo by Sam M. Flack

DENALI NATIONAL PARK
Alaska at rest: Fifty miles south of Denali
National Park on the Parks Highway, next
to an all-night gas station, a giant plywood
igloo glows in the early morning hours. Before
running out of money in the 70s, the igloo's
original owners had dreamed of a restaurant,
bar, and 48 pie-shaped motel rooms inside.
Hollow or not, the building endures.
Photo by Robert Hallinen,
Anchorage Daily News

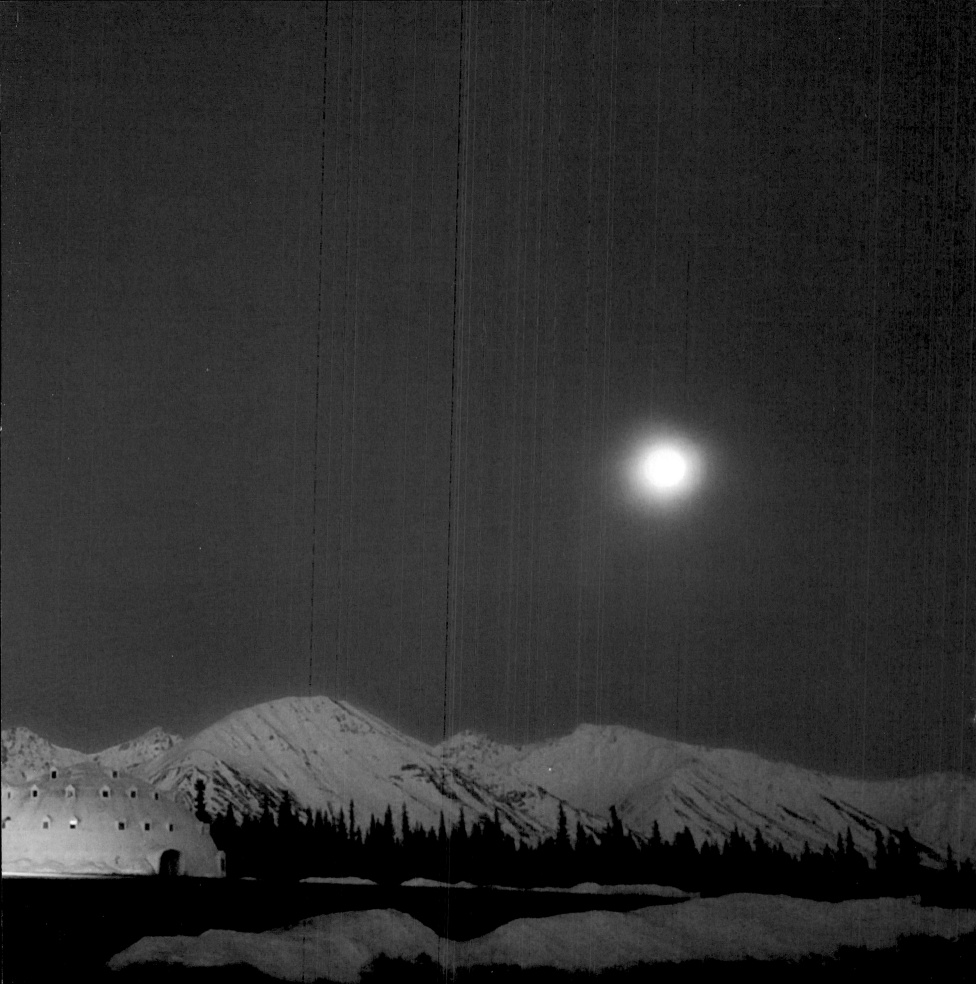

The week of May 12-18, 2003, more than 25,000 professional and amateur photographers spread out across the nation to shoot over a million digital photographs with the goal of capturing the essence of daily life in America.

The professional photographers were equipped with Adobe Photoshop and Adobe Album software, Olympus C-5050 digital cameras, and Lexar Media's high-speed compact flash cards.

The 1,000 professional contract photographers plus another 5,000 stringers and students sent their images via FTP (file transfer protocol) directly to the *America 24/7* website. Meanwhile, thousands of amateur photographers uploaded their images to Snapfish's servers.

At *America 24/7*'s Mission Control headquarters, located at CNET in San Francisco, dozens of picture editors from the nation's most prestigious publications culled the images down to 25,000 of the very best, using Photo Mechanic by Camera Bits. These photos were transferred into Webware's ActiveMedia Digital Asset Management (DAM) system, which served as a central image library and enabled the designers to track, search, distribute, and reformat the images for the creation of the 51 books, foreign language editions, web and magazine syndication, posters, and exhibitions.

Once in the DAM, images were optimized (and in some cases resampled to increase image resolution) using Adobe Photoshop. Adobe InDesign and Adobe InCopy were used to design and produce the 51 books, which were edited and reviewed in multiple locations around the world in the form of Adobe Acrobat PDFs. Epson Stylus printers were used for photo proofing and to produce large-format images for exhibitions. The companies providing support for the *America 24/7* project offer many of the essential components for anyone building a digital darkroom. We encourage you to read more on the following pages about their respective roles in making *America 24/7* possible.

SHOOT

7 images maximum uploaded to online Snapfish accounts

Snapfish servers

10s of 1,000s of amateurs

Photographers use **Adobe Photoshop** to convert RAW images to JPEG, and Photo Mechanic tagging software to add data

1,000 professionals with **Olympus** C-5050 cameras and **Lexar Media** compact flash cards

1,000s of stringers & students

Toolkit, registration info & password via email to photographer laptops

Printer

InDesign layouts output via **Acrobat** to PDF format

5 graphic design and production team

51 books: one national, 50 states

Produced by 24/7 Media, published by DK Publishing

50 state posters designed by 50 AIGA member firms

24/7

DESIGN & PUBLISH

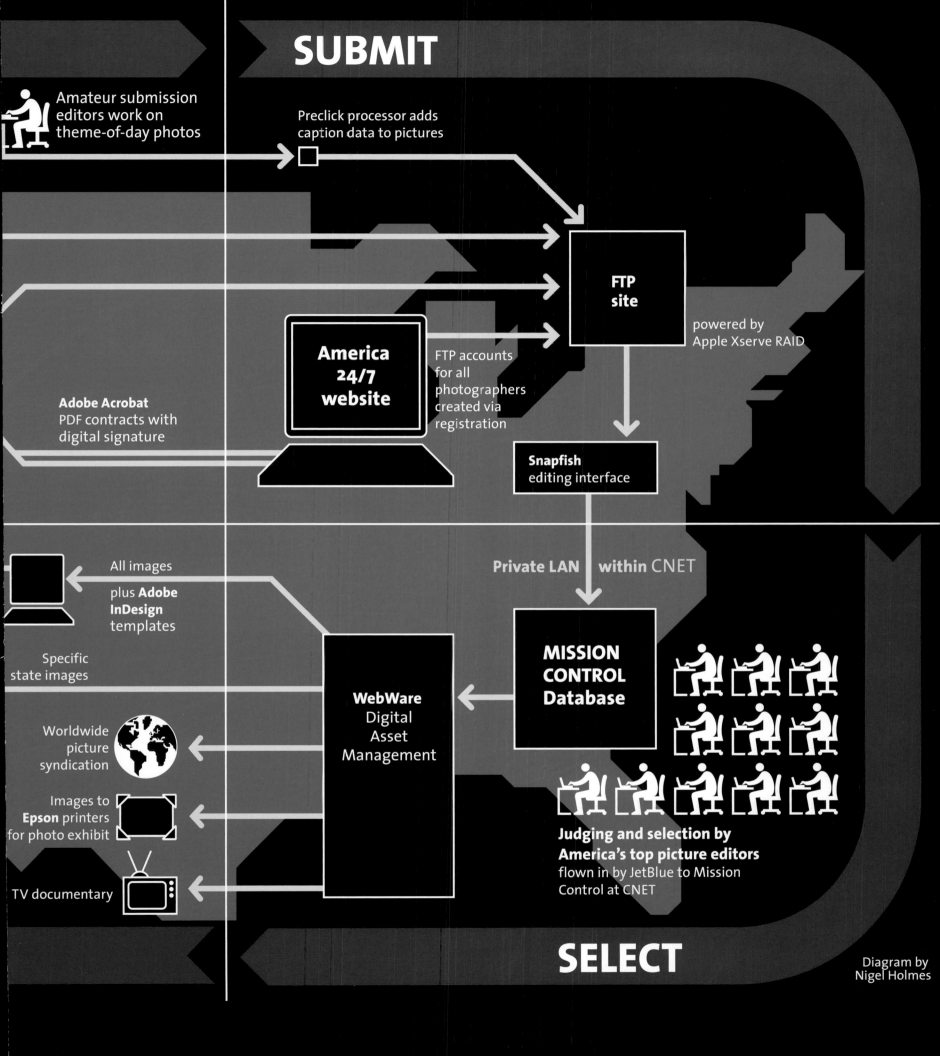

SUBMIT

Amateur submission editors work on theme-of-day photos

Preclick processor adds caption data to pictures

FTP site

powered by Apple Xserve RAID

America 24/7 website

FTP accounts for all photographers created via registration

Adobe Acrobat PDF contracts with digital signature

Snapfish editing interface

All images plus **Adobe InDesign** templates

Specific state images

Private LAN **within** CNET

MISSION CONTROL Database

WebWare Digital Asset Management

Worldwide picture syndication

Images to **Epson** printers for photo exhibit

TV documentary

Judging and selection by America's top picture editors flown in by JetBlue to Mission Control at CNET

SELECT

Diagram by Nigel Holmes

About Our Sponsors

America 24/7 gave digital photographers of all levels the opportunity to share their visions of what it means to live in the United States. This project was made possible by a digital photography revolution that is dramatically changing and improving picture-taking for professionals and amateurs alike. And an Adobe product, Photoshop®, has been at the center of this sea change.

Adobe's products reflect our customers' passion for the creative process, be it the photographer, graphic designer, layout artist, or printer. Adobe is the Publishing and Imaging Software Partner for *America 24/7* and products such as Adobe InDesign®, Photoshop, Acrobat®, and Illustrator® were used to produce this stunning book in a matter of weeks. We hope that our software has helped do justice to the mythic images, contributed by well-known photographers and the inspired hobbyist.

Adobe is proud to be a lead sponsor of *America 24/7*, a project that celebrates the vibrancy of the American spirit: the same spirit that helped found Adobe and inspires our employees and customers to deliver the very best.

Bruce Chizen
President and CEO
Adobe Systems Incorporated

Olympus, a global technology leader in designing precision healthcare solutions and innovative consumer electronics, is proud to be the official digital camera sponsor of *America 24/7*. The opportunity to introduce Americans from coast to coast to the thrill, excitement, and possibility of digital photography makes the vision behind this book a perfect fit for Olympus, a leader in digital cameras since 1996.

For most people, the essence of digital photography is best grasped through firsthand experience with the technology, which is precisely what *America 24/7* is about. We understand that direct experience is the pathway to inspiration, and welcome opportunities like this sponsorship to bring the power of the digital experience into the lives of people everywhere. To Olympus, *America 24/7* offers a platform to help realize a core mission: to deliver and make accessible the power of the digital experience to millions of American photographers, amateurs, and professionals alike.

The 1,000 professional photographers contracted to shoot on the America 24/7 project were all equipped with Olympus C-5050 digital cameras. Like all Olympus products, the C-5050 is offered by a company well known for designing, manufacturing, and servicing products used by professionals to perform their work, every day. Olympus is a customer-centric company committed to working one-to-one with a diverse group of professionals. From biomedical researchers who use our clinical microscopes, to doctors who perform life-saving procedures with our endoscopes, to professional photographers who use cameras in their daily work, Olympus is a trusted brand.

The digital imaging technology involved with *America 24/7* has enabled the soul of America to be visually conveyed, not just by professional observers, but by the American public who participated in this project—the very people who collectively breath life into this country's existence each day.

We are proud to be enabling so many photographers to capture the pictures on these pages that tell the story of who we are as a nation. From sea to shining sea, digital imagery allows us to connect to one another in ways we never dreamed possible.

At Olympus, our ideas have proliferated as rapidly as technology has evolved. We have channeled these visions into breakthrough products and solutions to meet the demands of our changing world-products like microscopes, endoscopes, and digital voice recorders, supported by the highly regarded training, educational, and consulting services we offer our customers.

Today, 83 years after we introduced our first microscope, we remain as young, as curious, and as committed as ever.

Lexar Media has grown from the digital photography revolution, which is why we are proud to have supplied the digital memory cards used in the America 24/7 project. Lexar Media's high-performance memory cards utilize our unique and patented controller coupled with high-speed flash memory from Samsung, the world's largest flash memory supplier. This powerful combination brings out the ultimate performance of any digital camera.

Photographers who demand the most from their equipment choose our products for their advanced features like write speeds up to 40X, Write Acceleration technology for enabled cameras, and Image Rescue, which recovers previously deleted or lost images. Leading camera manufacturers bundle Lexar Media digital memory cards with their cameras because they value its performance and reliability.

Lexar Media is at the forefront of digital photography as it transforms picture-taking worldwide, and we will continue to be a leader with new and innovative solutions for professionals and amateurs alike.

Snapfish, which developed the technology behind the *America 24/7* amateur photo event, is a leading online photo service, with more than 5 million members and 100 million photos posted online. Snapfish enables both film and digital camera owners to share, print, and store their most important photo memories, at prices that cannot be equaled. Digital camera users upload photos into a password-protected online album for free. Users can also order film-quality prints on professional photographic paper for as low as 25¢. Film camera users get a full set of prints, plus online sharing and storage, for just $2.99 per roll.

Founded in 1995, eBay created a powerful platform for the sale of goods and services by a passionate community of individuals and businesses. On any given day, there are millions of items across thousands of categories for sale on eBay. eBay enables trade on a local, national and international basis with customized sites in markets around the world.

Through an array of services, such as its payment solution provider PayPal, eBay is enabling global e-commerce for an ever-growing online community.

JetBlue Airways is proud to be *America 24/7's* preferred carrier, flying photographers, photo editors, and organizers across the United States.

Winner of Condé Nast Traveler's Readers' Choice Awards for Best Domestic Airline 2002, JetBlue provides friendly service and low fares for travelers in 22 cities in nine states across America.

On behalf of JetBlue's 5,000 crew members, we're excited to be involved in this remarkable project, and for the opportunity to serve American travelers each and every day, coast to coast, 24/7.

DIGITAL POND.

Digital Pond has been a leading creator of large graphic displays for museums, corporations, trade shows, retail environments and fine art since 1992.

We were proud to bring together our creative, print and display capabilities to produce signage and displays for mission control, critical retouching for numerous key images for the book, and art galleries for the New York Public Library and Bryant Park.

The Pond's team and SplashPic® Online service enabled us to nimbly design, produce and install over 200 large graphic panels in two NYC locations within the truly "24/7" production schedule of less than ten days.

WebWare Corporation is pleased to be a major sponsor of the America 24/7 project. We take pride in being part of a groundbreaking adventure that is stretching the boundaries—and the imagination—in digital photography, digital asset management, publishing, news, and global events.

Our ActiveMedia Enterprise™ digital asset management software is the "nerve center" of *America 24/7*, the central repository for managing, sharing, and collaborating on the project's photographs. From photo editors and book publishers to 24/7's media relations and marketing personnel, ActiveMedia provides the application support that links all facets of the project team to the content worldwide.

WebWare helps Global 2000 firms securely manage, reuse, and distribute media assets locally or globally. Its suite of ActiveMedia software products provide powerful media services platforms for integrating rich media into content management systems marketing and communication portals; web publishing systems; and e-commerce portals.

Google™

Google's mission is to organize the world's information and make it universally accessible and useful.

With our focus on plucking just the right answer from an ocean of data, we were naturally drawn to the America 24/7 project. The book you hold is a compendium of images of American life distilled from thousands of photographs and infinite possibilities. Are you looking for emotion? Narrative? Shadows? Light? It's all here, thanks to a multitude of photographers and writers creating links between you, the reader, and a sea of wonderful stories. We celebrate the connections that constitute the human experience and are pleased to help engender them. And we're pleased to have been a small part of this project, which captures the results of that interaction so vividly, so dynamically, and so dramatically.

Special thanks to additional contributors: FileMaker, Apple, Camera Bits, LaCie, Now Software, Preclick, Outpost Digital, Xerox, Microsoft, WoodWing Software, net-linx Publishing Solutions, and Radical Media. The Savoy Hotel, San Francisco; The Pan Pacific, San Francisco; Four Seasons Hotel, San Francisco; and The Queen Anne Hotel. Photography editing facilities were generously hosted by CNET Networks, Inc.

Participating Photographers

Coordinator: Richard J. Murphy, Director of Photography, *Anchorage Daily News*

Hall Anderson
James H. Barker
Fran Durner,* *Anchorage Daily News*
Mark Farmer, topcover.com
Robert Hallinen,* *Anchorage Daily News*
Jim Lavrakas,* *Anchorage Daily News*
Marc Lester, *Anchorage Daily News*
Charles Mason Photo, Corbis
Clark James Mishler
Richard J. Murphy,*
Anchorage Daily News
Stephen Nowers, *Anchorage Daily News*

Judy Patrick
Michael Penn*
David Predeger
Anne Raup, *Anchorage Daily News*
Bill Roth,* *Anchorage Daily News*
Jeff Schultz
Robert Stapleton, Jr.
Evan R. Steinhauser,
Anchorage Daily News
Luciana Whitaker

* Pulitzer Prize winner

Thumbnail Picture Credits

Credits for thumbnail photographs are listed by the page number and are in order from left to right.

22 Bill Roth, *Anchorage Daily News*
Evan R. Steinhauser, *Anchorage Daily News*
Anne Raup, *Anchorage Daily News*
Clark James Mishler
Evan R. Steinhauser, *Anchorage Daily News*
Evan R. Steinhauser, *Anchorage Daily News*
Evan R. Steinhauser, *Anchorage Daily News*

23 Evan R. Steinhauser, *Anchorage Daily News*
Laurel R Seals
Evan R. Steinhauser, *Anchorage Daily News*
Sam M. Flack
Evan R. Steinhauser, *Anchorage Daily News*
Sam M. Flack
Anne Raup, *Anchorage Daily News*

24 Jeff Schultz
Charles Mason Photo, Corbis
Hall Anderson
Charles Mason Photo, Corbis
Fran Durner, *Anchorage Daily News*
Jeff Schultz
Fran Durner, *Anchorage Daily News*

25 Charles Mason Photo, Corbis
Charles Tribbey Photography
Laurel R Seals
Richard J. Murphy, *Anchorage Daily News*
Richard J. Murphy, *Anchorage Daily News*
Sam M. Flack
Charles Mason Photo, Corbis

26 Charles Tribbey Photography
Clark James Mishler
Clark James Mishler
Clark James Mishler
Evan R. Steinhauser, *Anchorage Daily News*
Jim Lavrakas, *Anchorage Daily News*
James Mason, *Arctic Sounder*

27 Jeff Schultz
Clark James Mishler
James Mason, *Arctic Sounder*
Jeff Schultz
Clark James Mishler
Laurel R Seals
Clark James Mishler

28 Luciana Whitaker
Fran Durner, *Anchorage Daily News*
Hall Anderson
Jim Lavrakas, *Anchorage Daily News*
Charles Shepherd
Laurel R Seals
Laurel R Seals

29 Marc Lester, *Anchorage Daily News*
Robert Hallinen, *Anchorage Daily News*
Robert Hallinen, *Anchorage Daily News*
Charles Shepherd
Richard J. Murphy, *Anchorage Daily News*
Richard J. Murphy, *Anchorage Daily News*
Sam M. Flack

30 Erik Hill
Jeff Schultz
Laurel R Seals
Jeff Schultz
Laurel R Seals
Jeff Schultz
Jeff Schultz

31 Jeff Schultz
Erik Hill
Richard J. Murphy, *Anchorage Daily News*
Jeff Schultz
Erik Hill
Jeff Schultz
Erik Hill

32 Jeff Schultz
Jeff Schultz
Jeff Schultz
Jeff Schultz
Jeff Schultz
Fran Durner, *Anchorage Daily News*
Jeff Schultz

33 Jeff Schultz
Jeff Schultz
Marc Lester, *Anchorage Daily News*
Jeff Schultz
Laurel R Seals
Jeff Schultz
Laurel R Seals

37 James H. Barker
Clark James Mishler
James H. Barker
James H. Barker
James Mason, *Arctic Sounder*
James H. Barker
Clark James Mishler

38 Richard J. Murphy, *Anchorage Daily News*
Clark James Mishler
Fran Durner, *Anchorage Daily News*
Luciana Whitaker
Clark James Mishler
Evan R. Steinhauser, *Anchorage Daily News*
Jeff Schultz

39 Clark James Mishler
Marc Lester, *Anchorage Daily News*
Luciana Whitaker
Luciana Whitaker
Robert Hallinen, *Anchorage Daily News*
Fran Durner, *Anchorage Daily News*
Clark James Mishler

47 Marc Lester, *Anchorage Daily News*
Marc Lester, *Anchorage Daily News*
Marc Lester, *Anchorage Daily News*
Marc Lester, *Anchorage Daily News*
Marc Lester, *Anchorage Daily News*
Marc Lester, *Anchorage Daily News*
Stephen Nowers, *Anchorage Daily News*

50 Fran Durner, *Anchorage Daily News*
Charles Mason Photo, Corbis
Fran Durner, *Anchorage Daily News*
Charles Mason Photo, Corbis
Fran Durner, *Anchorage Daily News*
Charles Mason Photo, Corbis
Marc Lester, *Anchorage Daily News*

51 Fran Durner, *Anchorage Daily News*
Marc Lester, *Anchorage Daily News*
Fran Durner, *Anchorage Daily News*
Marc Lester, *Anchorage Daily News*
Fran Durner, *Anchorage Daily News*
Marc Lester, *Anchorage Daily News*
Fran Durner, *Anchorage Daily News*

52 Anne Raup, *Anchorage Daily News*
Charles Mason Photo, Corbis
Jim Lavrakas, *Anchorage Daily News*
Charles Mason Photo, Corbis
Anne Raup, *Anchorage Daily News*
Charles Mason Photo, Corbis
Jim Lavrakas, *Anchorage Daily News*

53 Charles Mason Photo, Corbis
Charles Mason Photo, Corbis
Charles Mason Photo, Corbis
Jim Lavrakas, *Anchorage Daily News*
Charles Tribbey Photography
Charles Mason Photo, Corbis
Judy Patrick

54 Judy Patrick
Charles Mason Photo, Corbis
Fran Durner, *Anchorage Daily News*
Judy Patrick
Judy Patrick
Marc Lester, *Anchorage Daily News*
Judy Patrick

55 Judy Patrick
Judy Patrick
Judy Patrick
Judy Patrick
Richard J. Murphy, *Anchorage Daily News*
Judy Patrick
Judy Patrick

58 Clark James Mishler
Clark James Mishler
Clark James Mishler
Clark James Mishler
Clark James Mishler
Clark James Mishler
Jeff Schultz

59 Marc Lester, *Anchorage Daily News*
Hall Anderson
Sam M. Flack
Clark James Mishler
Sam M. Flack
Bill Roth, *Anchorage Daily News*
Hall Anderson

60 Marc Lester, *Anchorage Daily News*
Marc Lester, *Anchorage Daily News*
Marc Lester, *Anchorage Daily News*
Marc Lester, *Anchorage Daily News*
Marc Lester, *Anchorage Daily News*
Marc Lester, *Anchorage Daily News*
Marc Lester, *Anchorage Daily News*

61 Charles Tribbey Photography
Marc Lester, *Anchorage Daily News*
Sam M. Flack
Marc Lester, *Anchorage Daily News*
Marc Lester, *Anchorage Daily News*
Marc Lester, *Anchorage Daily News*
Michael Penn

62 Mark Farmer, topcover.com
Hall Anderson
Hall Anderson
Charles Mason Photo, Corbis
Charles Mason Photo, Corbis
Hall Anderson
Charles Mason Photo, Corbis

63 Hall Anderson
Anne Raup, *Anchorage Daily News*
Hall Anderson
Charles Mason Photo, Corbis
Hall Anderson
Sam M. Flack
Hall Anderson

66 Jim Lavrakas, *Anchorage Daily News*
Jim Lavrakas, *Anchorage Daily News*
Jeff Schultz
Jim Lavrakas, *Anchorage Daily News*
Jim Lavrakas, *Anchorage Daily News*
Jeff Schultz
Jim Lavrakas, *Anchorage Daily News*

67 Jim Lavrakas, *Anchorage Daily News*
Jim Lavrakas, *Anchorage Daily News*
Jeff Schultz
Jim Lavrakas, *Anchorage Daily News*
Robert Hallinen, *Anchorage Daily News*
Stephen Nowers, *Anchorage Daily News*
Jim Lavrakas, *Anchorage Daily News*

68 Hall Anderson
Michael Conti
Hall Anderson
Hall Anderson
Michael Conti
David Predeger
Michael Conti

69 Michael Conti
Hall Anderson
Michael Conti
Hall Anderson
Hall Anderson
Hall Anderson
Michael Conti

70 Robert Stapleton, Jr.
Robert Stapleton, Jr.
Robert Stapleton, Jr.
Robert Stapleton, Jr.
Robert Stapleton, Jr.
Robert Stapleton, Jr.
Robert Stapleton, Jr.

73 Fran Durner, *Anchorage Daily News*
Michael Penn
Fran Durner, *Anchorage Daily News*
Michael Penn
Fran Durner, *Anchorage Daily News*
Fran Durner, *Anchorage Daily News*
Michael Penn

74 Mark Farmer, topcover.com
Mark Farmer, topcover.com
Erik Hill
Jeff Schultz
Mark Farmer, topcover.com
Stephen Nowers, *Anchorage Daily News*
Mark Farmer, topcover.com

75 David Predeger
Robert Stapleton, Jr.
Mark Farmer, topcover.com
Stephen Nowers, *Anchorage Daily News*
Mark Farmer, topcover.com
Jim Lavrakas, *Anchorage Daily News*
Mark Farmer, topcover.com

78 Marc Lester, *Anchorage Daily News*
Stephen Nowers, *Anchorage Daily News*
Stephen Nowers, *Anchorage Daily News*
Robert Hallinen, *Anchorage Daily News*
Hall Anderson
Stephen Nowers, *Anchorage Daily News*
Marc Lester, *Anchorage Daily News*

79 Marc Lester, *Anchorage Daily News*
Robert Hallinen, *Anchorage Daily News*
Stephen Nowers, *Anchorage Daily News*
Stephen Nowers, *Anchorage Daily News*
Marc Lester, *Anchorage Daily News*
Stephen Nowers, *Anchorage Daily News*
Robert Hallinen, *Anchorage Daily News*

82 Anne Raup, *Anchorage Daily News*
Anne Raup, *Anchorage Daily News*
Michael Penn
Anne Raup, *Anchorage Daily News*
Anne Raup, *Anchorage Daily News*
Anne Raup, *Anchorage Daily News*
Anne Raup, *Anchorage Daily News*

83 Bill Roth, *Anchorage Daily News*
Michael Penn
Evan R. Steinhauser, *Anchorage Daily News*
Anne Raup, *Anchorage Daily News*
Evan R. Steinhauser, *Anchorage Daily News*
Anne Raup, *Anchorage Daily News*
Anne Raup, *Anchorage Daily News*

84 Clark James Mishler
Hall Anderson
Laurel R Seals
Fran Durner, *Anchorage Daily News*
Bill Roth, *Anchorage Daily News*
Clark James Mishler
Laurel R Seals

85 Hall Anderson
Marc Lester, *Anchorage Daily News*
James Mason, Arctic Sounder
James H. Barker
Michael Penn
Fran Durner, *Anchorage Daily News*
Marc Lester, *Anchorage Daily News*

88 Stephen Nowers, *Anchorage Daily News*
Charles Tribbey Photography
Charles Mason Photo, Corbis
Hall Anderson
Jeff Schultz
Jim Lavrakas, *Anchorage Daily News*
Charles Mason Photo, Corbis

89 Mike Yoder, *The Lawrence Journal-World*
Jeff Schultz
Mike Yoder, *The Lawrence Journal-World*
Mike Yoder, *The Lawrence Journal-World*
Charles Mason Photo, Corbis
Michael Penn
Stephen Nowers, *Anchorage Daily News*

92 Robert Stapleton, Jr.
Richard J. Murphy, *Anchorage Daily News*
Richard J. Murphy, *Anchorage Daily News*
Marc Lester, *Anchorage Daily News*
Michael Conti
Jim Lavrakas, *Anchorage Daily News*
Michael Conti

93 Jeff Schultz
Robert Stapleton, Jr.
Richard J. Murphy, *Anchorage Daily News*
Richard J. Murphy, *Anchorage Daily News*
Marc Lester, *Anchorage Daily News*
Richard J. Murphy, *Anchorage Daily News*
Michael Conti

94 Evan R. Steinhauser, *Anchorage Daily News*
Jeff Schultz
Evan R. Steinhauser, *Anchorage Daily News*
Robert Stapleton, Jr.
Jim Lavrakas, *Anchorage Daily News*
Jeff Schultz
Robert Stapleton, Jr.

95 Michael Penn
Robert Stapleton, Jr.
Jeff Schultz
Robert Stapleton, Jr.
Jim Lavrakas, *Anchorage Daily News*
Michael Penn
Robert Stapleton, Jr.

100 Bill Roth, *Anchorage Daily News*
Anne Raup, *Anchorage Daily News*
Anne Raup, *Anchorage Daily News*
Anne Raup, *Anchorage Daily News*
Anne Raup, *Anchorage Daily News*
Anne Raup, *Anchorage Daily News*
Anne Raup, *Anchorage Daily News*

101 Anne Raup, *Anchorage Daily News*
Richard J. Murphy, *Anchorage Daily News*
Marc Lester, *Anchorage Daily News*
Michael Penn
Anne Raup, *Anchorage Daily News*
Anne Raup, *Anchorage Daily News*
Anne Raup, *Anchorage Daily News*

102 Marc Lester, *Anchorage Daily News*
Bill Roth, *Anchorage Daily News*
Marc Lester, *Anchorage Daily News*
Michael Penn
Bill Roth, *Anchorage Daily News*
Bill Roth, *Anchorage Daily News*
Bill Roth, *Anchorage Daily News*

108 Marc Lester, *Anchorage Daily News*
Charles Mason Photo, Corbis
David Predeger
Marc Lester, *Anchorage Daily News*
Charles Shepherd
Michael Penn
Evan R. Steinhauser, *Anchorage Daily News*

109 Charles Mason Photo, Corbis
Hall Anderson
Richard J. Murphy, *Anchorage Daily News*
Judy Patrick
Charles Mason Photo, Corbis
Marc Lester, *Anchorage Daily News*
Marc Lester, *Anchorage Daily News*

114 Michael Penn
Michael Penn
Michael Penn
Fran Durner, *Anchorage Daily News*
Bill Roth, *Anchorage Daily News*
Michael Penn
Fran Durner, *Anchorage Daily News*

118 Clark James Mishler
Clark James Mishler
Clark James Mishler
Clark James Mishler
Clark James Mishler
Luciana Whitaker
Clark James Mishler

120 Luciana Whitaker
Marc Lester, *Anchorage Daily News*
Michael Penn
Charles Mason Photo, Corbis
Mark Farmer, topcover.com
Luciana Whitaker
Bill Roth, *Anchorage Daily News*

121 Mike Yoder, *The Lawrence Journal-World*
Michael Penn
Marc Lester, *Anchorage Daily News*
Michael Penn
Richard J. Murphy, *Anchorage Daily News*
Robert Stapleton, Jr.
Evan R. Steinhauser, *Anchorage Daily News*

122 Anne Raup, *Anchorage Daily News*
Clark James Mishler
Jeff Schultz
Richard J. Murphy, *Anchorage Daily News*
Jeff Schultz
Jeff Schultz
Jeff Schultz

123 Jeff Schultz
Clark James Mishler
Jeff Schultz
Jeff Schultz
Jeff Schultz
Richard J. Murphy, *Anchorage Daily News*
Evan R. Steinhauser, *Anchorage Daily News*

128 Clark James Mishler
Sam M. Flack
James Mason, *Arctic Sounder*
Clark James Mishler
James Mason, *Arctic Sounder*
Clark James Mishler
Bill Roth, *Anchorage Daily News*

129 Clark James Mishler
James Mason, *Arctic Sounder*
Jim Lavrakas, *Anchorage Daily News*
James Mason, *Arctic Sounder*
James Mason, *Arctic Sounder*
Clark James Mishler
Clark James Mishler

130 Clark James Mishler
Evan R. Steinhauser, *Anchorage Daily News*
Clark James Mishler
Evan R. Steinhauser, *Anchorage Daily News*
Evan R. Steinhauser, *Anchorage Daily News*
Evan R. Steinhauser, *Anchorage Daily News*
Evan R. Steinhauser, *Anchorage Daily News*

133 Mark Farmer, topcover.com
Mark Farmer, topcover.com
Mark Farmer, topcover.com
Mark Farmer, topcover.com
Mark Farmer, topcover.com
Mark Farmer, topcover.com
Mark Farmer, topcover.com

136 Clark James Mishler
Jim Lavrakas, *Anchorage Daily News*
Luciana Whitaker
Jim Lavrakas, *Anchorage Daily News*
Clark James Mishler
Marc Lester, *Anchorage Daily News*
Michael Conti

137 James H. Barker
Stephen Nowers, *Anchorage Daily News*
Marc Lester, *Anchorage Daily News*
Jim Lavrakas, *Anchorage Daily News*
Stephen Nowers, *Anchorage Daily News*
Richard J. Murphy, *Anchorage Daily News*
Marc Lester, *Anchorage Daily News*

138 Jim Lavrakas, *Anchorage Daily News*
Anne Raup, *Anchorage Daily News*
Mark Farmer, topcover.com
Jim Lavrakas, *Anchorage Daily News*
Clark James Mishler
Fran Durner, *Anchorage Daily News*
Jim Lavrakas, *Anchorage Daily News*

139 Marc Lester, *Anchorage Daily News*
Erik Hill
Jim Lavrakas, *Anchorage Daily News*
Anne Raup, *Anchorage Daily News*
Anne Raup, *Anchorage Daily News*
Hall Anderson
Bill Roth, *Anchorage Daily News*

144 Luciana Whitaker
Luciana Whitaker
Luciana Whitaker
Luciana Whitaker
Luciana Whitaker
Luciana Whitaker
Luciana Whitaker

145 Luciana Whitaker
Luciana Whitaker
Luciana Whitaker
Luciana Whitaker
Luciana Whitaker
Luciana Whitaker
Luciana Whitaker

146 Luciana Whitaker
Luciana Whitaker
Luciana Whitaker
Luciana Whitaker
Luciana Whitaker
Luciana Whitaker

147 Luciana Whitaker
Luciana Whitaker
Luciana Whitaker
Luciana Whitaker
Luciana Whitaker
Luciana Whitaker
Luciana Whitaker

148 Fran Durner, *Anchorage Daily News*
David Predeger
Fran Durner, *Anchorage Daily News*
Fran Durner, *Anchorage Daily News*
Fran Durner, *Anchorage Daily News*
Jeff Schultz
Fran Durner, *Anchorage Daily News*

149 Jeff Schultz
Fran Durner, *Anchorage Daily News*
Jeff Schultz
Marc Lester, *Anchorage Daily News*
Charles Shepherd
Richard J. Murphy, *Anchorage Daily News*
Sam M. Flack

150 Anne Raup, *Anchorage Daily News*
Clark James Mishler
Richard J. Murphy, *Anchorage Daily News*
Clark James Mishler
Clark James Mishler
Charles Mason Photo, Corbis
Hall Anderson

151 Richard J. Murphy, *Anchorage Daily News*
Hall Anderson
Luciana Whitaker
Sam M. Flack
Luciana Whitaker
Sam M. Flack
Charles Mason Photo, Corbis

152 Fran Durner, *Anchorage Daily News*
Marc Lester, *Anchorage Daily News*
Hall Anderson
Anne Raup, *Anchorage Daily News*
Clark James Mishler
Charles Mason Photo, Corbis
Fran Durner, *Anchorage Daily News*

153 Marc Lester, *Anchorage Daily News*
Bill Roth, *Anchorage Daily News*
Fran Durner, *Anchorage Daily News*
Marc Lester, *Anchorage Daily News*
Marc Lester, *Anchorage Daily News*
Bill Roth, *Anchorage Daily News*
Charles Mason Photo, Corbis

154 Fran Durner, *Anchorage Daily News*
Clark James Mishler
Fran Durner, *Anchorage Daily News*
Fran Durner, *Anchorage Daily News*
Judy Patrick
Fran Durner, *Anchorage Daily News*
Fran Durner, *Anchorage Daily News*

155 Jeff Schultz
Fran Durner, *Anchorage Daily News*
Robert Stapleton, Jr.
Clark James Mishler
Sam M. Flack
Robert Hallinen, *Anchorage Daily News*
Fran Durner, *Anchorage Daily News*

156 Clark James Mishler
Clark James Mishler
Jim Lavrakas, *Anchorage Daily News*
James Mason, *Arctic Sounder*
Stephen Nowers, *Anchorage Daily News*
Clark James Mishler
Erik Hill

157 Anne Raup, *Anchorage Daily News*
Jeff Schultz
Clark James Mishler
Clark James Mishler
Marc Lester, *Anchorage Daily News*
Richard J. Murphy, *Anchorage Daily News*
Charles Mason Photo, Corbis

158 Anne Raup, *Anchorage Daily News*
Robert Stapleton, Jr.
Erik Hill
Robert Hallinen, *Anchorage Daily News*
Michael Penn
Robert Hallinen, *Anchorage Daily News*
Jeff Schultz

159 Robert Hallinen, *Anchorage Daily News*
Richard J. Murphy, *Anchorage Daily News*
Robert Hallinen, *Anchorage Daily News*
Richard J. Murphy, *Anchorage Daily News*
Bill Roth, *Anchorage Daily News*
Robert Hallinen, *Anchorage Daily News*
Bill Roth, *Anchorage Daily News*

164 Charmain McAdory
Fran Durner, *Anchorage Daily News*
James H. Barker
Marc Lester, *Anchorage Daily News*
Michael Penn
Sam M. Flack
Jim Lavrakas, *Anchorage Daily News*

165 Marc Lester, *Anchorage Daily News*
Marc Lester, *Anchorage Daily News*
Sam M. Flack
Stephen Nowers, *Anchorage Daily News*
Sam M. Flack
Michael Penn
Marc Lester, *Anchorage Daily News*

166 Evan R. Steinhauser, *Anchorage Daily News*
Anne Raup, *Anchorage Daily News*
Judy Patrick
Marc Lester, *Anchorage Daily News*
Judy Patrick
Evan R. Steinhauser, *Anchorage Daily News*
James H. Barker

167 Michael Penn
Judy Patrick
Robert Hallinen, *Anchorage Daily News*
Robert Hallinen, *Anchorage Daily News*
Richard J. Murphy, *Anchorage Daily News*
Bill Roth, *Anchorage Daily News*
Robert Hallinen, *Anchorage Daily News*

168 James H. Barker
Michael Penn
James H. Barker
Evan R. Steinhauser, *Anchorage Daily News*
Michael Penn
Jeff Schultz
Robert Hallinen, *Anchorage Daily News*

174 Robert Hallinen, *Anchorage Daily News*
Robert Hallinen, *Anchorage Daily News*
Robert Hallinen, *Anchorage Daily News*
Robert Hallinen, *Anchorage Daily News*
Robert Hallinen, *Anchorage Daily News*
Robert Hallinen, *Anchorage Daily News*
Robert Hallinen, *Anchorage Daily News*

175 Robert Hallinen, *Anchorage Daily News*
Robert Hallinen, *Anchorage Daily News*
Marc Lester, *Anchorage Daily News*
Robert Hallinen, *Anchorage Daily News*
Robert Hallinen, *Anchorage Daily News*
Robert Hallinen, *Anchorage Daily News*
Robert Hallinen, *Anchorage Daily News*

178 Marc Lester, *Anchorage Daily News*
Robert Stapleton, Jr.
Erik Hill
Bill Roth, *Anchorage Daily News*
Robert Hallinen, *Anchorage Daily News*
Robert Stapleton, Jr.
Robert Hallinen, *Anchorage Daily News*

180 Michael Penn
Hall Anderson
Michael Penn
Michael Penn
Michael Penn
Marc Lester, *Anchorage Daily News*
Hall Anderson

Staff

The *America 24/7* series was imagined years ago by our friend Oscar Dystel, a publishing legend whose vision and enthusiasm have been a source of great inspiration.

We also wish to express our gratitude to our truly visionary publisher, DK.

Rick Smolan, Project Director
David Elliot Cohen, Project Director

Administrative
Katya Able, Operations Director
Gina Privitere, Communications Director
Chuck Gathard, Technology Director
Kim Shannon, Photographer Relations Director
Erin O'Connor, Photographer Relations Intern
Leslie Hunter, Partnership Director
Annie Polk, Publicity Manager
John McAlester, Website Manager
Alex Notides, Office Manager
C. Thomas Hardin, State Photography Coordinator

Design
Brad Zucroff, Creative Director
Karen Mullarkey, Photography Director
Judy Zimola, Production Manager
David Simoni, Production Designer
Mary Dias, Production Designer
Heidi Madison, Associate Picture Editor
Don McCartney, Production Designer
Diane Dempsey Murray, Production Designer
Jan Rogers, Associate Picture Editor
Bill Shore, Production Designer and Image Artist
Larry Nighswander, Senior Picture Editor
Bill Marr, Sarah Leen, Senior Picture Editors
Peter Truskier, Workflow Consultant
Jim Birkenseer, Workflow Consultant

Editorial
Maggie Canon, Managing Editor
Curt Sanburn, Senior Editor
Teresa L. Trego, Production Editor
Lea Aschkenas, Writer
Olivia Boler, Writer
Korey Capozza, Writer
Beverly Hanly, Writer
Bridgett Novak, Writer
Alison Owings, Writer
Fred Raker, Writer
Joe Wolff, Writer
Elise O'Keefe, Copy Chief
Daisy Hernández, Copy Editor
Jennifer Wolfe, Copy Editor

Infographic Design
Nigel Holmes

Literary Agent
Carol Mann, The Carol Mann Agency

Legal Counsel
Barry Reder, Coblentz, Patch, Duffy & Bass, LLP
Phil Feldman, Coblentz, Patch, Duffy & Bass, LLP
Gabe Perle, Ohlandt, Greeley, Ruggiero & Perle, LLP
Jon Hart, Dow, Lohnes & Albertson, PLLC
Mike Hays, Dow, Lohnes & Albertson, PLLC
Stephen Pollen, Warshaw Burstein, Cohen, Schlesinger & Kuh, LLP
Rick Pappas

Accounting and Finance
Rita Dulebohn, Accountant
Robert Powers, Calegari, Morris & Co. Accountants
Eugene Blumberg, Blumberg & Associates
Arthur Langhaus, KLS Professional Advisors Group, Inc.

Picture Editors
J. David Ake, Associated Press
Caren Alpert, formerly *Health* magazine
Simon Barnett, *Newsweek*
Caroline Couig, *San Jose Mercury News*
Mike Davis, formerly *National Geographic*
Michel duCille, *Washington Post*
Deborah Dragon, *Rolling Stone*
Victor Fisher, formerly Associated Press
Frank Folwell, *USA Today*
MaryAnne Golon, *Time*
Liz Grady, formerly *National Geographic*
Randall Greenwell, *San Francisco Chronicle*
C. Thomas Hardin, formerly *Louisville Courier-Journal*
Kathleen Hennessy, *San Francisco Chronicle*
Scot Jahn, *U.S. News & World Report*
Steve Jessmore, *Flint Journal*
John Kaplan, University of Florida
Kim Komenich, *San Francisco Chronicle*
Eliane Laffont, *Hachette Filipacchi Media*
Jean-Pierre Laffont, *Hachette Filipacchi Media*
Andrew Locke, MSNBC
Jose Lopez, *The New York Times*
Maria Mann, formerly AFP
Bill Marr, formerly *National Geographic*
Michele McNally, *Fortune*
James Merithew, *San Francisco Chronicle*
Eric Meskauskas, *New York Daily News*
Maddy Miller, *People* magazine
Michelle Molloy, *Newsweek*
Dolores Morrison, *New York Daily News*
Karen Mullarkey, formerly *Newsweek, Rolling Stone, Sports Illustrated*
Larry Nighswander, Ohio University School of Visual Communication
Jim Preston, *Baltimore Sun*
Sarah Rozen, formerly *Entertainment Weekly*
Mike Smith, *The New York Times*
Neal Ulevich, formerly Associated Press

Website and Digital Systems
Jeff Burchell, Applications Engineer

Television Documentary
Sandy Smolan, Producer/Director
Rick King, Producer/Director
Bill Medsker, Producer

Video News Release
Mike Cerre, Producer/Director

Digital Pond
Peter Hogg
Kris Knight
Roger Graham
Philip Bond
Frank De Pace
Lisa Li

Senior Advisors
Jennifer Erwitt, Strategic Advisor
Tom Walker, Creative Advisor
Megan Smith, Technology Advisor
Jon Kamen, Media and Partnership Advisor
Mark Greenberg, Partnership Advisor
Patti Richards, Publicity Advisor
Cotton Coulson, Mission Control Advisor

Executive Advisors
Sonia Land
George Craig
Carole Bidnick

Advisors
Chris Anderson
Samir Arora
Russell Brown
Craig Cline
Gayle Cline
Harlan Felt
George Fisher
Phillip Moffitt
Clement Mok
Laureen Seeger
Richard Saul Wurman

DK Publishing
Bill Barry
Joanna Bull
Therese Burke
Sarah Coltman
Christopher Davis
Todd Fries
Dick Heffernan
Jay Henry
Stuart Jackman
Stephanie Jackson
Chuck Lang
Sharon Lucas
Cathy Melnicki
Nicola Munro
Eunice Paterson
Andrew Welham

Colourscan
Jimmy Tsao
Eddie Chia
Richard Law
Josephine Yam
Paul Koh
Chee Cheng Yeong
Dan Kang

Chief Morale Officer
Goose, the dog

24/7 books available for every state. Collect the entire series of 50 books. Go to www.america24-7.com/store